Studies on
Camille Pissarro

Contributors

Kathleen ADLER, *Middlesex Polytechnic*

Françoise CACHIN, *Musée d'Orsay, Paris*

Anne DISTEL, *Musée d'Orsay, Paris*

John HOUSE, *Courtauld Institute of Art, London*

Christopher LLOYD, *The Ashmolean Museum, Oxford*

Michel MELOT, *Centre d'Art et de la Culture Georges Pompidou*

Linda NOCHLIN, *Graduate School and University Center, City University of New York*

Martin REID, *London*

Barbara Stern SHAPIRO, *Museum of Fine Arts, Boston*

Ralph E. SHIKES, *New York*

Studies on
Camille Pissarro

Edited by
Christopher Lloyd

Routledge & Kegan Paul
London and New York

First published in 1986 by
Routledge & Kegan Paul Ltd
11 New Fetter Lane, London EC4P 4EE

Published in the USA by
Routledge & Kegan Paul Inc.
in association with Methuen Inc.
29 West 35th Street, New York, NY 10001

Set in Old Style, 10 on 12pt
and printed in Great Britain
by Butler & Tanner Ltd
Frome and London

Library of Congress Cataloging in Publication Data

Studies on Camille Pissarro.
Includes index.
1. Pissarro, Camille, 1830–1903—Criticism and
interpretation. 2. Impressionism (Art)—France.
I. Lloyd, Christopher Hamilton.
ND553.P55S78 1986 759.4 86–3876

British Library CIP Data also available

ISBN 0–7102–0928–2

Contents

Illustrations

Unless otherwise stated, all works are by Camille Pissarro and are in oils on canvas

Preface

The one hundred and fiftieth anniversary of Camille Pissarro's birth was marked by a retrospective exhibition held in London (Hayward Gallery), Paris (Grand Palais) and Boston (Museum of Fine Arts) between October 1980 and August 1981. To coincide with the showings in London and Boston conferences were organised by the Courtauld Institute of Art and the Museum of Fine Arts, respectively. It is the papers given on those two occasions that form the basis of the present volume, although for various reasons it has not proved possible to include all the contributions offered at the two conferences. The Museum of Fine Arts, Boston, also organised at the time of the exhibition a series of Sunday lectures. Three of the contributors to that series, John House, Linda Nochlin and Ralph Shikes, have kindly allowed their texts to be incorporated here. These, together with Martin Reid's paper on the movements of the Pissarro family in London in 1870–1, bring the total number of essays to ten.

The retrospective exhibition of 1980–1 served several purposes. First, it provided the opportunity of showing a large selection of paintings, drawings and prints by a widely appreciated Impressionist painter whose popularity with the general public was reflected in the attendance figures. Second, the selection of works included in the exhibition was specifically intended to emphasise the artist's pivotal role in French painting during the second half of the nineteenth century. To a certain extent this intention was recognised in the critical reception accorded the exhibition at the time and also in the longer, more considered reviews that have subsequently appeared in specialist journals. Third, it has always been accepted that Pissarro studies have lagged some way behind the attention given by scholars to other Impressionist artists. It was hoped that the exhibition would encourage further study of an artist whose important position in French art is often acknowledged but has never been properly explored. It is in this last respect that the present volume aims to complement the exhibition and it is earnestly desired that it should encourage others to undertake research on Camille Pissarro. One of the classic statements on the artist was made by Linda Nochlin, in an article entitled 'Camille Pissarro: the unassuming eye', first published in *ARTnews* in April

1965 (vol. 64, no. 2). Although appearing in a well-known journal, Nochlin's essay has not been as widely read as it deserves. Happily, it is republished here as adapted for the public lecture at Boston and, hopefully, it will inspire a new generation of Pissarro scholars.

Acknowledgment

The publication of this volume of essays on Camille Pissarro has been made possible only by the generosity of Catherine Schlageter-Boulton of Caracas, Venezuela, through the kind intervention of Mr Juan Parra in London. Camille Pissarro worked in Venezuela between 1852 and 1854 and it is therefore appropriate that his connections with that country should be honoured in this way over a century later. The publishers and the editor are most grateful for this financial assistance.

Abbreviations

P & V L.-R. Pissarro and L. Venturi, *Camille Pissarro, son art – son oeuvre,* 2 vols, Paris, 1939

D L. Delteil, *Le Peintre-Graveur illustré,* vol. XVII, *Pissarro, Sisley, Renoir,* Paris, 1923

B & L R. Brettell and C. Lloyd, *A Catalogue of Drawings by Camille Pissarro in The Ashmolean Museum, Oxford,* Oxford University Press, 1980

Correspondance *Correspondance de Camille Pissarro, Vol. 1, 1865–1885,* ed. Janine Bailly-Herzberg, Presses Universitaires de France, 1980

Lettres *Camille Pissarro. Lettres à son fils Lucien,* ed. J. Rewald, Paris, 1950

Pissarro exhibition 1980–1 *Camille Pissarro 1830–1903,* London (Hayward Gallery), Paris (Grand Palais), Boston (Museum of Fine Arts), 1980–1

Chapter 1

Camille Pissarro: the unassuming eye

Linda Nochlin

'The gift of seeing is rarer than the gift of creating,' Zola once remarked. Certainly, it is this rare gift, more than any other, which marks the work of Camille Pissarro (1830–1903). His long career encompasses the whole range of nineteenth-century French visual discovery, from Corot through Neo-Impressionism, and ends on the very brink of the Cubist rejection of perception as the foundation of art. Reversing the usual direction of the voyage of self-discovery, Pissarro fled his exotic but stultifying birthplace, Saint Thomas in the West Indies, for the stimulation of mid-century Paris and its infinitely civilized countryside, just in time to participate in the major artistic revolution of his epoch.

The present-day penchant for ferocity, singlemindedness and ambiguity may stand in the way of a full response to an art at once so open and so limited as Pissarro's, unredeemed by either emotional undertow or technical bravura. The finished work reveals that Pissarro's self-effacement before the motif was at times truly remarkable. In the late 1860s and early 1870s, with a modesty matched only by that of his first master, Corot, he produced a series of landscapes so disarming in their unassailable visual rectitude, so unforced in execution and composition, that Cézanne said of them in later years: 'If he had continued to paint as he did in 1870, he would have been the strongest of us all' (plate 1). Cézanne's remark reminds us that Pissarro was not only endowed with the gift of seeing, but with the even rarer ability to make other artists see for themselves: Cézanne, Gauguin and Van Gogh bear witness to the effectiveness of Pissarro as a teacher, or rather, one whose very presence in the vicinity of the chosen motif might serve as a catalyst, a liberating agent for the act of visual response, freed both from traditional *poncif* and subjective distortion. Nor was his role forgotten: Gauguin hotly defended his former master's 'intuitive, purebred' art against charges of derivativeness as late as 1902, and the old, already venerated Cézanne, in an exhibition at Aix in 1906, the year before his death, had himself listed in the catalogue as 'Paul Cézanne, pupil of Pissarro.' More than any other Impressionist, Pissarro remained faithful to the basic tenets of the group as they were formulated during the high point of the 1870s – he was the only one to participate in all eight

Impressionist exhibitions – and to the end, maintained his faith in natural vision as the guiding principle of art.

But this is far too simple and unproblematic a formulation of both the revolutionary nature of the Impressionist enterprise and Pissarro's specific contribution to it. Seeing, for a painter, must always involve a simultaneous act of creation if there is to be a work of art at all, and in any case, 'la petite sensation,' the whole notion that it is possible to divorce seeing from its cognitive, emotional and social context is as idealistic, in its way, as any classical norm. The idea that there can be such a thing as a neutral eye, a passive recorder of the discrete color sensations conveyed by brilliant outdoor light is simply an element of Impressionist ideology, like their choice of 'ordinary' subjects and 'casual' views, not an explanation of the style itself. After all, the difference between what Vermeer 'saw' when he looked out of his window in Delft in the seventeenth century and what Pissarro 'saw' when he looked out of his in Rouen in the nineteenth can hardly be laid to mere physical differences like optic nerves and climate on the one hand, nor to willful distortion of the visual facts on the other. Yet the same light that crystalized and clarified forms on a surface of impeccable, mirrorlike smoothness in the *View of Delft* seems to have blurred and softened them on Pissarro's crusty, pigment-streaked canvas. What an artist sees, as revealed by the evidence of the painted image, would seem to depend to an extraordinary degree on *when* he is looking and *what* he has chosen to look at.

For Pissarro, a convinced and professing anarchist, Impressionism was the natural concomitant of social progress, political radicalism, belief in science rather than superstition, individualism and rugged straightforwardness in personal behavior. His lifelong insistence on art as truth to immediate perception, his faith in 'les effets si fugitifs et si admirables de la nature'[1] were intimately related to his commitment to the progressive nineteenth-century belief in human and physical nature as basically good, corrupted only by a repressive and deceiving social order, by prejudice and obscurantism. Impressionism sought to restore the artist to a state of pristine visual innocence, to a prelapsarian sense-perception free of the *a priori* rules of the academy or the *a posteriori* idealization of the studio. Courbet, professing ignorance of the subject recorded by his brush, Monet wishing that he had been born blind, Pissarro advising his artist-son, Lucien, not to overdevelop his critical sense but to trust his sensations blindly – all testify to the same belief that natural vision is a primary value in art, and can only be attained through a process of ruthless *divestment* rather than one of solid accumulation, a rejection of past traditions rather than a building upon them.

Pissarro, in the course of one of the heated discussions of the young rebels at the Café Guérbois, once declared that they ought to 'burn down the Louvre,'[2] surely the most extreme statement of its kind until the Futurist manifestoes of the twentieth century. 'L'Impressioniste,' wrote the poet, Jules Laforgue, in a remarkable article of 1883, '... est un peintre moderniste qui ... oubliant les tableaux amassés par les siècles dans les musées, oubliant l'éducation optique de l'école (dessin et perspective, coloris), à force de vivre

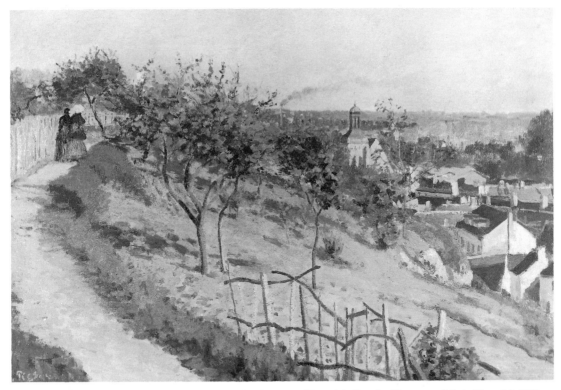

1 *La Sente de Justice, Pontoise*, c. 1872, 52.1 by 81.3 cm. Memphis Brooks Museum of Art, Memphis TN, gift of Mr and Mrs Hugo N. Dixon 53.60

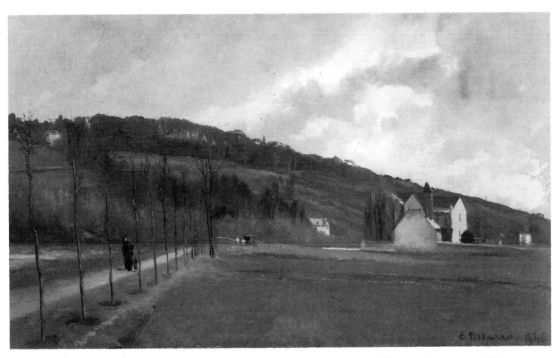

2 *Bords de la Marne en hiver*, 1866, P & V 47, 91 by 150 cm. Courtesy of The Art Institute of Chicago

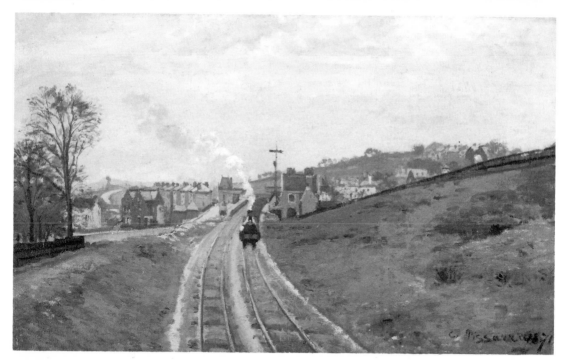

3 *Lordship Lane Station, Upper Norwood, London,* 1871, P & V 111, 45 by 74 cm. London, Courtauld
Institute Galleries (Courtauld collection)

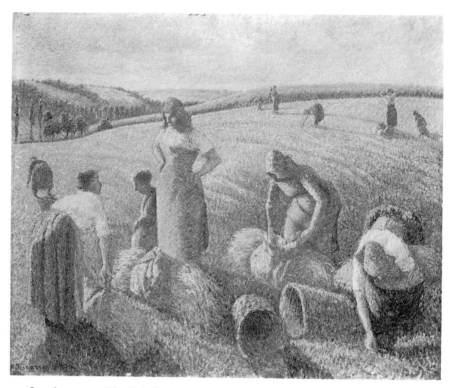

4 *Les glaneuses,* 1889, P & V 730, 65 by 81 cm. Basle, Kunstmuseum (Dr H. C. Emile
Dreyfus Foundation)

et de voir franchement et primitivement dans les spectacles lumineux en plein-air ... est parvenu à se refaire un oeil naturel, à voir naturellement et à peindre naïvement comme il voit.'[3] Painting becomes a continual search and learning to paint the often agonizing process of a lifetime, not a set of rules to be mastered in a series of graduated stages within an academy. The rejection of 'values' as the basis of painting in the progressive art after Corot can thus be interpreted both in the pictorial sense of an abandonment of under-painting – a fixed, hierarchical scheme of abstract light-and-shade pre-determining the final 'meaning' of the work – and at the same time, as the rejection of the social, moral and epistemological structures which such a pictorial scheme presupposes. As such, it has constituted a permanent rejection on the part of avant-garde art right down to the present day.

Like the other Impressionists, and more strongly than some of them, Pissarro was convinced that what the purified eye must confront was contemporary appearance. '[Nous devons chercher] des éléments dans ce qui nous entoure, avec nos propres sens,' he wrote to Lucien in 1898. 'Et l'on ne travaille dans ce sens qu'en observant la nature avec notre propre tempérament moderne. ... c'est une erreur grave de croire que tous les arts ne se tiennent pas étroitement liés à une époque.'[4] This sensitivity to the quality of his own time is evident in Pissarro's work as early as 1866, when a critic remarked on his landscape in the Salon of that year, *Bords de la Marne en hiver* (plate 2) that 'M. Pissarro n'est pas banal par impuissance d'être pittoresque' and has used his robust and exuberant talent specifically 'à faire ressortir les vulgarités du monde contemporain.' Zola commented on the harsh veracity of the same work, and of a similar view in the Salon of 1868, exclaimed: 'C'est là la campagne moderne.' One is often aware of the more or less discreet encroachments of industrialization in Pissarro's landscapes: a smokestack appears as early as 1868 and there is a fine group of paintings of factories in 1873. Pissarro sees them neither as dark, satanic mills nor as harbingers of technological progress, but simply as elements, neither denied nor unduly emphasized, within an admirable, contemporary pictorial motif.

When he sought refuge in London from the rigors of the Franco-Prussian War, he chose to paint, forthrightly, with a sprightly, unromantic verve, that emblematic structure of modernity, the Crystal Palace, not just once but twelve times over. His vision of the railroad there is not visionary and excited like Turner's *Rain, Steam and Speed: the Great Western Railway,* but direct, vivid, matter of fact (plate 3). Yes, the tracks cut a path through the bosom, as it were, of nature. No, this is not horrific or menacing, but part of the modern given, how things are in the industrial world.

Yet, while he never said it in so many words, and generally insisted on equating Impressionist vision with scientific progress, human value and left-wing politics, Pissarro could not have failed to have been aware of the basically subjective, almost solipsistic bias with which Impressionism might be afflicted. The 'petite sensation,' the basis of Pissarro's art, while it made for the richness and range of individual styles within the Impressionist gamut, could also lead to fantasy and exaggeration – in short, to precisely that self-indulgent

mysticism which Pissarro found so abhorrent and reactionary. What one might be painting might not be nature, not wholesome, everyday reality, but a shifting, floating, evanescent, even deceptive, veil of maya. The poet, Jules Laforgue, found this *symboliste* aspect of Impressionism much to his taste: the impossibility of attaining a stable, unequivocal reality, the inevitable exaltation of the individual sensibility at a unique moment in time. 'Même en ne restant que quinze minutes devant un paysage, l'oeuvre ne sera jamais l'équivalent de la réalité fugitive . . .'. Laforgue wrote, 'L'objet et le sujet sont donc irrémédiablement mouvants, insaisissables et insaisissants.'[5] Pissarro, one imagines, did not feel easy with this aspect of the movement.

It was perhaps for this reason, among others, in the middle 1880s, when the Impressionist impulse was at a low ebb and the group itself disintegrating as a coherent entity, that Pissarro took temporary refuge in the solid theoretical basis and apparently universal objectivity of Neo-Impressionism, adopting the 'scientific' color-division and painstaking, dotted brushwork of the young Seurat when he himself was fifty-five years old. The Neo-Impressionist affinity for the systematized and the socially progressive might also have been tempting at this time, as a comparison of the 1889 painting of *Les glaneuses* (plate 4) with some of Pissarro's earlier, less consciously monumental representations of peasants in landscapes would reveal. At this moment, he refers to the orthodox Impressionists as 'romantic' (to differentiate them from his new 'scientific' colleagues), and criticizes Monet's work of 1887 as suffering from a 'désordre qui ressort de cette fantaisie romanesque qui . . . n'est pas en accord avec notre époque.'[6]

Pissarro's whole series of paintings of peasant women in the decade of the 1880s raises certain interesting social and stylistic issues. Certainly, as Richard Brettell has pointed out, it is Degas who stands behind Pissarro in his renewed concentration on the expressive potential of the human figure in these paintings (as opposed to earlier ones where they are just staffage) and doubtless, as Brettell says, it was Degas' images of the working women of Paris that provided a new repertory of poses, gestures and viewpoints;[7] I think Degas' ballet dancers also figured in this process.

A few years before he painted *Les glaneuses,* in the early to mid-1880s, Pissarro's resolute modernity, his intention not to sentimentalize but to be of his times is evident in his choice of the theme of the peasant woman in the market-place rather than the more traditional *topos* of the peasant woman working in fields or nourishing her young (plate 5). These more traditional peasant themes evoke the connection of the peasant woman with the unchanging natural order. Pissarro's market-woman, on the contrary, clearly demonstrates that the peasant woman like the rest of humanity and perhaps in a heartfelt way, like the artist in particular, has to hustle her wares for a living. The country woman is envisioned by Pissarro as an active and individuated force in contemporary economic life rather than as a generalized icon of timeless submission to nature. At the same time, town and country are seen to interact in the modest arena of commerce – briskly, not darkly – rather than being idealized as opposing essences.

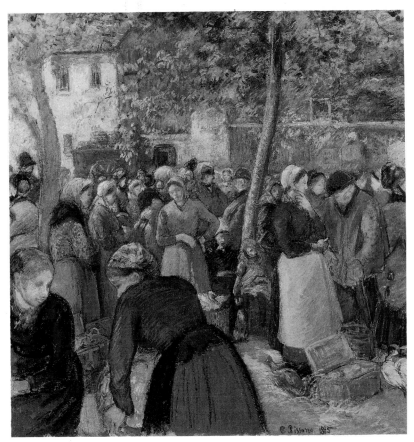

5 *Le marché à la volaille, Gisors,* tempera, 1885, P & V 1400, 81 by 81 cm.
Courtesy, Museum of Fine Arts, Boston, bequest of John T. Spaulding

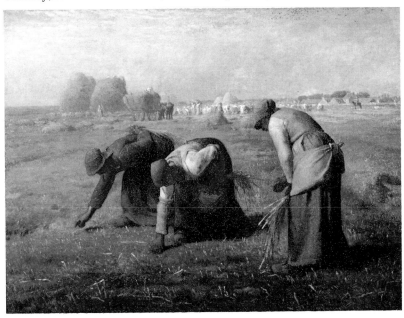

6 J. F. Millet, *Les glaneuses,* 1857. Paris, Musée du Louvre

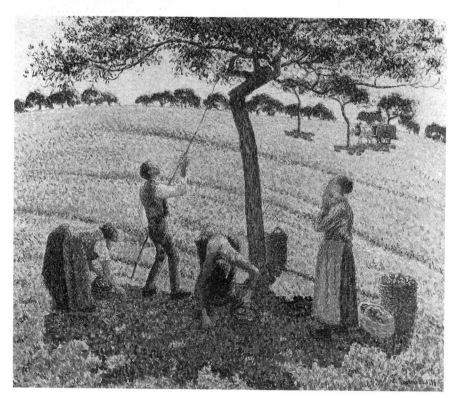

7 *La cueillette des pommes, Eragny-sur-Epte,* 1888, P & V 726, 60 by 73 cm. Dallas, Museum of Fine Arts, Munger Fund purchase

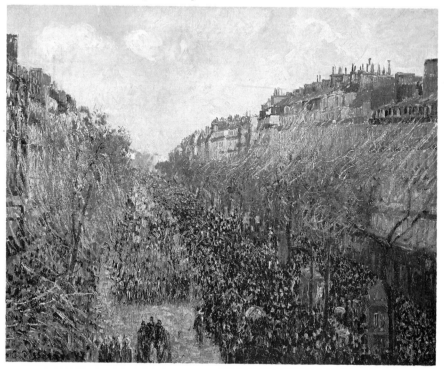

8 *Boulevard Montmartre, mardi-gras,* 1897, P & V 995, 65 by 81 cm. Los Angeles, The Armand Hammer Foundation

One can see differences in a comparison of Pissarro's and Millet's *Les glaneuses* (plate 6). Pissarro has, in a sense, responded to the challenge of Millet by demystifying Millet's image, making it more irregular and variegated; having one woman stand up in an assertive and dominating pose and talk to another, he refuses the identification of woman and nature suggested by Millet's composition. In the same way, Pissarro's *Paysans dans les champs, Eragny-sur-Epte* of 1890 seems to be a contemporary, up-to-date reinterpretation of the generalized pieties of Millet's *L'angélus*. There are ways in which Pissarro's *Les glaneuses* reminds one of the self-conscious multiplicity of poses and variations of Jules Breton's *Le rappel des glaneuses* of 1859, although he has staunchly refused both Breton's glamorization of his subject and the slick, fussy detail of his style.

Still, one does not feel that either the ambitious monumentality or the systematic paint application of Neo-Impressionism have been satisfactorily assimilated by Pissarro. The ghostly example of *La Grande Jatte* lies in the background of works like the 1889 *Les glaneuses* and accounts for its inner contradictions. The Seurat-inspired self-consciousness of the composition – rationalized brushwork, clarifying light and measured space – clashes with the spontaneous irregularity of Pissarro's figure style. Missing is that harmonious regularity of contour and volume with which Seurat had united his figures with their setting. The demands of systematization and the delights of informality; the countering signs of the colloquial and the monumental are left unresolved in Pissarro's paintings.

The same contradictions, redeemed by a more interesting decorative effect, mark another major Neo-Impressionist work, *La cueillette des pommes* of 1888 (plate 7). It is hard to escape certain allegorical significations of the theme itself in this painting, for the tree is deliberately, and apparently meaningfully, centralized and the composition regularized as though to insist upon its metaphorical status. The motif of fruit-picking with symbolic overtones becomes a kind of *fin de siècle leitmotif*. It is picked up in Mary Cassatt's 1893 mural for the Chicago World's Fair, the *Allegory of Modern Woman*, a work which is more overtly utopian in its resonance than Pissarro's *La cueillette des pommes*: the women are represented plucking the fruits of knowledge. And certainly 'utopian' is the word to describe Signac's social allegory, featuring a worker plucking fruit from a tree, *Au Temps d'Harmonie*, painted for the town hall of Montreuil in 1895. And, in a very different mood, fruit-picking figures as the central motif of Gauguin's dark allegory of human existence, *D'où venons-nous? Que sommes-nous? Où allons-nous?* of 1897.

Yet Pissarro's work, neither before nor after what Rewald has termed his 'divisionist deviation' was never really threatened by the dissolution of objects into webs of broken color. In his *Boulevard Montmartre, mardi-gras* (plate 8), for example, one of a series of city vistas of 1897, there is a sense of lively, allover surface activation, merging people, buildings and budding trees in a carnival atmosphere of colored movement, somewhat reminiscent of Monet's dazzling *La rue Montorgueil fête du 30 juin* of 1878, and illustrating his own advice to a young artist of the very year it was painted: 'Ne pas faire morceau

par morceau; faire tout ensemble, en posant des tons partout.... L'oeil ne doit pas se concentrer sur un point particulier, mais tout voir'[8] But at the same time, Pissarro's brush scrupulously maintains the individual rights of separate forms, substances and textures within this context of unifying atmosphere, differentiating with staccato touches the crowd at the right from the longer, more continuous strokes of the procession in the background, and distinguishing by feathery, diaphanous swirls the tops of the trees from the solid rectangular patches of the kiosks beneath them, marking off the latter in turn from the more fluid, less substantial rectangles of chimneys and attics.

It was perhaps his feeling for things, his commitment to nature and human value, rather than theory or an innate sense of form which protected him, or limited his power of invention, according to how one chooses to look at it. Pissarro was never, as was Monet (or as the Monet mythology would have it) in his later years forced into near-abstraction by the urgency of an obsessive chase after the wild goose of the *instantané*; for Pissarro, the vision of nature always implied a point of view, a certain distance, a beginning, a middle and an end within a given canvas. One might even say (as one never could of the tormented old Monet, hovering feverishly over his ninety canvases in the Savoy Hotel in London, searching for exactly the right patch in exactly the right canvas for this particular instant of light), that Pissarro accepted nature's calm quiddity as simply more *possible* for the painter than the perpetual flow of her random splendor, more appropriate to his temperament and the nature of his task than a dizzying descent into the heart of process at the bottom of a lily-pond. If one compares Pissarro's view of Rouen cathedral (plate 9) with one of Monet's famous Rouen *Façades* of the previous years (plate 10), one immediately sees that while Monet completely identifies pictorial motif and painted object, dissolving the architectonic façade of the actual building in light, and then petrifying his sunset sensations into a corrugated, eroded pigment-façade, Pissarro has effected no such alchemical metamorphosis. Thoroughly familiar with Monet's series, which he had admired at Durand-Ruel's, he deliberately chose a more panoramic, less destructive view. 'Tu te rappelles,' he wrote to Lucien, 'que les *Cathédrales* de Monet étaient toutes faites avec un effet très voilé qui donnait, du reste, un certain charme mystérieux au monument. Mon vieux Rouen avec sa Cathédrale au fond est fait par temps gris et assez ferme sur le ciel. J'en étais assez satisfait; cela me plaisait de la voir se profiler grise et ferme sur un ciel uniforme de temps humide.'[9] In Pissarro's painting, Rouen cathedral remains Rouen cathedral, paint remains paint, and both depend on the eye and hand of the painter, situated at a certain determinable point of distance from his motif.

The ultimately liberating implications of Impressionism, its freeing of the artist to establish a system of independent relationships of form and color on the canvas were obviously foreign to Pissarro's conception of it. Like others of his time, he saw Gauguin's synthetist symbolism and the decorative abstraction of the Nabis as rejections of Impressionism, rather than extensions of its inherent possibilities. Gauguin, with his turning away from natural perception in favor of 'mysterious centers of thought' and his quasi-religious predilections,

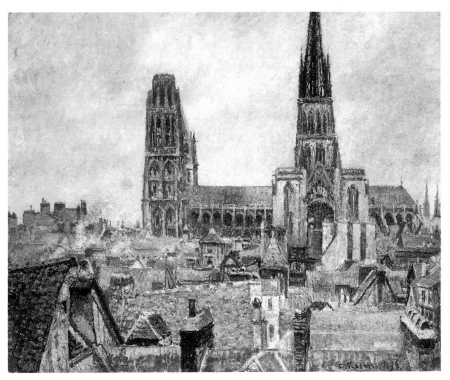

9 *Les toits du vieux Rouen, temps gris (la cathédrale),* 1896, P & V 973, 72.3 by 91.4 cm. Toledo, The Toledo Museum of Art, gift of Edward Drummond Libbey

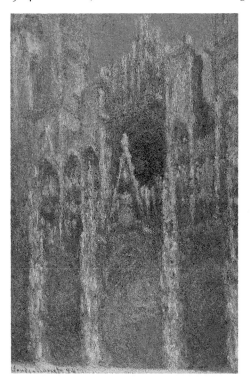

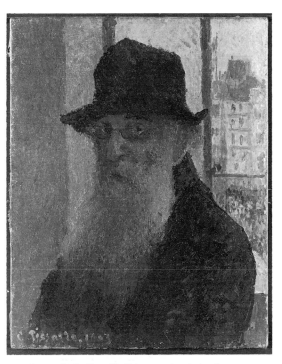

11 *Portrait de Camille Pissarro par lui-même,* 1903, P & V 1316, 41 by 33 cm. London, The Tate Gallery

10 Claude Monet, *Cathédrale de Rouen, effet de soleil,* 1894. Courtesy, Museum of Fine Arts, Boston, Juliana Cheney Edwards collection, bequest of Hannah Marcy Edwards in memory of her mother

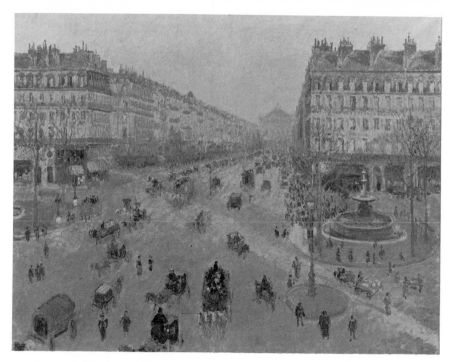

12 *Avenue de l'Opéra, soleil, matinée d'hiver,* 1898, P & V 1024, 73 by 91.8 cm. Reims, Musée de Saint Denis

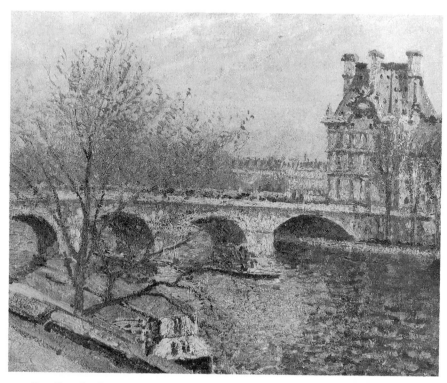

13 *Pont Royal et Pavillon de Flore,* 1903, P & V 1286, 54.5 by 65 cm. Paris, Musée du Petit Palais. Photo Bulloz

he considered an apostate if not an outright charlatan. 'Je ne reproche pas à Gauguin d'avoir fait un fond vermillon . . . ,' he wrote in 1891, 'je lui reproche de ne pas appliquer sa synthèse à notre philosophie moderne qui est absolument sociale, anti-autoritaire et anti-mystique. . . . Gauguin n'est pas un voyant, c'est un malin qui a senti un retour de la bourgeoisie en arrière'[10]

In the last years of his life, a bent but indefatigable old man with a prophet's beard and ailing eyes (plate 11), he returns to the deep perspectives and apparently spontaneous perceptions characteristic of the Pontoise land-scapes of the 1870s, but this time, chooses to immerse himself in the variegated motifs offered by the boulevards and avenues of Paris (plate 12). How little sense there is of the grimness of urban reality in these panoramas, viewed, generally rather distantly, from the height of a hotel window! It is not that the painter has avoided the issue, it is just that what he sees before him is anything but grim. 'Ce n'est peut-être très esthétique,' he writes to Lucien near the turn of the century, 'mais je suis enchanté de pouvoir essayer de faire ces rues de Paris que l'on a l'habitude de dire laides, mais qui sont si argentées, si lumineuses et si vivantes. . . . C'est moderne en plein!'[11] Allées of trees are now replaced by vistas of stone façades, peasants by pedestrians, hedgerows by carriages, cabbage fields by cobblestones, or, at times, nature is permitted to intrude, mingle with, enrich the cityscape. Although these late Parisian street-scenes are uneven in quality, in the best of them there is an invigorating achievement of freshness, consummate control and freedom. In the *Pont Royal et Pavillon de Flore* (plate 13) painted during the last year of the artist's life, a sense of vernal lightness arises from the delicate balance established between the demands of the motif – sprightly, wavering openness of the central tree, calm horizontal curve of the bridge, diagonal of façades on the opposite bank – and those of pictorial unity, the latter created by an all-over high-keyed pastel palette and the granular consistency of the surface texture.

Looking at this group of late cityscapes as a whole, no matter how we evaluate them – and certainly, they are not masterpieces in the usual sense of the term – we nevertheless tend to accept them as authentic records of how things looked, how things *were* in Paris at the turn of the century. Perhaps this is because they coincide so neatly with our own view of how Paris was – or even, if we are unabashedly romantic and Francophile, of how Paris is. Pissarro has created an imagery of liveliness rather than urban hysteria; of spontaneity rather than confusion; of pleasurable randomness within a setting of spacious order rather than alienation in an oppressively crowded chaos.

Yet Pissarro's vision of a motif like the Pont Neuf is as determining and chosen as any other: it is no more 'real' Paris than say, the photographer Hippolyte Jouvin's cooler and more utilitarian stereoscopic photograph of the same motif – the Pont Neuf of 1860–5. It involves a certain notion of the nature of the modern city itself and the artist's relation to it.

Nor is Pissarro's vision of urban reality any more privileged than Gustave Doré's melodramatic, exaggerated perspective of workday London in 1872, which emphasized the feverish pressure of a crowd in a blocked, funnel-like space rather than easy recession. By 'vision' I of course mean the social and

psychological assumptions controlling vision at any moment in history as well as aesthetic decisions about vantage point, distance, or placing of the image within the frame. It is precisely the difference in these assumptions which, of course, makes Caillebotte's urban imagery in his *Boulevard vu d'en haut* of 1880 so different from Pissarro's boulevard paintings: so much more distanced, arbitrary-seeming and aestheticized. And it is obvious that Pissarro was incapable of experiencing or setting forth the city as a projection of menacing alienation as had Munch in 1889.

Pissarro's particular unstrained and accepting modality of urban vision had to do with a kind of freedom which he thought of as freedom of perception. We are, perhaps, more cynical about the possibilities of individual freedom, or, alternatively, conceive of freedom – artistic freedom at any rate – in more grandiose terms. But confronting some of these later urban vistas of Pissarro one feels ready to revise, no matter how little, one's twentieth-century prejudices about the nature of freedom in art, prejudices about the necessarily *extreme* character of all choice. Perhaps one can be relatively free without self-conscious rebellion or dramatic gestures, free like Pissarro to trust one's own unassuming but unacerbated intuitions of truth and reality. For the old anarchist, freedom in this unspectacular sense seems to have been the essential condition of painting, of seeing; perhaps of living. 'Il faut de la persistance, de la volonté et des sensations *libres*', he wrote, well on in years and neither very rich nor very famous, 'dégagées de toute autre chose que sa propre sensation.'[12]

Notes

This is an expanded and revised version of an article that was originally published with the same title in *ARTnews* LXIV, April 1965, pp. 24–7 and 59–62. Thanks are due to the Editor of *ARTnews* for permission to reprint the article in this way.

1 Pissarro to H. van de Velde, 27 March 1896 as quoted in J. Rewald, *L'Histoire de l'impressionnisme*, Paris, 1955, pp. 329–30.
2 Pissarro as cited in J. Rewald, *Camille Pissarro*, New York, 1963, p. 18.
3 *Oeuvres complètes de Jules Laforgue, Mélanges posthumes*, 3rd ed., Paris, 1903, p. 133.
4 *Lettres*, pp. 451 and 459 (7 March 1898 and 19 August 1898).
5 Laforgue, op. cit., pp. 140 and 141.
6 *Lettres*, pp. 111 and 124 (November 1886 and 9 January 1887).
7 Pissarro exhibition, 1980–1, p. 29.
8 From the unpublished private notes of the painter Louis LeBail, who received Pissarro's advice during the years 1896–7, as quoted in Rewald, op. cit. (1955), pp. 279–80.
9 *Lettres*, p. 403 (24 March 1896).
10 *Lettres*, pp. 234–5 (20 April 1891).
11 *Lettres*, p. 442 (15 December 1891).
12 *Lettres*. p. 291 (9 September 1892).

Chapter 2

Camille Pissarro's idea of unity

John House

The art of Camille Pissarro presents an immediate problem, by its constant changes of style. Perhaps more than any other painter of his stature, Pissarro changed his style and working methods in response to his latest artistic encounters and working relationships. But this does not mean that he was simply a born follower, for he played a major role in forging these successive styles and was at the centre of the theoretical debates surrounding them. To chart Pissarro's stylistic evolution is to describe a succession of artistic relationships, each having a formative influence on his style of the moment: we meet in turn Corot, Daubigny, Courbet, Jongkind, Monet, Cézanne, Renoir, Millet, Seurat, Turner and Monet again. These relationships often overlap, and none operated in isolation; but the very length of the list, and Pissarro's constant openness to such influences, mean that we cannot gain access to his artistic personality by the most obvious means – by seeking a consistency and continuity in the physical appearance of his paintings. On strictly visual grounds it is difficult to define any overall unity in Pissarro's art: where is the distinctively Pissarro element in it?

Even Pissarro's son Lucien sensed the problem raised by his father's changes of direction. He wrote to him in 1903, after looking over a selection of paintings from his whole career: 'C'est étonnant comme tout se tient. Les premiers tableaux, la série de Pontoise, les toiles à division systématique et les choses récentes, quand on les voit ensemble, forment un tout et ne semblent pas avoir l'écart que je me figurais qu'elles avaient. De quelque façon et sous quelque influence que tes oeuvres soient faites, elles conservent toujours cette recherche des valeurs rapprochées qui forme, au fond, le grand caractéristique de ton art.'[1]

Lucien was certainly right to stress Pissarro's concern for *valeurs rapprochées*. Pissarro always devoted great care to the internal coherence of his paintings, whatever his style of the moment; this concern went back to the beginnings of his career as a landscapist, and to the instructions he had received from Corot in the late 1850s. But this does not answer the larger question, whether there is any deeper level of consistency running through his whole career, behind the changes of style. Pissarro himself insisted in 1891

that his artistic 'personality' did not simply lie in his technique: 'Il y a bien quelques jeunes malins qui prétendent que j'ai passé une partie de mon existence à me laisser influencer par Manet (un comble), Monet, Renoir, Sisley (étonnant) et même les pointillistes! Ces jeunes parlent à tort et à travers de "personnalité", sans savoir au juste ce que cela peut signifier. Pour eux il n'y a de personnalité que dans la technique.'[2] In this letter Pissarro did not define where he felt his personality might be sought, but clearly we must look beyond style and technique.

On 5 May 1890, Pissarro wrote to his niece Esther Isaacson about his aims in art. He emphasised first the importance of the artist's *sensations* – his direct experiences – and then his need to understand them and order them in his *pensée* – his thoughts and mind. To explain this, he defined, invaluably for us, the successive stages of his own career as he saw them: 'J'ai commencé à *comprendre mes sensations* à savoir ce que je voulais vers les 40 ans – mais vaguement – à 50 ans c'est en 1880, je formule l'idée d'unité, sans pouvoir la rendre à 60 ans je commence à voir la possibilité de rendre.'[3] I want in turn to focus on these three stages: beginning to understand his *sensations*, around 1870; formulating the idea of unity, around 1880; and seeing how to render it, around 1890. By examining Pissarro's work in the context of the continuity and development which he himself saw running through his career, we can characterise his art more fully. The essential key to this is the gradual emergence of his 'idea of unity'.

To the end, Pissarro insisted that his *sensations* were the essential basis of his art, and the nature of these *sensations* must be our starting point too: we must look at them first in the context of his art around 1870, when he began to understand them. This date corresponds with the birth of Impressionism as we know it today, in the comparatively small, informally composed landscapes on which Pissarro and his friends began to concentrate in the late 1860s (e.g. Pissarro exhibition 1980–1, 13–14). In handling and technique these landscapes are always varied, responsive to different effects of light and atmosphere and to the diversity of textures within the forms represented. Touch and colour alike are used with great flexibility, in direct response to the particulars of the scene. Subjects and effects are carefully chosen, but there is no sense of any purely pictorial effect being superimposed. The pictures remain first and foremost representations of the artist's direct experience, of his *sensations*.

But what was the status of these *sensations*? Were they objective experiences of the material world, or subjective responses to experience? Richard Shiff has discussed this issue in 'The End of Impressionism', and has made one point which is crucial to understanding the nature of Impressionism.[4] In the framework within which the terms *sensation* and *impression* were used in the 1860s and 1870s, the polarity between the subjective and the objective is misleading. A *sensation* or *impression* of nature is essentially personal to the perceiver; but it is only through these *sensations* and *impressions* that he has any access to the reality of the physical world. Our knowledge of the external world can only be derived from our *sensations* and *impressions*; they cannot

be formally verified, but can only be compared with other people's *sensations* and *impressions*. This language was particularly current among positivist philosophers such as Littré, Taine and Ribot, and was widely used in Pissarro's circle at the time.[5]

An artist's vision of nature can thus be both individual and truthful. This can well be illustrated, from the immediate context within which the young Impressionists were working, by Zola's discussion of Jongkind in his review of the Salon of 1868. Zola switches effortlessly from the truthfulness of Jongkind's vision to its personal individuality: 'Il voit un paysage d'un coup, dans la réalité de son ensemble, et il le traduit à sa façon, en en conservant la vérité et en lui communiquant l'émotion qu'il a ressentie. C'est ce qui fait que le paysage vit sur la toile, non plus seulement comme il vit dans la nature, mais comme il a vécu pendant quelques heures dans une personnalité rare et exquise. ... Ici, tout est original, le métier, l'impression, et tout est vrai, parce que le paysage entier a été pris dans la réalité avant d'avoir été vécu par un homme.'[6]

This terminology shows that within their context there was no inconsistency whatsoever for the young Impressionists to cultivate a personal vision of nature and at the same time to seek an essentially natural, truthful form of art. What Pissarro and his colleagues achieved around 1870 was a pictorial language, of varied touches and colour, which recreated nature as they saw it. It was thus that Pissarro, in his words of 1890, 'began to understand his *sensations*' around 1870.

His idea of unity, as he formulated it around 1880, did not in any way involve a rejection of his *sensations*. *Sensations* remained his essential starting point, but now the finished work of art had to go beyond the mere *sensation* and introduce the artist's *pensée*. In his 1890 letter to Esther Isaacson, Pissarro said little more than this, but elsewhere he explained his ideas on art more fully. Unfortunately we have no such statement from around 1880 when the idea of unity was formed. Our evidence dates from the period of the letter to Esther, and thus reflects his ideas at the moment when he was beginning to see the possibility of rendering his idea of unity. He was of course using hindsight in 1890 when he described the stages of his past development, and we have to be careful in looking back from this date to his formation of his idea of unity ten years earlier. We are seeking the germs of his 1890 ideas in his practices of 1880, but, as we will see, these ideas in fact evolved over a period of fifteen years.

His fullest statement of them appeared in an interview of 1892: 'Je ne peins pas mes tableaux directement d'après nature: je ne fais ainsi que des études; mais l'unité que l'esprit humain donne à la vision ne peut se trouver que dans l'atelier. C'est là que nos impressions, disséminées d'abord, se coordonnent, se font valoir réciproquement pour former le vrai poème de la campagne. Au dehors, on peut saisir les belles harmonies qui s'emparent immédiatement des yeux: mais l'on ne peut suffisamment s'interroger soimême pour affirmer dans l'oeuvre ses sentiments intimes. C'est à la recherche de cette unité intellectuelle que je mets tous mes soins.'[7]

This statement suggests two threads which I want to trace through Pissarro's career: first, his use of the studio; and second, his subject matter, the vision of nature which he sought to distil into the 'vrai poème de la campagne'. The third essential element is his technique, since it was from the material substance of his paintings, as well as from their imagery, that the idea of unity had to emerge; it is from here that I will continue, working my way towards the broader questions about his vision of the world.

As we have seen, his handling around 1870 was characterised by its diversity: individual touches of paint are part of an endlessly flexible representational shorthand, perfected in its boldest and simplest form by 1873 (e.g. Pissarro exhibition 1980–1, 17 and 30; 17 belongs most plausibly in 1873). In 1874, by contrast, there is a marked change, to a far greater physical presence and materiality in the paint surface, which makes the whole image more emphatically two-dimensional (e.g. Pissarro exhibition 1980–1, 36). This is not achieved at the expense of a sense of space; but the emphasis on surface planes, often very even in colour and density, establishes a dialogue or a tension between the two-dimensional and the three-dimensional. As we move towards the painting, space dissolves into surface, and we sense the process of transformation which the painter himself has gone through in translating his *sensations* into paint. This accentuated surface is most marked in the palette knife paintings of 1875 (e.g. Pissarro exhibition 1980–1, 39–42), but it did not lead Pissarro into any consistent stylistic path. Indeed, the later 1870s is the most varied and restless phase of his whole career, as he moved from the bold planes of 1875 to the over-insistent accents of 1876, notably in the large *Le jardin des Mathurins* (Pissarro exhibition 1980–1, 44), and then to the far more delicate, almost woven handling of 1877–8 (e.g. Pissarro exhibition 1980–1, 46–9).

These changes can in part be explained by reference to outside influences. Cézanne lies behind the emphasised surface planes and palette knife work of 1874–5, Monet behind the attempted virtuosity and accentuated touch of the 1876 *Jardin*, and Renoir behind the delicacy of 1877–8. Then the tauter hatching style of c. 1880 seems to look to Cézanne again, this time at the so-called constructive stroke which he had evolved in the late 1870s (e.g. particularly *Paysage à Chaponval*, 1880, P & V 509, Jeu de Paume, Paris). But this linear account of Pissarro's development, couched in terms of successive influences, does nothing to explain why, at this period, Pissarro was so open to outside stimuli; what, in his own right, he was seeking so restlessly. It is clearly no coincidence that this very experimental phase immediately preceded 1880, the date at which, he later said, he formulated the 'idea of unity'; and that 1880 itself is the beginning of a phase of five years of comparative consistency in technique.

The experiments of the later 1870s were all concerned with ways of organising the picture surface; there is no return to the natural, unassertive touch of c. 1870. Pissarro's anxiety in the later 1870s seems to be about what the picture surface should do in its own right, what role the material fabric of paint on the canvas should play in the meaning of the painting: should it

reflect underlying structures within nature, as in 1874–5? or should it express the immediacy of the painter's encounter with natural effects, as in 1876? or, as in 1877–8, recreate the subtle atmospheric web which unites the objects within a scene?

Pissarro's answer, at least as he phrased it around 1890, was that none of these solutions on its own was enough. The unity which he sought was not just a coherence within the scene or a means of achieving *valeurs rapprochées*, but a unity 'que l'esprit humain donne à la vision'. We will see later what this involved, but, once he had formulated this idea, the question of technique and handling, in itself, became more of a side issue, a means to an end rather than an end in itself. The physical expression of the 'idea of unity' in the early 1880s can be seen in *Jeune fille à la baguette* (Pissarro exhibition 1980–1, 53): the surface is built up from closely woven sequences of small touches, fairly regular in scale and rhythm, often grouped parallel to each other, and sometimes following the forms or contours of objects; the colour is similarly integrated, knit together by small rhyming accents of soft blues and reds which may even appear when there is no apparent reason for them, and by the occasionally heightened emerald greens. The organisation of the brushwork and these interconnections of colour give the whole painting a deliberate coherence.

When Pissarro espoused Neo-Impressionism in 1886, he thought at first that he had found in Seurat's and Signac's pointillist execution a physical means of imposing his sense of unity more fully on to the natural scene. Even at the height of this short-lived phase, though, his touch never wholly lost its directional rhythm (cf. Pissarro exhibition 1980–1, 65), and Pissarro soon realised that the rigours of Neo-Impressionism were at odds with his basic vision. He explained his reasons for abandoning it in letters which are particularly important because they reaffirm that the *sensation* remained his essential starting point. In 1888 he lamented that the monotony of the *point* was at odds with 'le gras, la souplesse, la liberté, la spontanéité, la fraîcheur de sensation de notre art impressionniste', and in 1896, in retrospect, said that he had returned to a broader handling after realising that the Neo-Impressionist technique made it impossible for him 'de suivre mes sensations, par conséquent de donner la vie, le mouvement, ... de suivre les effets si fugitifs et si admirables de la nature, ... de donner un caractère particulier à mon dessin'.[8] Only gradually did his touch loosen in his finished paintings, remaining dense and granular on occasion until the mid-1890s, though seeking a sense of diversity and movement, in contrast to the dryness and neutrality which he had rejected in Neo-Impressionism. His broader, more spontaneous handling of the later 1890s corresponds, as we will see, to a more general return to an open-air aesthetic on his part.

As Pissarro explained in the 1892 interview, his finished paintings were at that time executed in the studio. This allowed him to build up their very controlled and elaborately wrought surfaces at his leisure, in order, as he put it, to co-ordinate his impressions and express the unity which the human spirit gives to vision. His evolving use of the studio over the previous decades is

another gauge of the changing relationship between his direct experiences of nature and the meaning he sought in his art.

In the 1860s, many, and perhaps all, of his large Salon paintings were worked up in the conventional way, in the studio from small studies.[9] The smaller outdoor scenes of the late 1860s and early 1870s were doubtless begun out of doors, but the precise finish of many of these makes it likely that they were elaborated away from the initial transitory natural effect (e.g. Pissarro exhibition 1980–1, 14–15). The figures in these landscapes were consistently added at a very late stage, over dry paint layers and very probably in the studio, which would account for the slight oddities of scale which often occur.

The studio became more important for Pissarro in the mid-1870s as he turned to themes with more prominent figures. The reasons for this appear in a letter of December 1873. Théodore Duret had written to Pissarro urging him to follow the path which suited him best, that of rural nature, and to paint rustic nature with animals; Pissarro replied: 'Ce qui m'a empêché longtemps de faire la nature vivante c'est tout simplement la facilité d'avoir des modèles à ma disposition, non pas seulement pour faire le tableau, mais pour étudier la chose sérieusement. Du reste, je ne tarderai pas à essayer encore d'en faire, ce sera fort difficile, car vous devez vous douter que ces tableaux ne peuvent se faire toujours sur nature, c'est-à-dire dehors; ce sera bien difficile.'[10]

At this point, the role of Pissarro's drawings has to be taken into account.[11] Around this date, his drawings came increasingly to focus on elements, not whole scenes – generally figures and animals, sometimes also trees and buildings. Few of these drawings seem to have been direct preparations for particular paintings; they acted instead as potential raw material for paintings, a sort of data bank, or, as Delacroix would have put it, a dictionary, on which Pissarro could draw as and when he pleased. Two paintings from 1874 show the way in which small elements might be reused: both *La barrière du chemin de fer aux Pâtis* (Pissarro exhibition 1980–1, 35) and *La causette, chemin du Valhermeil* (P & V 273) show variants on the same figure group. Other paintings from the mid-1870s where the figures play a more central role, such as the *Bergère* of 1875 (P & V 322; plate 14), clearly involved a more complex act of composition, and were very probably wholly executed in the studio.[12]

In the 1870s, though, the studio seems to have been an expedient which Pissarro needed to use for certain types of painting, rather than a positive virtue. Around 1880, that is around the time of his formulation of the idea of unity, he began on occasion to use the studio rather differently and, it seems, for more positive reasons. This can be illustrated by two paintings of 1882. First, the large tempera *La moisson* (P & V 1358) was built up from a long set of preparatory drawings and studies, to produce an elaborate and clearly synthetic image of harvest-time.[13] Second, Pissarro painted a snowscene in 1882 which was a direct reworking from an outdoor painting executed at Montfoucault in 1874 (P & V 554, cf. P & V 286; plates 15 and 16); this is one

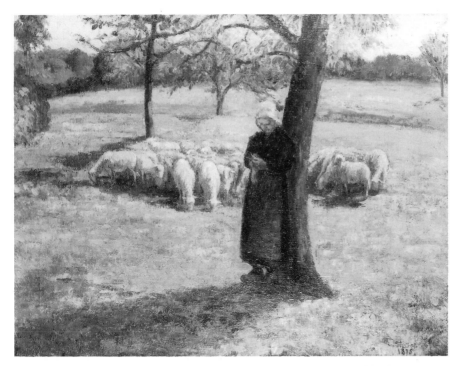

14 *Bergère à Montfoucault,* 1875, P & V 322, 66 by 87 cm. Private collection. Photo Courtesy of Sotheby's

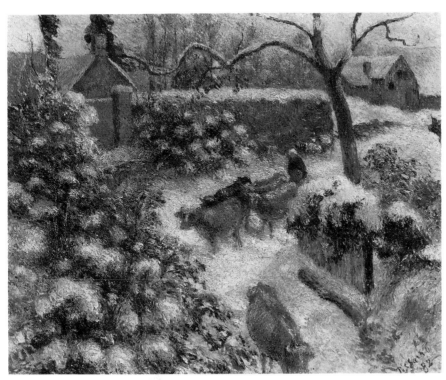

15 *Effet de neige à Montfoucault,* 1882, P & V 554, 46 by 55 cm. Formerly collection of Sir Charles Clore. Photo Courtesy of Marlborough Fine Art

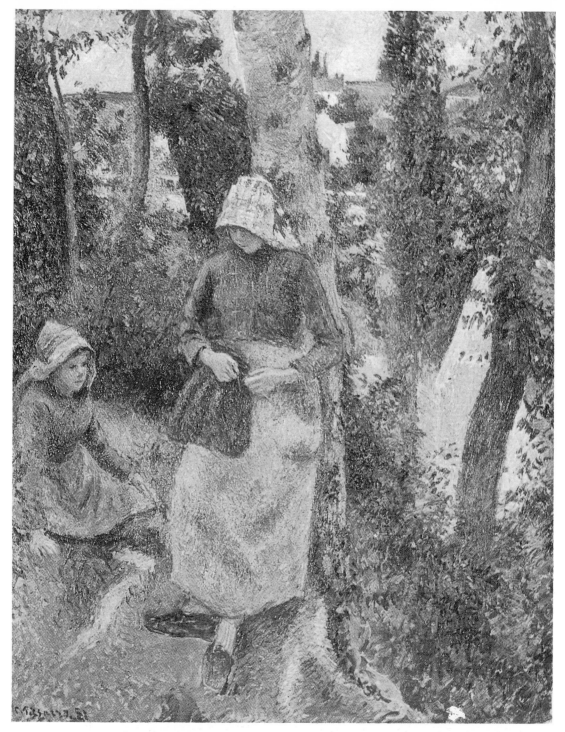

17 *Deux jeunes paysannes causant sous les arbres, Pontoise,* 1881, P & V 541, 81 by 65 cm. Cologne,
Gemälde Galerie Abels

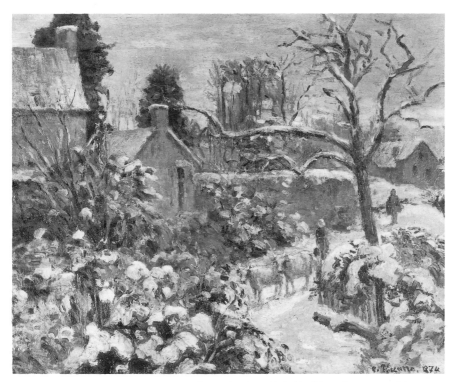

16 *Effet de neige avec vaches à Montfoucault,* 1874, P & V 286, 40 by 51 cm. Photo Courtesy of Christie's, London

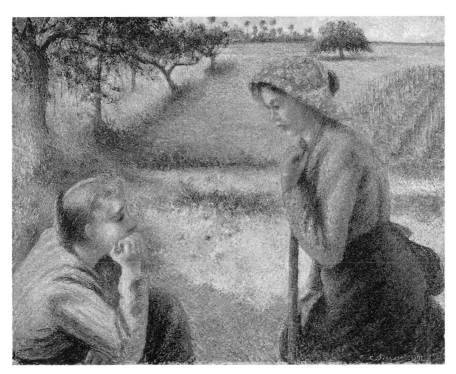

18 *La causette,* 1892, P & V 792, 89 by 165 cm. New York, The Metropolitan Museum of Art, gift of Mr and Mrs Charles Wrightsman 1973

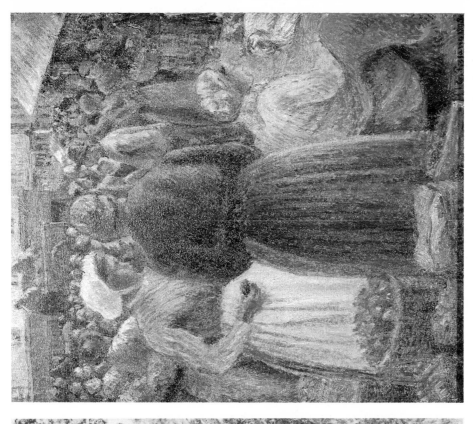

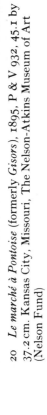

20 *Le marché à Pontoise* (formerly *Gisors*), 1895, P & V 932, 45.1 by 37.2 cm. Kansas City, Missouri, The Nelson-Atkins Museum of Art (Nelson Fund)

19 *Paysanne assise, soleil couchant*, 1892, P & V 824, 81 by 65 cm. Formerly collection of Lucien Pissarro

of the earliest examples of a process of repetition which he used more often later. The changes reveal the positive qualities which Pissarro felt able to add when rethinking the image at his leisure in the studio. The brushwork becomes far more delicate and regular in touch, the colour more nuanced; the angle of vision becomes narrower, which emphasises surface pattern at the expense of space; and the cows are changed in colour, and one is added in the foreground. The first is a marvellously immediate outdoor sketch, the second a far more considered, carefully integrated image, with more emphasis on the animals and figures. The change is a measure of the extent to which, by 1882, Pissarro had rejected the directness of his early Impressionist canvases in favour of a more elaborated and synthetic vision.

Later in the 1880s, Pissarro came to execute all of his figure paintings in the studio, a practice which continued through his Neo-Impressionist phase and up to the mid-1890s. The landscapes of these years were often, though not always, begun on the spot, but their final appearance emerged indoors.[14] By 1890, Pissarro held clear views about the advantages of studio work, as he explained to Lucien in letters of 1891–2: 'Il est bien certain que le travail d'atelier est identique comme difficulté à celui de la nature, seulement c'est absolument différent au point de vue métier, méthode et résultat. Il ne faut chercher à l'atelier que ce qui est possible, comme du reste sur nature il ne faut chercher que des sensations directes et instantanées. Rappelle-toi que l'aquarelle est un bon moyen pour aider la mémoire, surtout dans les effets fugitifs – l'aquarelle rend si bien l'impalpable, la puissance, la finesse.' Water-colour, then, is the ideal means of recording the *sensations*, but one can only get beyond these in the studio, as he explained: '[In studio paintings] il y a un calme, une unité, un je-ne-sais-quoi des plus artistiques! Le résultat de l'atelier est quelques fois plus sévère, moins joli de couleurs, mais en revanche plus artistique et plus pensé.' In 1892, he compared the results of outdoor and studio work: 'Je crois que ces tableaux [done in the studio] ont beaucoup gagné au point de vue de l'unité. Quelle différence avec les études [executed outdoors]! Je suis plus que jamais pour l'impression par le souvenir; c'est moins la chose même – la vulgarité disparaît pour ne laisser flotter que la vérité entrevue, sentie.'[15]

His bather paintings of 1894–6 were his last major group of studio figure paintings, with a strong element from the imagination because of his problems in getting models; at one point he even used himself as a model for them. Sometimes peasant girls did pose clothed for drawings (e.g. Pissarro exhibition 1980–1, 145), to be reused clothed in oil paintings, and then reworked as imagined nudes.[16] Once, and apparently once only, a gypsy girl did pose nude: an oil study, in an interior, probably records this; the pose was incorporated into a vertical bathers composition, never fully finished, and then in a horizontal version of the same composition.[17]

In his last years Pissarro moved away from these synthetic compositions back to direct work in front of nature and back to a unity more of atmosphere than of intellectual conception, particularly in his townscapes. This was possibly in part the result of dissatisfaction with his studio compositions, to which

I will return; but it also perhaps reflects the impact of Monet's contemporary series, notably that of Rouen cathedral, exhibited in 1895. Monet's serial paintings revealed to Pissarro the possibility of an all-embracing coloured unity developed from nature itself, from the light and atmosphere. When Pissarro saw Monet's cathedrals he found in them 'une unité superbe que j'ai tant cherchée'.[18] It was a unity of this kind, not an intellectual unity, which Pissarro described in the last interview he gave, at Le Havre in 1903: 'Je ne vois que des taches. Lorsque je commence un tableau la première chose que je cherche à fixer, c'est l'accord. Entre ce ciel et ce terrain et cette eau il y a nécessairement une relation. Ce ne peut être qu'une relation d'accords, et c'est là la grande difficulté de la peinture. Ce que m'intéresse de moins en moins dans mon art, c'est le côté matériel de la peinture (les lignes). Le grand problème à resoudre, c'est de ramener tout, même les plus petits détails du tableau, à l'harmonie de l'ensemble, c'est-à-dire à l'accord.'[19]

In these last works he painted his subjects again essentially as he found them, as he had in the 1870s, rather than recomposing them wholesale. This is not, though, to play down the importance of their subject matter. For an outdoor landscapist the choice of subjects and effects is a decision quite as crucial as the calculating composition of the studio painter. To understand Pissarro's art, we cannot examine his methods and techniques in isolation: they are the material expression of his vision of the world, but it was this vision itself which guided him to paint what he did and the way he did. His themes and the way he saw them have to be woven back into our account of the material development of his art.

In the 1892 interview from which I have quoted, Pissarro said that he wanted to express 'le vrai poème de la campagne',[20] a phrase which embodies a central paradox, between truth and poetry. To understand how his art and ideas developed, we have to see how this apparent paradox emerged and how Pissarro set about resolving it.

Until his last decade, Pissarro focused his attention on the villages and small towns of the Ile de France and the countryside surrounding them. *L'Hermitage à Pontoise* of 1867 (Pissarro exhibition 1980–1, 10) already shows many of his abiding preoccupations: figures at work in a hospitable, inhabited, enfolding milieu, very much a man-made universe, shaped by many generations of agricultural work, with little reference to anything specifically modern. The years between 1869 and 1873 form something of an interlude in his development: at Louveciennes and on his first arrival at Pontoise, Pissarro focused on more suburban themes, closer to those favoured by his Impressionist brethren, seen from a more detached, less engaged viewpoint. Figures always appear, but they are less tied to their working surroundings. During his first year at Pontoise, Pissarro concentrated on contrasts in his scenes, on the strange juxtaposition of modern with timeless, of suburban or industrial with natural, which were characteristic of the growing towns of the area. In *L'Oise aux environs de Pontoise* of 1873 (Pissarro exhibition 1980–1, 30), for instance, trees and chimneys, smoke and clouds are deliberately rhymed, with no sense of incongruity, still less of criticism; all are equivalent elements in a

multiple-valued scene. Very similar analogies are made in Monet's contemporary work.[21]

It was at this point that Pissarro's friend Duret intervened, in the letter of December 1873 which I have mentioned.[22] He urged Pissarro not to think too much of Monet or of Sisley, but to follow his own path, that of rural nature, and to paint scenes with figures and animals; he maintained this propaganda over the next two years. Figures, specifically peasants, emerge as a far more central part of Pissarro's art in 1874. This crucial change coincided with Pissarro moving house in October 1873, from central Pontoise to the more rural Hermitage district, but we cannot tell for sure which was cause and which effect. The results were clear: in the Hermitage district he found subjects within which peasant figures could be given a prominent role. Landscapes remain the larger part of his work, but this was in part because of the difficulty of finding and paying for models for figure paintings. The landscapes are always peopled and always dependent for their meaning on a central human reference (cf. Pissarro exhibition 1980–1, 36). However it remained Pissarro's ambition, as he put it in 1875, to paint 'un tableau important de figures en plein air'.[23] From 1874 onwards he painted occasional canvases where the figure played a major role, but he was only able to do this regularly from around 1881, when at last he could afford models, as a result of the comparative financial security brought by Durand-Ruel's renewed purchase of his work.

The *Bergère* of 1875 (plate 14) is characteristic of the figures in landscape of the mid-1870s. The picture is very much on the borderlines between figure and landscape painting, neither a landscape with subordinate figure nor a figure painting in an outdoor setting. This ambivalent relationship is just what one finds in Millet's art, which became of central importance to Pissarro at this point. However the obvious similarities should not blind us to a significant difference between their visions of nature. This is revealed in the ways in which they constructed their scenes: in Millet's, the distances and sides are generally open, implicitly continuing far beyond our sight, and contrasting the peasants and their scale with the great expanses around them; Pissarro's, by contrast, are enclosed and framed, a self-contained universe all within man's grasp. One can explain this difference on several levels. First, the two men worked in different physical surroundings: Millet was used to the open spaces and panoramas of the Barbizon plain, while Pissarro found his central experience of landscape in the smaller spaces of the Ile de France. Second, on pictorial grounds, one can contrast Millet's ability to give pictorial structure to his open spaces with Pissarro's persistent tendency to frame his views at the edges. But one has to look further too, and ask whether the two men's preferences reveal something more basic about their different sense of the relationship between man and nature. I will return to this question after looking further at Pissarro's view of peasant life.

In 1877 he wrote to Murer about one of his recent figure paintings, *Mère Gaspard* (1876, P & V 373): 'C'est une forte paysanne à la figure rouge brique, la tête couverte d'un capuchon jaunâtre. Toile sombre, terrible, ne manquant

pas de caractère, du reste longuement étudiée.'[24] From this description it is clear that the picture's colour and form are themselves meant to be expressive, to convey the essentials of the sitter's character and life, though as a type, not as a specific individual; as always with Pissarro's peasant paintings, the artist remains wholly detached in psychological terms from his sitter. The phrase 'toile sombre, terrible' suggests the mood which Pissarro wanted to convey here; later letters show that he felt this mood to be most characteristic of rural life as a whole. He wrote in 1882 to Duret about a recent painting (P & V 541; plate 17): 'Je suis très heureux de penser que la *Paysanne appuyée contre un arbre* vous plaît, c'est absolument pour moi ce que j'ai de meilleur. . . . C'est le type qui m'intéresse comme recherche, ce n'est pas gai par exemple, mais que voulez-vous, je suis la pente de mes sensations, je m'y laisse rouler.'[25] The next year he wrote to Lucien, referring to *Jeune fille à la baguette* (Pissarro exhibition 1980–1, 53): 'Rappelle-toi que je suis de tempérament rustique, mélancolique, d'aspect grossier et sauvage, ce n'est qu'à la longue que je puis plaire. . .'.[26]

These and Pissarro's other figure paintings of the period convey a sense of the peasant's fatigue as they rest from toil – a response close to Millet's. But, like the *Bergère* of 1875, the figures are presented within a structured, enclosed space. We, as spectators, are close to them, but at the same time detached from them. These characteristics emerge clearly in *Paysannes gardant des vaches* of 1882 (Pissarro exhibition 1980–1, 57): here the mood is almost contemplative; we are close to the figures, but they are quite unaware of us and we do not in any way participate in their interchange. We are excluded from their space, but they with their cows exist in a carefully circumscribed, self-contained arena.

Such paintings raise questions about Pissarro's broader political and social attitudes. He was a wholehearted supporter of the French anarchist movement by the mid-1880s, at least, and probably much earlier. Anarchism was a major independent political and ideological force in France during these years, and Pissarro fully endorsed its basic tenets: the rejection of institutionalised powers, elections and representative government, in favour of the full realisation of the rights of the individual; Kropotkin seems to have been the most important source of his ideas at this period.[27] We can also reconstruct his responses to the issues which divided the movement. First, over means: Pissarro repudiated the use of violence to attain their ends. And second, over the type of society they sought: Pissarro felt that society should return to loosely structured agrarian communities and economic structures, and that mechanisation and industrialisation could not be harnessed to their interests; the roots of the future society should be found in the soil.[28]

He explained his ideas on the countryside most fully in letters of 1891–2. He found himself in complete sympathy with Proudhon's connection between the love of the soil and the revolution,[29] but in April 1892 he found his attitude to the soil challenged by Kropotkin's latest book *The Conquest of Bread*. In one chapter in this book, entitled 'The Need for Luxury', Kropotkin justified the role of art in the future anarchist society, but insisted that the artist could

only understand the soil if he had worked it himself: 'The love of the soil and of what grows on it is not acquired by sketching with a paint-brush; it is only in its service. ... That is why all that the best painters have produced in that direction is still so imperfect, not true to life, nearly always sentimental. There is no *strength* in it.'[30] Pissarro countered these arguments in a letter to Mirbeau: 'Ainsi Kropotkine croit qu'il faut vivre en paysan pour bien les comprendre. Il me semble qu'il faut être emballé par son sujet pour le bien rendre; mais est-il nécessaire d'être paysan? Soyons d'abord artiste et nous aurons la faculté de tout sentir, même un paysage sans être paysan.'[31] So it was by the artist's *sensation* that he could understand the countryside itself, as well as perceive its forms and effects; this *sensation* had then to be recreated in the work of art in order to produce the 'vrai poème de la campagne'.

The same letter reveals another crucial element in this 'vrai poème', in Pissarro's discussion of Kropotkin's blueprint for the future: 'Il faut avouer que si c'est utopique, dans tous les cas c'est un beau rêve et comme nous avons eu souvent l'exemple d'utopies devenues des réalités, rien ne vous empêche de croire que ce sera possible un jour, à moins que l'homme ne sombre et ne retourne à la barbarie complète.' Utopian imagery was closely bound up with anarchist theory at the time. Indeed Signac, in the same year, described Kropotkin's vision of the future as a 'grand décor poétique à la Puvis',[32] and when in 1893–5 he painted a major anarchist manifesto-painting, *Au Temps d'Harmonie,* he drew directly on the tradition of images of Utopias, of Golden Ages, current in European painting since the Renaissance, and most directly on Puvis de Chavannes himself. Such imagery could, then, in a real sense be seen both as romantic and also as modern and progressive.

The figure paintings of 1888–92, like those of the earlier 1880s, do not speak toil in a literal, physical sense. These studio compositions present a conception of the countryside, even an idealised vision, of women and occasionally men working in harmony with nature. The poses of the figures in *Les glaneuses* (Pissarro exhibition 1980–1, 69) suggest weariness and the weight of the loads, but they are simplified and monumentalised, even heroised. Here and in *Paysannes plantant des rames* of 1891 (P & V 772) we are far from the informal kitchen-garden naturalism of twenty years earlier. The vision is now generalised, not localised, the order now imposed on to nature, not found in it; form, pattern, composition and colour alike are combined to create a suggestive image of a harmonious universe, an integrated rural Utopia.

Pissarro's son Lucien realised, perhaps more clearly than his father, how far his vision had changed. In April 1891 Pissarro claimed that the new trend towards mysticism (he is referring especially to Gauguin) was preventing popular understanding of his work.[33] Lucien replied: 'Ce que tu me dis à propos des jeunes et des tendances mystiques ne peut pas être la cause du peu de succès commercial de tes peintures, car cet art mystique pour se faire comprendre des masse [sic] prendra autant de temps que notre art, et si avec l'estime et la bienveillance de la presse tu ne vends pas plus, il ne faut pas chercher plus loin que les machinations de la spéculation – car ces jeunes mystiques n'ont-

ils pas puisé à pleines mains dans tes découvertes esthétiques?? Je crois qu'au lieu du mot mystique qui ne peut s'appliquer qu'à quelques uns le mot littéraire serait beaucoup plus juste – à mon point de vue les tendances de l'art nouveau sont vers une peinture plus littéraire, mais toi-même en a subi l'influence et n'est-ce pas pour cela que l'on ne veut plus de ta peinture? Est-ce qu'en synthétisant tes personnages et tes paysages tu ne leur as pas donné un caractère moins épisodique, plus général et par conséquent plus symbolique??'[34] Pissarro was outspoken in his condemnation of the mystical, religious aspects of Symbolism, but Lucien was certainly right to suggest that Pissarro's new, more generalised vision allied him to aspects of Symbolist thought, in moving away from mere description towards a type of suggestiveness.

These tendencies came to a head in a group of figure paintings of 1891–2, *La vachère* (P & V 823) and *Paysanne assise* (P & V 824; plate 19). He wrote of these to Mirbeau in November 1891: 'Que je voudrais vous montrer ma vachère, que j'ai rudement tritutée. ... Elle n'est pas encore terminée, mais je la crois en bonne voie, jusqu'au moment du désenchantement qui survient au dernier coup de pinceau? Moment solennel. Et ma paysanne rêveuse, assise sur un talus en contre-bas d'un champ, soleil couchant. Elle vient de faire de l'herbe, elle est triste, bien triste, notre Mirbeau. ... Le chiendent c'est que cela ne souffre pas la médiocrité, sans quoi ce sera une romance. ... Je hais la romance! comment ne pas tomber en ce crime??'[35]

Form and expression, then, are meant to express melancholy and reverie; but Pissarro was here his most acute critic, in pinpointing the dangers of anecdotalism in such a picture: how could he show that her reverie was about the human condition and not about her own poverty? Pissarro was at just this time vigorously warning Lucien about the dangers of Pre-Raphaelitism and sentimentality,[36] but here his fears for Lucien can perhaps be turned against himself: a 'poetic' conception has, in essence, taken over from direct experience. Pissarro's subsequent return to themes taken more directly from nature suggests that he came to realise this. Unity, in the final analysis, had to be found within nature, rather than imposed on to it.

However, this phase produced one of his most remarkable canvases, *La causette* (Metropolitan Museum of Art, New York; P & V 792; plate 18); this is Pissarro's largest and most complete statement of the 'vrai poème de la campagne'. The surface is elaborately knit together, in colour and touch and texture. Two figures, one in reverie, one resting from work, face each other; their attitudes are deliberately contrasted, and each is further characterised by what lies behind her – a shady bank beyond the *rêveuse*, a staked field beyond the woman who has been working. The space is very inexplicit, and the figures are forced towards us and on to the picture plane. But we make no contact with them: their strict profiles exclude us. We are in a sense eavesdropping, but the types and attitudes of the figures are so generalised that they are suggestive only in a general sense, and not remotely anecdotal. This is the visual expression of Pissarro's desire, voiced the same year: 'Soyons d'abord artiste et nous aurons la faculté de tout sentir, même un paysage sans être paysan.'[37] This overtly synthetic vision of rural existence is at first

sight hard for a late twentieth-century viewer to accept: it lacks the directness of vision of Impressionism, and has none of the explicitly imaginary poetry of a Burne-Jones. In its own terms, though, it is a very complete and very satisfying picture. The unity here is all-embracing: colour, technique, space, composition and subject are all used, together, to express the meaning of the countryside as Pissarro saw it.

Here we can return to the contrast between his vision of the countryside and Millet's. For Pissarro, nature is enfolding, for Millet (at least in the great peasant paintings) it is open and expansive. Pissarro's pictures look to a harmonious co-existence between people living in harmony with nature; for Millet, work meant extracting a living from the harshness of nature. Both saw toil on the land as inevitable, as the archetype of country life: but Millet's fatalism was a sense of the continuity of long-established patterns of life, whereas Pissarro saw such toil as an element in a possible re-structured society. Thus the framing and enclosedness of Pissarro's country scenes is not merely a pictorial device: it expresses a basic attitude towards nature.

This aspect of Pissarro's work continued into the mid-1890s in his bather pictures, a further attempt to express a vision of country women living in harmony with nature. However, much of the work of his last years was, as we have seen, quite different in theme – urban, rather than rural. The subjects of the city paintings are clear enough: they are townscapes, descendants of a long topographical tradition, and particularly reminiscent of Monet's and Renoir's Paris scenes of the 1870s. But this does not explain their meaning within Pissarro's art: how does this vision of the city relate to the 'vrai poème de la campagne'?

The city subjects are consistently treated quite differently from the rural themes. In *Le marché à Pontoise* of 1895 (P & V 932; plate 20), for instance, the figures are monumental and integrated into their surroundings, and they belong with the spectator; whereas in the Paris scenes we are distanced from the boulevards, and the people and traffic on them are all carefully separated from each other (cf. Pissarro exhibition 1980–1, 79–80). Anarchist writing at the time makes much of the rootlessness of city life, but Pissarro's pictures do not, in themselves, seem to carry any overriding condemnation of the city: there is often wit in the observation of the figures, and a real appreciation of the architectural grandeur of Paris. But the form of the pictures is an essential part of their content, and the very different compositional patterns which Pissarro used to convey urban and rural subjects are the material expression of the total contrast between city and country life as he saw them – integrated in the country, diverse and dispersed in the city.[38]

This contrast introduces the concluding question: what, in the end, is the basic concern underlying Pissarro's art? As we have seen, it is clearly not a single-minded pursuit of pictorial solutions to the problem of translating nature into paint; in this way Pissarro is very different from Monet or Cézanne. As Pissarro emphasised in 1891,[39] his personality did not reside in technique alone. The central point about his art lies in this contrast between his urban and rural images: there are real and continuous correspondences between the

pictorial form of his canvases and their social meaning; and these correspondences were the object of his endless restive searching.

Pissarro's subjects are always essentially social: man-made or man-moulded landscapes; agriculture, towns and villages, cities, roads. Moreover, they are generally peopled, or at least directly reflect a potential human presence. The figures which appear in them are in character with their surroundings: they define the nature of the various social milieus depicted. What Pissarro was seeking, in whatever subject he chose, was a pictorial formulation which could sum up the essential character which he saw in that particular milieu. Pictorial styles and technical devices were never ends in themselves, but only means towards expressing these essential characteristics, and the relationships which he saw operating within each milieu. Technique is, though, important: the dense integration of touch and colour in the rural idylls expresses Pissarro's view of rural life, just as the staccato rhythm of the cityscapes, often sparer and less nuanced in handling and colour, expresses the essentials of life in a big city. This search for correspondences between form and subjects does not only belong to the late work: it lies behind the whole development of his art. The unity which he was seeking was both pictorial and thematic – a pictorial metaphor for humanity living in relation to its surroundings.

So, the meaning of Pissarro's art was essentially social, its theme the interrelationship between mankind and its environment. Different situations and outside stimuli led him, at different times, to explore many aspects of this interrelationship, and to adopt varied techniques and methods of formulating his subjects, but the continuity lies in the nature of the quest itself.

Notes

This essay originated as a public lecture given at the conclusion of the Pissarro symposium at the Museum of Fine Arts, Boston, in May 1981; I am most grateful to John Walsh for the invitation to speak on that occasion. I would like to express my gratitude to the Pissarro scholars who have shared their ideas with me, in particular to Kathleen Adler, Richard Brettell, Christopher Lloyd and Martha Ward; we all owe a great debt to the pioneering scholarship of John Rewald.

This essay was completed for publication in 1981. Were I to tackle the subject afresh, I would investigate the discrepancy between Pissarro's search for unity and his constant artistic experimentation, and explore the difficult relationship between avant-garde styles and socially significant content. I would also treat Pissarro's 'vision' and the artistic 'personality' he created for himself more critically; on this, cf. J. House, 'Camille Pissarro's *Seated Peasant Woman:* The Rhetoric of Inexpressiveness', in J. Wilmerding (ed.), *Essays in Honor of Paul Mellon* (National Gallery of Art, Washington, 1986).

1 Lucien Pissarro, letter to Camille Pissarro, 2 September 1903, in *Lettres,* p. 507.
2 Letter to Lucien, 5 May 1891, in *Lettres,* p. 237.
3 Letter to Esther Isaacson, 5 May 1890, quoted in *Archives de Camille Pissarro,* sale at Hôtel Drouot Salle No. 6, Paris, 21 November 1975, lot no. 146.
4 R. Shiff, 'The End of Impressionism: A Study in Theories of Artistic Expression', *Art Quarterly,* n.s.1 (1978), pp. 338–78.

5 For Littré, Taine and Ribot, see ibid., passim; for the use of this vocabulary in Pissarro's circle, see Monet, letter to Bazille, December 1868, in D. Wildenstein, *Monet, Biographie et catalogue raisonné, I* (Paris and Lausanne, 1974), letter no. 44; and also Cézanne's comments quoted by Stock in 1870, cited in Paul Cézanne, *Correspondance,* ed. J. Rewald (Paris, 1978), p. 135.

6 E. Zola, *Mon Salon,* 1868, section on 'Les Paysagistes', reprinted in *Mon Salon, Manet, Ecrits sur l'art,* ed. A. Ehrard (Paris, 1970), p. 160.

7 P. Gsell, 'La Tradition artistique française, I, L'Impressionnisme', *Revue bleue,* 26 March 1892, p. 404.

8 Letter to Lucien, 6 September 1888, in *Lettres,* pp. 177–8; draft of letter to Van de Velde, March 1896, quoted in J. Rewald, *Georges Seurat* (Paris, 1948), pp. 131–2.

9 For an 1864 Salon exhibit, cf. Pissarro exhibition 1980–1, 2–3; for 1865, cf. P & V 46 (Pissarro exhibition 1980–1, 4) and the small related study in the Jeu de Paume, P & V 36; for 1866, cf. P & V 47 (Pissarro exhibition 1980–1, 6) and the study for it, sold Sotheby's, London, 2 April 1981, lot 303.

10 Letter to Duret, 8 December 1873, in *Correspondance,* pp. 87–8.

11 Cf. B & L especially pp. 15–17, 42–3, and nos 73 et seq.

12 *La bergère* (P & V 322) is clearly an elaboration, tautening the composition and enlarging the figure, of P & V 279; for the question of Pissarro's studio work during the 1870s, cf. K. Adler, 'Aspects of Camille Pissarro, c. 1871–1883', unpublished MA Report, Courtauld Institute of Art, London, 1969.

13 Cf. B & L, pp. 43–5.

14 For the process used in two figure paintings of the mid- and later 1880s, P & V 695 and 726, cf. Pissarro exhibition 1980–1, 64 and 68; among many indications of his procedures in his landscapes, cf. letters to Lucien, 15 May 1888, 10 June 1891, 16 September 1892, 4 December 1895 (*Lettres,* pp. 170, 252, 292, 391).

15 Letters to Lucien, 13 and 14 May 1891, 26 April 1892, in *Lettres,* pp. 246, 249, 278.

16 The nude version of this figure (P & V 904, Metropolitan Museum of Art, New York) is so unspecific in its observation that it was clearly worked up from the drawing and from P & V 901 and 903, the related oils with the figure clothed. For Pissarro using himself as a model, cf. his letter to Lucien, 12 July 1896, in *Lettres,* p. 412.

17 The nude study is P & V 936, the outdoor compositions P & V 938 and 940; for the single visit of the gypsy model, cf. J. Rewald, *Camille Pissarro* (London and New York, 1963), p. 140.

18 Letter to Lucien, 1 June 1895, in *Lettres,* p. 382.

19 R. de la Villehervé, 'Choses du Havre; les dernières semaines du peintre Camille Pissarro', *Havre-Eclair,* 25 September 1904.

20 Cf. note 7.

21 Cf. in particular his Argenteuil views of 1872, especially Wildenstein, *Monet,* 219, 221–4.

22 Cf. note 10; the relevant passage of Duret's letter is quoted in full in P & V, p. 26.

23 Letter to Duret, 12 June 1875, in *Correspondance,* p. 98; he makes it clear here that his main problem was in affording models. The large unfinished outdoor canvas of his wife (P & V 290) of c. 1875–7 is presumably an unsuccessful attempt to realise this ambition; for the very plausible suggestion that this canvas was begun c. 1875 and partially reworked a year or two later, cf. Adler, op. cit., ch. IV, note 62.

24 Letter to Murer, 1877, in *Correspondance,* pp. 102–3.

25 Letter to Duret, 12 March 1882, in *Correspondance,* p. 157.

26 Letter to Lucien, 20 November 1883, in *Correspondance,* p. 252.

27 Cf. in particular his crucial letters to Esther Isaacson, 12 and 22 December 1885, in *Correspondance,* pp. 360–2, 368–70.

28 Cf. the letters cited in notes 27, 29, 31, and letters to Lucien, 13 April and 5 May

1891, in *Lettres,* pp. 233, 237–8; also Pissarro's drawings *Turpitudes sociales* of 1889–90, published Geneva, 1972, with facsimiles of letters to Esther Isaacson, 29 December 1889, and to Alice and Esther Isaacson, (?) January 1890; on *Turpitudes sociales,* cf. R. Thomson, 'Camille Pissarro, "Turpitudes Sociales", and the Universal Exhibition of 1889', *Arts Magazine,* LVI, no. 8 (April 1982), pp. 82–8.

29 Letter to Lucien, 8 July 1891, in *Lettres,* p. 258.

30 Kropotkin, *The Conquest of Bread,* English edition (London, 1906), p. 151.

31 Letter to Mirbeau, 21 April 1892, in C. Kunstler, 'Des Lettres inédites de Camille Pissarro', *La Revue de l'art ancien et moderne,* LVII (April 1930), p. 228.

32 Signac, letter to Jean Grave, c. 1893, in R. L. and E. W. Herbert, 'Artists and Anarchism: Unpublished Letters of Pissarro, Signac and Others – II', *Burlington Magazine,* CII (1960), p. 519.

33 Letter to Lucien, 13 April 1891, in *Lettres,* p. 233.

34 Lucien, letter to Pissarro, 19 April 1891, quoted in B. Thomson, 'Camille Pissarro and Symbolism', *Burlington Magazine,* CXXIV (1982), pp. 19–20; I am most grateful to Belinda Thomson for showing me this in advance of its publication; it provides a valuable summary of Pissarro's relationship with the Symbolist movement.

35 Letter to Mirbeau, 22 November 1891, in *La Revue de l'art ancien et moderne,* LVII (March 1930), p. 186.

36 Cf. especially letter to Lucien, 8 July 1891, in *Lettres,* pp. 257–8.

37 Cf. note 31.

38 On this question, cf. also Kathleen Adler's essay in the present volume; for Pissarro's enthusiasm for the urban scene, cf. his letters to Lucien, 2 October 1896 (on Rouen), 15 December 1897 (on Paris), in *Lettres,* pp. 419, 441–2; for the very different vision of the city expressed in *Turpitudes sociales* (1889–90), cf. R. Thomson, article cited in note 28.

39 Cf. note 2.

Chapter 3

Pissarro's political philosophy and his art

Ralph E. Shikes

Pissarro's gradual political evolution was somewhat the reverse of the usual progression from radical youth to conservative or non-political old age. Well into his sixties, when he was relatively prosperous, he clung to his anarchist beliefs and did what he could to aid the cause.

Although there is no evidence that the youthful Pissarro was radical, he already evinced a humanistic empathy with the St Thomas and Venezuelan equivalent of the French agricultural workers, whom he was to paint for half his life. From the beginning his orientation was toward the humble. In the extant figure drawings of St Thomas, nearly all the figures are of blacks, presented straightforwardly, without condescension or any attempt to make them 'picturesque,' as in the precise, somewhat cramped drawing of *Black Woman Washing* (repr. R p. 50, S & H p. 24) and the sensitive sketch *Black Boy* (B & L 13 verso). There were approximately 1,600 white families on St Thomas when he returned there in 1847, yet he seems to have had little or no visual interest in them. In St Thomas and Venezuela, some of his drawings also reflect interest in a theme that was always to attract him – the social intercourse of the small marketplace.

In Venezuela, Pissarro became absorbed in the life of the *mestizos,* Indians and blacks (plate 21), and he sketched them washing clothes, carrying water jugs, riding donkeys, playing cards, and dancing. In the wash drawings *Women in the Kitchen* (repr. R p. 51) and *Carnival Dance* (repr. S & H p. 29), he captured their infectious vitality; and he drew them with much more élan and intimacy than he did the French peasants he painted later. Pissarro probably took the advice of his mentor, Fritz Melbye, and painted portraits in order to support himself, but his genre drawings and watercolors reflected a fundamental sympathy with those whose lives were controlled by those who sat for his portraits. Venezuela and St Thomas were seminal for Camille Pissarro as artist and as social observer.

When the 25-year-old Pissarro arrived in Paris, he had migrated from one area with extremes of society to another almost equally disparate. Imperial society was characterized by the pursuit of pleasure, extravagance rather than taste, ostentatious luxury rather than elegance. The relatively small middle

class profited from speculation, the spread of railroads, the momentary prosperity of the incipient Industrial Revolution; but the vast majority, at the bottom of the heap, lived in wretched housing and earned a minimum subsistence.

The Pissarro of the 1850s surely had none of the political sophistication of the anarchist Pissarro of the 1890s. For that matter, there was no regularly published anarchist journal in the late 1850s and early 1860s, and no organized movement. There was, however, a small body of anarchist literature, written before or during Pissarro's early years in France, that had a germinal influence on him. In 1858 P.-J. Proudhon had published his monumental *De la Justice dans la Révolution et dans l'Eglise,* which Pissarro read in part at some point and reread in the 1890s. In 1865 Pissarro and many of his friends, conservative as well as radical, were discussing Proudhon's latest, and last, work, *Du Principe de l'art et de sa destination sociale.* Since Proudhon believed that the mission of art was to educate the public to an understanding of social reality and its injustices, it is possible that he inspired Pissarro to paint *La promenade à âne, à La Roche-Guyon* (plate 22), the only canvas of his career with an overt social message. The two ragamuffins staring wistfully at the well-dressed middle-class children astride the donkeys are plaintive to the point of bathos, placed in a retreating plane to emphasize their position in the social hierarchy.

Proudhon used Courbet's paintings of peasants and workers to illustrate his conviction that 'l'art ... faut nous voir tels que nous sommes, non dans une image fantastique, indirecte, qui n'est plus nous.'[1] He advocated that modern artists paint men at home and at work naturally, without glorifying them, without posturing. Much of the rest of his life, Pissarro was to adhere to that principle, although with more than a little idealism and often with a poetic interpretation of what was reality.

Proudhon's ideas, along with those of the anarchist philosopher-geographer Elisée Reclus, and especially the ideological refinements and elaborations of Peter Kropotkin, were eventually to influence three generations of French intellectuals, including Pissarro. Like all anarchists, Proudhon was opposed to government. He urged that it be replaced by a Federalist system of volunteer, mutualist associations. Spokesman for the land-owning peasant – as well as the small entrepreneur – he strongly backed the small family farm. In a key passage that must have struck a chord in Pissarro, he had written in *La Justice* that agriculture had primacy; it promised independence to those who pursued it and offered much to the artistic imagination.[2] This conception was crucial to Pissarro. As he wrote years later to his son Lucien, 'Proudhon, dans *De La Justice*, dit que l'Amour de la terre se lie à la Revolution, par conséquent à l'idéal artistique.'[3]

Proudhon was characteristically inconsistent. He opposed universal suffrage, considering it a ploy to divert the peasant and worker from protecting their economic interests, yet at one time he ran for and was elected to the Chamber of Deputies. He was a passionate advocate of Justice, Liberty and Equality, yet his Equality did not embrace blacks, whom he regarded as inferior, and women, equally inferior, whose place he felt was in the home,

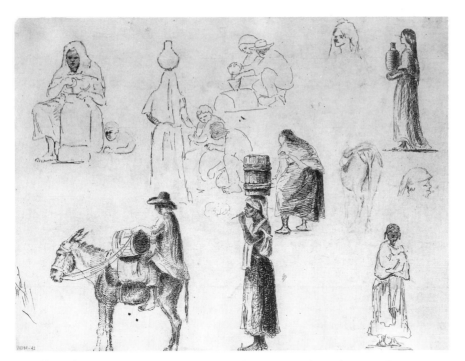

21 *Sheet of studies of watercarriers,* pen and ink over pencil, c. 1852, 22.2 by 29.7 cm.
Caracas, Banco Central de Venezuela

22 *La promenade à âne, à La Roche-Guyon,* 1864–5, P & V 45, 35 by 51.7 cm. Tim Rice, England

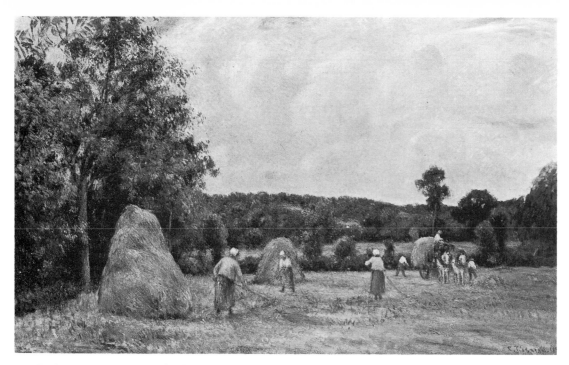

23 *La fenaison à Montfoucault,* 1876, P & V 363, 56 by 92 cm. Present whereabouts unknown

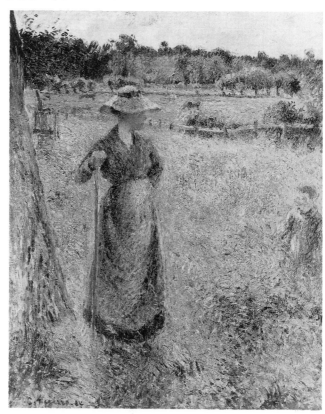

24 *La faneuse,* 1884, P & V 651, 73 by 60 cm. Photo
Courtesy of Christie's, London

subservient to the needs of their husbands, the breadwinners. He was fiercely against nationalism, militarism and imperialism, but at heart his concern was France and France alone. In his opposition to any state authority whatsoever, he was never as explicitly clear as Kropotkin was later. To Proudhon work was a virtue, idleness a vice, luxury reprehensible. Pissarro certainly lived by the first two of these precepts and there is no evidence that he would have wanted luxury, although he longed for bourgeois comfort.

Proudhon's preachments had no direct connection with Pissarro's painting, with one notable exception. Occasionally one can deduce an indirect influence. Pissarro's landscapes in the 1850s were conventional and derivative. In the early and mid-1860s, he was still groping. In *Cours de ferme* (P & V 26) of 1863 and in a few other paintings he tentatively approaches the motif of rustic life that later epitomized an important part of his political philosophy. But he keeps his distance; his touch is not yet that of an intimate observer. However, he is also beginning to paint with a directness, an honesty, an occasional tendency to ignore the demands of art market or convention. In *Les champs* (P & V 18), Pissarro conveys, with subdued greens and browns, the emptiness of the countryside, the sterility emphasized by the facelessness of the figures. *Bords de la Marne en hiver* (P & V 47) – surprisingly accepted, albeit reluctantly, at the Salon because of Daubigny's intervention – is a blunt statement of the bleakness of the countryside, a far cry from the superficiality of most Salon art. Zola called it, 'Une peinture austere et grave, un souci extrême de la vérité et de la justesse.'[4] Consciously or not, he was obeying Proudhon's dictum to paint reality.

In the 1860s, then, we can see in Pissarro an awareness of class, a disinterest in painting the historical evocations, classical allegories or morality scenes so popular at the Salon, a tendency to paint realistically, as Proudhon had advocated; but there was no 'radical' commitment as yet in his art or in his philosophy. In 1870, when the Franco-Prussian war broke out, an enthusiastic Pissarro twice wanted to enlist, at the age of 40, to defend the new Republic.[5] His position contrasts with that of the anarchist Bakunin, who called for an uprising of the masses and non-participation in the war. It is safe to conclude that at the beginning of the 1870s Pissarro's political outlook was liberal and democratic, not radical.

In 1873, when Pissarro drew up the charter for the Impressionists' Society, he based it on the Pontoise bakers' union contract. Obviously, he was already aware of, and approving of, incipient unionism. Since Renoir later complained of the 'egalitarian theories' that Pissarro expounded at that time, Pissarro's political philosophy was beginning to take more concrete form. We have an additional clue in 1874, when he painted Cézanne's portrait. He included a caricature of Thiers, who had crushed the Commune, taken from *L'Eclipse*, a paper critical of the conservative government, and one of Courbet, friend of Proudhon and in exile for his activities in the Commune. The painting is not only a tribute to his friend but a political portrait, reflecting his political tutelage of Cézanne.[6] In 1876, Cézanne reports proudly to his mentor what he thinks will please Pissarro: 'Figurez-vous, je lis la *Lanterne de Marseille*, et je

dois m'abonner à la *Religion Laïque*. As-tu fini? J'attends que Dufaure soit à terre.'[7] The *Lanterne de Marseille* was a radical paper, *Religion Laïque* was anti-clerical, and Dufaure was responsible for the murder of Communards.

In the last half of the 1870s, a period of extreme financial stress for Pissarro, his political outlook continued to move leftward; by 1882, Renoir referred to Pissarro as a 'sociale' and 'révolutionnaire' and wrote that 'un peu plus, Pissarro inviterait le Russe Lavrof'[8] to exhibit. Lavrof was an anarchist. The fact that Pissarro was the only painter to participate in all eight Impressionist exhibitions was, of course, no accident. He was opposed to participation in any activity that smacked of authority, such as the Salon. He deeply believed in cooperative endeavor as a form of political action, and he had an emotional need for it. In 1883, when Pissarro's correspondence with Lucien begins, he suspected the police of opening his mail, indicated that Proudhon was his political guide, and was by then of anarchist persuasion.

All of this leads to the critical question: did Pissarro's anarchist philosophy carry over into his art? The answer is an unequivocal 'no' if you seek direct, polemical propagandistic expression of his philosophy in specific paintings, but a qualified 'yes' if you view the *corpus* of his work as a reflection of the artist's outlook on life and society. Pissarro himself was convinced that it did. He wrote to Lucien in 1891, 'Je crois fermement que nos idées imprégnées de philosophie anarchique se déteignent sur nos oeuvres et dès lors antipathiques aux idées courantes.'[9] But there is no explicit political content in his painting.

The most obvious anarchist element in Pissarro's work, in a general philosophical sense, is to be found, of course, in the paintings, drawings, and prints of peasant farm activity in the outskirts of Pontoise and Eragny. After sporadic and miscellaneous attempts in the 1860s, these scenes became a consistent element in his art during 1873 and 1874, approximately the time his interest in anarchism was growing – probably a coincidence, possibly not.

One special characteristic that pervades Pissarro's work can perhaps be expressed by only one word – humanism. With few exceptions, all of his paintings carry some imprint of humanity's presence – whether men or women, their homes, farms or cultivated fields. The pure landscape, in which there is no sign of man's or woman's existence – as in many of the Barbizon paintings – is almost non-existent in his work. Pissarro's early master, Corot, and others often dropped human figures into their paintings, frequently as a pictorial device (as Pissarro did, too), but Corot was never so consistent as Pissarro. In Pissarro's case, it must have been a felt philosophy.

Except when he visits his friend Piette at Montfoucault in Brittany, where farming was on a larger scale, Pissarro observes the daily rounds on the small, self-contained farm. Often he paints the grubby kitchen gardens, quite understandably paintings of little appeal to a self-conscious middle class. His agricultural workers – members of the peasant family or day laborers – carry buckets of water, herd the cows, feed the chickens. They are mostly women performing lowly chores. They are not heroic figures, but simply humanity observed, in the cadenced rhythm of farm life, the rhythm of the seasons and of the peasants' lives, the rhythm as they perform their tasks. In Pontoise,

Pissarro's peasants in these mid-1870s paintings are unassuming, solid, integral parts of their environment.

In *La fenaison à Montfoucault* of 1876 (plate 23) he finally paints what was to become his most philosophically significant theme – the cutting, gathering, bundling, and storing of the crop. In this painting, however, his figures are not yet the focus. Placed in the middle ground, they are but part of the *mise-en-scène*, the hills absorbing them all.

In 1880–1, however, a qualitative change takes place in Pissarro's depiction of peasant cultivation of the soil. The activities become the convenient background for a series of his most important studies of the human figure. The settings are real enough, as are the costumes, the nature of the work, the authenticity of the rapport between the peasants and their visible world. At the same time, many of these paintings have an idealized quality, a hint of Paradise Gained. *La faneuse* (plate 24) casually pauses in her work to lean on her rake, answer the child's question – and to pose for Pissarro. She also gives us an opportunity to compare Pissarro's peasants briefly with Millet's. Pissarro's young woman is shown against a pastoral background of grazing cows and low hills. The countryside and a high horizon envelope her and make her an intimate integer of a rural scene. In Millet's *The Rake* (1854–7) a boldly painted figure stands pre-eminent, rising above her horizon, monumentalized. However, Millet's vision of rural France was frequently much more naturalistic than Pissarro's.

In Julien Dupré's haymaking scenes, the young peasant women typically work with heroic vigor in the hot sun to catch every blade of hay. The bourgeois of the Third Republic liked to see hard work ennobled on canvas. While many nineteenth-century French painters heroicized or sentimentalized the peasant, Pissarro tended to idealize him – or, more frequently, her. He seemed most content when he portrayed a pastoral arcadia, as in the gouache of 1887, *Gardeuses de vaches, Eragny* (P & V 1416), painted during one of the years of greatest personal stress. He seemed to escape wistfully from the realities of the present in order to preserve the past in the hope that it would become the future. As in many of these idyllic scenes, his young peasant is not working, at least not very hard.

This idyllic quality is also apparent in his *La cueillette des pommes* of 1882–6 (P & V 695). As George Moore expressed it, in a rare burst of insight: 'We are on the thither side of life, in a world of quiet color and happy aspiration. These apples will never fall from the branches, those baskets ... will never be filled.' He called it 'an eternal dream.'[10]

But one can exaggerate the dreamlike aspects of Pissarro's rather myopic view of an anarchist utopia. In many of his group scenes, Pissarro's peasants are working vigorously. *La moisson* of 1882 (plate 25) is a carefully composed studio détrempe of the activity that symbolized cooperative endeavor – humankind's ultimate salvation, according to anarchist theory. It offered Pissarro a means for expressing an attitude toward life, with men and women in harmony with nature, productive, fulfilling Proudhon's and Reclus's ideal. And it gave him an equally appealing opportunity to paint the female figure

in action, even though sometimes they are so bundled up that the forms are concealed. Note that his women are working on an equal level with the men. *Les moissonneuses* (P & V 730) of 1889 again gave Pissarro an opportunity to combine his dominant theme – cooperative labor in a healthy rural setting – with a group of studies of the female figure. The figures are especially interesting. They show how Neo-Impressionism militated against naturalism: the poses are inevitably statuesque, frozen in motion, in conflict with their function. And they are all women.

This is not meant to imply that Pissarro was a premature feminist; but the fact is that in Pissarro's twenty-five years of presenting farm life in many of its varied aspects, by far the greatest number of personages are women. In the Brettell-Lloyd catalogue of Pissarro drawings at the Ashmolean – many of them preparatory studies – of those concerned with farm activity eighty-five are women, thirty-five are men and thirty mixed. Obviously, and quite understandably, like most male artists, he preferred women as models. He paid no heed to Proudhon's conception of woman's role. In the final volume of Proudhon's *De la Justice dans la Révolution et dans l'Eglise,* Proudhon has sections on both the physical and the intellectual inferiority of women. Proudhon argued that women's productive capacity was only a third that of men and that a woman should not help her man to earn their bread. Obviously Pissarro did not believe this. Despite Pissarro's claims, it is doubtful that he ever got as far as the last volume in Proudhon's turgid prose.

In the 1870s especially, many of his female figures are performing lowly tasks, often hard physical tasks, dressed in unflattering clothes. His later female figures are more idealized. With some exceptions, most of these figures of the 1880s do not sweat. They do not even perspire. In the 1880s and 1890s Pissarro tended to confine to his prints, rather than to his paintings, any bluntly realistic representations of farm life. In *Paysanne barattant* (D 162), there is nothing idealized about the ill-dressed, ungainly peasant woman performing her tedious task. In *Faneuses d'Eragny* (plate 26) the farm workers, hired or otherwise, swarm over the haystack while the peasant-owner at the right stands by, doing nothing. Proudhon's rugged-individualist peasant here becomes, in Pissarro's lexicon, a *patron.*

With few exceptions, Pissarro shied away from painting harvest scenes showing mechanized equipment, even though Kropotkin, in *Fields, Factories and Workshops,* had called for more widespread use of machinery in agriculture with factories in the countryside to replace broken parts. Perhaps mechanical harvesters or threshers jarred the arcadian mood he chose to depict; perhaps he was uncertain about welcoming those iron intruders, despite Kropotkin's endorsement, for they helped to create unemployment.

A final note on Pissarro's peasant oeuvre: there are few studies of men, few paintings focused on men at work. And the subjects are never shown digging ditches or engaged in some of the really strenuous labor that marked rural existence. No one cleans out the stables in Pissarro's paintings. He averts his eyes from some of the harsh realities of peasant life. Later, as his anarchist identification intensified, so did a roseate film tend to modify even more the

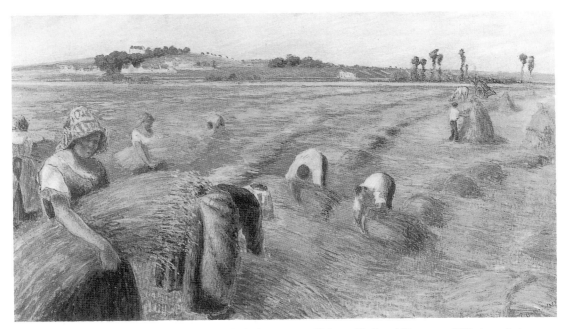

25 *La moisson,* tempera, 1882, P & V 1358, 67 by 120 cm. Tokyo, National Museum of Western Art

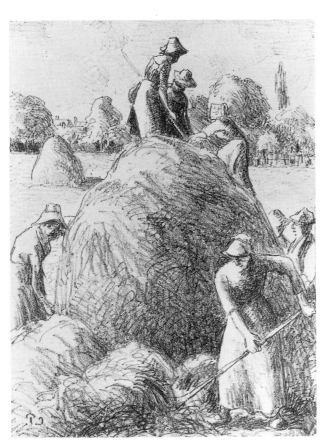

26 *Faneuses d'Eragny,* lithograph, c. 1896, D 163,
22 by 16.7 cm. Paris, Bibliothèque Nationale

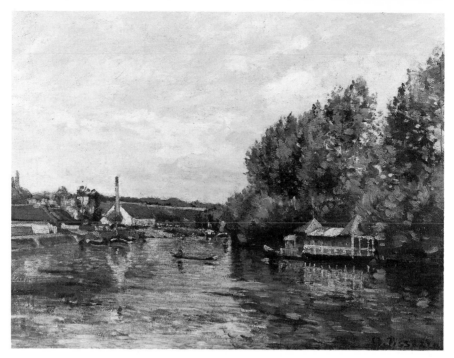

27 *La Seine à La Grenouillère* (formerly known as *L'Oise à Pontoise*), c. 1869(?), P & V 174, 35 by 46 cm. From the collection of The Earl of Jersey

28 *La sente du Chou, Pontoise*, 1878, P & V 452, 57 by 92 cm. Douai, Musée de la Chartreuse (inv. 2231)

realism of his paintings of agricultural life in Normandy and Brittany. He had to believe.

When Renoir attacked Pissarro for his anarchist sympathies in 1882, Pissarro was almost the sole advocate of anarchism in the café discussions. By the mid-to-late 1880s many of France's leading intellectuals and artists and the Symbolist poets had joined the anarchist cause, spurred by the writings of Kropotkin and Jean Grave's anarchist journal, *La Révolte*. In *La Conquête du Pain* Kropotkin declared that the painter could not express 'la poésie de travail' in the fields if he had never engaged in it himself. Disturbed, Pissarro wrote to Octave Mirbeau, 'Kropotkine croit qu'il faut vivre en paysan pour bien les comprendre. Il me semble qu'il faut être emballé par son sujet pour le bien rendre: mais est-il nécessaire d'être paysan? Soyons d'abord artiste et nous aurons la faculté de tout sentir, même un paysage, sans être paysan.'[11] Pissarro knew he was no peasant, that he was bourgeois, even though, as he put it bitterly, a 'bourgeois ... sans le sou'[12] – bourgeois, in education and way of life, though not in taste, in aspiration, or in the acquisitive instinct. Many of his paintings of peasant life expressed a fundamental anarchist philosophy, but they were painted through the filter of bourgeois eyes. Note that Kropotkin referred to the 'poésie de travail,' typical of the attitude of so many French radicals, including Pissarro, who did no physical labor themselves. In many of his paintings, what he saw of the poetry, the rhythm, the vitality, the naïveté of peasant life was viewed from an ideological stance.

As an observer of rural life, Pissarro could not escape the intrusion of the Industrial Revolution on the countryside. He could not ignore, nor did he, the factories that began to appear in the marketing towns and to dot the rural areas.

L'Oise à Pontoise (plate 27), wrongly listed in the *catalogue raisonné* as 'about 1872' but probably painted in 1869, is actually a painting of La Grenouillère, where Monet and Renoir were capturing the vibrations of light and water. Richard Brettell has identified the building across the river as La Grenouillère, which Pissarro contrasts with the factory at the left of the painting, setting leisure and work on equal terms. The somber mood he portrays is far from the gay celebration of bourgeois holidays that appealed to Monet and Renoir.

When Pissarro returned to Pontoise in 1873, he painted a series of four views of the factory complex of Chalon et Cie across the river from Pontoise. In these paintings, Pissarro seems to be trying to come to terms with the role of the factory in the society he envisaged and in the observed landscape. In *Usine près de Pontoise* (P & V 215), aside from obvious Impressionist painterly concern with reflected sunlight, he directly confronts the factory. With the soaring vertical stacks, the smoke floating in the wind, its visual and dramatic possibilities are apparent. But externally, it is immobile, lifeless, very much like the *La petite fabrique* (P & V 66) he had painted five years before. No one enters, no one leaves. He neither accepts nor rejects; its social implications are still unclear. If there were any sign of life, we could get a glimpse of how

he felt; later, as we shall see, his feelings about the factory worker are made vividly clear. In *L'Oise aux environs de Pontoise* (P & V 218), however, he seems to find a comfortable, and beautiful, reconciliation between landscape and factory, the buildings and their reflections a harmonious counterpoint to the flowered bank in the foreground. He is still more concerned with the aesthetics than with the social implications. He is uncommitted. His reserve contrasts with the attitude of realist painters like François Bonhommé, who concentrated on documenting, without comment, France's entry into the Industrial Revolution.

In 1878, when he painted the panoramic *La sente du Chou* (plate 28), he seems to have resolved his attitude toward the factory's position in rural society. The factory complex, at the left, shares the landscape with nature, which occupies the vast middle ground, and the peasants, who predominate in the right foreground. The factory is relegated to a subordinate place in this hierarchy. There is no intimate communication with industry as there is with agriculture. But by then he has anticipated – or he may have read – Kropotkin's advocacy of the dispersal of small factories throughout the countryside to supply local needs, such as the replacement of broken farm equipment.[13]

If Pissarro only grudgingly accepted the usefulness of the factories in the nearby towns, he welcomed a town institution where peasants and townspeople intermingled – the marketplace. In his paintings of the poultry markets at Pontoise and Gisors, Pissarro seems to share the peasants' pleasure of the market-day visit to town after a week of hard work, just as he did in St Thomas and Caracas. To Pissarro the market may well have had a political symbolism. He despised the antisocial, uncreative, conniving atmosphere of the Bourse. He may well have been comparing the two in the back of his mind when he painted the salubrious give-and-take of markets like these, crossroads of country and city.

Pissarro's trip to Rouen in 1883 enabled him to observe – and paint and etch – the bustling activity of the docks. He is entranced by the loading and unloading of ships and barges, the local movement of material. In these waterfront scenes, he seems to feel that dock labor is healthy and constructive because it is done outdoors, like farm labor.

His political philosophy may have been a factor in his decision to join the Neo-Impressionists. Virtually all of them were anarchists; their society was now more congenial to him. Neo-Impressionism's 'scientific' methodology was in harmony with the anarchist belief that scientific advances should be welcomed for their potential for the well-being of all.

When Neo-Impressionism was launched, anarchist influence was considerable in republican France. A police dossier listing the readers of Grave's *La Révolte* included many of France's leading artists, poets, novelists, and critics. They were attracted to anarchism's stress on the rejection of authority – after all, authority had rejected them – and its exaltation of the individual. Theorists emphasized that under anarchism the artist would be free to express his own concept of the beautiful.

Prince Peter Kropotkin, exiled from France to England in 1883, continued

to produce a steady stream of books and pamphlets that considerably influenced the French anarchists. Unlike Proudhon, who stressed individual ownership of land by the peasant, he advocated communal ownership, cooperative farming, and a network of communes that would replace the state. Even more, he stressed that the ultimate aim of society was to eliminate all functions of government. Kropotkin repudiated, as did Jean Grave, Proudhon's racism and his views on the inferiority of women.[14]

Kropotkin's newspaper was taken over by Jean Grave, who changed the name to *La Révolte*. It was read eagerly and thoroughly by Pissarro and his artist-sons. Pissarro's letters to Lucien usually reflect opinions expressed in *La Révolte* – denunciations of universal suffrage, of imperialist actions by England or France, of bourgeois control of art, of the Church's alliance with the military. But the strong castigations of French society expressed to Lucien are tepid in comparison with the acidulous contempt he displayed at the end of 1889 in the series of drawings he called *Turpitudes sociales*[15] created for the political education of his English nieces, Alice and Esther Isaacson. Facing many of the twenty-eight drawings is an appropriate quotation from *La Révolte*, supplemented by detailed comments in his covering letter to Alice and Esther. Savage and ironic, sentimental and tough, Pissarro pours out in them all the political passion that he sublimated in his paintings. Some draw their inspiration from Daumier, Hogarth and Cruikshank.

John House has argued that Pissarro often adjusted his style to his subject. Here it is acerbic, pen-and-ink caricature. The title page shows 'un pauvre vieux philosophe' – Pissarro himself – as Father Time. The Eiffel Tower,[16] hated symbol of bourgeois taste, what Pissarro calls 'beau moderne,' 'tache de cacher' the dawn of anarchy. There follow twenty-eight of what he calls the shameful vices of bourgeois society, except for prostitution which he felt was too offensive a subject for the delicate sensibilities of his nieces. The opening one, appropriately, is *Capital*, symbol, as he quotes *La Révolte*, of the war of the dispossessed against the possessors, of the weak against the strong, 'des pauvres contre les riches, la guerre de la vie contre la mort.' In his letter, he refers to *Capital* as 'le portrait d'un Bischoffheim ou d'un Oppenheim, d'un Rothschild, d'un Gould, quelconque.' That Pissarro, of Jewish background, should select only Jewish bankers seems surprising, if not shocking, but it was no coincidence. In a drawing of the hated Bourse some of the bankers are shown with exaggeratedly big noses. However, his hostility was essentially a class attitude, that of the radical, artistic Jew toward the wealthy Jews involved in banks and speculation rather than in what he regarded as creative endeavor. As he wrote to Lucien later, 'Le peuple ... n'aime pas la Banque juive, avec raison, mais il a des faiblesses pour la Banque catholique, ce qui est idiot.'[17] During the Dreyfus case, he was strongly supportive of Zola and others who defended Dreyfus, unlike some of the anarchists, who were indifferent to Dreyfus's fate.

He hurls 'hypocrisie' and 'mensonge' at the elaborate funeral of a Cardinal, contrasting it with the harsh, spare lines of the lonely, unattended funeral of a workingman. The depth of his feeling about factory life is revealed in twin

drawings of scenes in a factory – a 'prison' to Pissarro. 'L'extrait tiré de la Révolte en dit assez,' Pissarro writes his nieces, 'Les pauvres sont assujettis à l'esclavage du salariat, enchaînés au pauperisme perpetuel ... condemnés à fournir par un travail excédant et abrutissant le superflu et le luxe des bourgeois.'

Pissarro parades life's victims and ironies: a wretch hangs himself; an old man sprawls in the gutter awaiting death; an abandoned woman leaps to her death in a scene derived from Cruikshank's *The Drunkard's Child*. He also portrays a struggling musician, a failed artist, a homeless child condemned as a vagabond, the poor begging for bread while the bourgeois make merry at a café. But he had no illusions about the city poor. They, too, get drunk and beat their wives.

All this tragedy ends on a note of defiance, if not triumph. In *Insurrection* (plate 29) the poor take to the barricades. 'Les pauvres vont se ruer sur les riches,' reads the final caption from *La Révolte*. A woman, a child, and an old man, symbols of the weak who die first, lie at their feet while the workers fight on.

Violence and hatred are expressed in *Turpitudes sociales* by a man who was gentle and tolerant by nature. Pissarro's passionate indictment of urban, bourgeois society was created near the end of 1889, after nearly four years of hardship and rejection brought on by his temporary adherence to Neo-Impressionism. He must have been bitter indeed to find himself at the age of 60 struggling to regain his artistic standing and a measure of material comfort. The eight quotations from *La Révolte* indicate how carefully he had read the anarchist journal, how much he relied on it. Pissarro was not an original radical analyst of society; he tended to repeat in his letters to Lucien what he had read in the anarchist press. He rarely theorized beyond what others had written, but his reactions to current events were spontaneously indignant or compassionate, fitting the incident. He had a huge capacity for reacting against society's stupidities and injustices. Cézanne called him 'Le Bon Dieu' – but sometimes he was an angry God.

Four aspects of *Turpitudes sociales* are of particular interest. First, the note of optimism on which he opened and closed – the indication that revolution was imminent persisted for several years in his letters to Lucien. 13 May 1891: 'La bourgeoisie inquiète, surprise par l'immense clameur des masses deshéritées.' 28 June 1891: 'L'avenir sera tellement différent, avec l'anéantissement du capital et de la propriété.' 26 April 1892: 'Il est facile de se rendre compte que l'on est en pleine révolution.' 8 October 1896: 'C'est de la réaction qui veut se saisir, mais il est trop tard, on ne croit plus en l'autorité ou Dieu.' Pissarro was a much better painter than a political prophet.

Second, he was almost 60 at the time. Pissarro never wavered in his radical vision, even though in old age he did achieve success and relative financial ease. During his sixties, his financial and artistic aid to the anarchist cause was at its highest.

Third, all the scenes in *Turpitudes sociales* take place in the city. True, there was less hunger in the countryside, and the contrasts between relatively

29 *Insurrection* (*Turpitudes sociales*, f. 28), pen and ink, 1889, 31.5 by 24.5 cm. Daniel Skira, Switzerland

30 *Les sarcleuses* (*Travaux des champs*, 1st series, no. 5), woodcut, 1893, 17.4 by 11.3 cm. Oxford, Ashmolean Museum

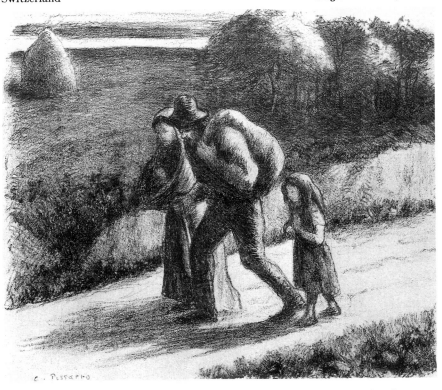

31 *Les trimardeurs,* lithograph, 1896, D 154, 25 by 30.2 cm. Oxford, Ashmolean Museum

rich and poor were not so extreme. But like city workers, peasants got drunk and beat their wives. Unemployment increased in the rural areas during this period and with it homeless wanderers. But basically Pissarro was justifying not only his condemnation of a brutal society, but also his philosophical and artistic belief in the superiority of rural society, where men and women had what was so important to Pissarro – dignity. Throughout the last half of the nineteenth century French intellectuals explored this theme of city versus country, tending for the most part to view the countryside idealistically. Kropotkin's view of the city was typical. He deplored the anonymity of city dwellers, their lack of common interest, their mutual exploitation.

Fourth, the gentle Pissarro seems to be advocating – or, at least, accepting – the use of force by the exploited to regain their rights. In *Les Strugleforlifeurs,* he combines English and French to describe the robbery of a bourgeois by these paupers 'qui font restituer par la force l'argent qu'il a volé par la force.' Here he is reflecting the philosophy of Emile Pouget's *Le Père Peinard* rather than that of *La Révolte.* Pouget called for direct action, including theft if one was hungry and assassination of unjust judges. In *Insurrection*, Pissarro implies that only by force, by a violent uprising, can the poor gain their freedom.

None of the themes he exploits in *Turpitudes sociales* appears in his painting. The drawings were made only for the eyes of his family. But they do reveal what was in the back of his mind when he stood by his easel surveying a seemingly bucolic rural paysage.

In startling contrast to *Turpitudes sociales* is the portfolio of six woodcuts by Lucien Pissarro based on drawings by Camille and published in 1893. *Travaux des champs* portrays peasant men and women engaged in typical farm labor, all bearing the aura of Arcadia, explicit or implicit. The first drawing, *Le labour,* as Christopher Lloyd has pointed out, drew for its source on *The Dance of Death* by Holbein, whom Pissarro greatly admired. The title drawing, *Travaux des champs*, is a splendid montage of farm activity with many of Pissarro's images more animated than those in his paintings. Here Pissarro turned to Hokusai rather than Holbein for his inspiration. The Japanese influence is also apparent in the greatly idealized, delicate-hued *Les sarcleuses* (plate 30). The print has an extraordinary painterly quality with the setting sun bathing the multicolored figures in a delicate light so difficult for a printmaker to capture. Nothing could be farther from the degradation and misery shown in *Turpitudes sociales* than this pastoral image. Although *Turpitudes sociales* has a strong element of caricature, it has a core of reality; hence, it is understandable that Pissarro tended to idealize rural life. In a sense, his images are implicitly comparative. When one looks at a Pissarro painting of rural life, such as the tranquil *Fenaison à Eragny* of 1892 (P & V 789), one must keep in the back of one's mind – as quite possibly Pissarro sometimes did – the stark images of *Turpitudes sociales.* 'Montrez au peuple ce que la vie actuelle a de laid,' Kropotkin has written, 'et faites-nous toucher du doigt les causes de cette laideur.'[18] Pissarro would not, could not, do this in his painting. His optimistic nature impelled him to paint what he regarded

as the beauty of contemporary life. But in the privacy of his family, not in the public face of his paintings, he carried out both of Kropotkin's injunctions.

Toward the end of his life Pissarro was more closely identified with the anarchist movement than at any other time. In 1889 he joined Le Club de l'Art Social, which met weekly for a year, with Ajalbert, Cladel, Tabarant, Louise Michel, Grave, Rodin and others to discuss the social aims of art.[19] He contributed to anarchist causes and the families of prisoners, even when funds were low, and twice he paid substantial printers' debts for Jean Grave for *La Révolte* and its successor *Les Temps nouveaux*.[20] Together with his artist-sons he contributed paintings for lotteries for the benefit of *Les Temps nouveaux*. He was listed in a police dossier of 1894 for reading *La Révolte*. The dossier adds, 'Ses opinions politiques sont ignorées à Gisors,'[21] the town a few miles from his village of Eragny. Obviously, he was no activist.

He spent a considerable part of 1894 in exile in Belgium after the President of France was assassinated by an anarchist following several bombing episodes. Pissarro's own attitude toward the bombings may be deduced from a letter he wrote to Lucien in 1884 when Irish terrorists exploded bombs in London: 'Tu as raison de considérer les explosions comme inutiles et lâches.'[22] Many other anarchists shared this distrust of violence. Kropotkin warned of the futility of trying to achieve victory by bombing. Even though, as Camille wrote to Lucien, 'Il me semble que moi qui ne suis absolumment rien et en dehors de toute action, je ne dois rien avoir à craindre,'[23] he did not trust some of the people in his village of Eragny, so he stayed in exile for four months, passing many evenings at the home of his friend Théo van Rhysselberghe, with Elisée Reclus, Bernard Lazare, the symbolist poet and anarchist, and occasionally Emile Verhaeren, the Belgian poet and anarchist, who in his poetry posed country versus city life, but his basic note was one of despair in contrast to Pissarro's optimism.

Pissarro's cityscapes, painted from the mid-1890s on, have none of the harsh indictment of *Turpitudes sociales* but none the less have a political relevance. The anonymity of the crowds, the bustle, the movement, obviously contrast with the surface calm of his peasant paintings. The almost frenzied rhythm of people going to and from work in individual isolation is a vivid opposite to the placid rhythm of peasant laborers at cooperative work in a bucolic environment. He accepted the painterly challenge and he triumphed; but in the light of *Turpitudes sociales*, we know that he knew he was painting the surface, not what lay behind it.

Clues to Pissarro's philosophy may also possibly be indicated by what he did not paint. Except for the portrait of Murer, he painted no portraits of the bourgeois or the *haut monde*. One cannot imagine him painting – or attempting to paint – the Charpentier family. At Louveciennes and at Pontoise, as Richard Brettell has pointed out, he omitted the château from his landscapes, with a few exceptions. Nor did he paint the rural poor of Pontoise or the 'picturesque' urban poor of Paris. He avoided the extremes of luxury and of hopeless poverty. When he moved to Eragny, he regaled Lucien with the attractions of nearby Gisors, but he painted none of them.

But one can exaggerate the significance of his omissions. He may not have painted bourgeois or socially prominent families because he was never invited to paint them. Removed from Paris, he was not an habitué of the artistic salons. In Louveciennes and Pontoise he was not invited to the château, except to Les Mathurins. In any case the châteaux *per se* had no visual interest for him, as they did for Monet and Sisley, and certainly no social appeal. His views were solidly opposed to wealth and the display of wealth.[24]

Occasionally in the 1890s Pissarro made more direct political comment, although not in his paintings. In 1893, he gave *Les chargeurs de charbon,* a drawing, to *La Plume,* the socialist magazine. In the later 1890s he made three prints for Jean Grave's *Les Temps nouveaux. Porteuses de fagots* (D 153) is a departure from his usual portrayal of women farm laborers. These bearers trudge wearily along, bent over by the weight of their burdens after a hard day's work. In *Les trimardeurs* (plate 31) he employs a favorite theme of radical protest: the unemployed migrants made jobless by the decline in agriculture who wandered through the French villages, often with their families, begging for food. In *Mendiant à la bequille* (D 182), a lithograph of 1897, he tugs at the emotions again, with two waifs trailing their one-legged father.

So Pissarro, like all anarchists, despised contemporary society. But what did he envisage in its place? What kind of society would exist when the 'no-government' concept prevailed? Pissarro's idealized paintings give us a hint of his feeling for a future rural paradise, but they leave many questions unanswered. Pissarro realized this. He wrote to Lucien: 'L'avenir sera tellement différent, avec l'anéantissement du capital et de la propriété, que l'on ne peut concevoir quel sera l'idéal, ou du moins qu'on ne peut sonder les profondeurs avec nos yeux de myopes.'[25] He never attempted to portray the future, but some of his friends did and they prove how impossible it is to portray utopia, how much easier it is to attack. Paul Signac, intimate friend of Lucien and of Camille, tried it, in his *Au Temps d'Harmonie.* People relax, bowl, enjoy earthly and heavenly delights. No one seems to be working. Quite appropriately, it has the unreality of a dream.

After Pissarro sent his drawing of *Les chargeurs de charbon* to *La Plume,* he wrote to Mirbeau: 'J'ai fait un dessin représentant des chargeurs de charbon sur le port à Rouen, heureusement que j'avais fait ce motif lors de mon séjour dans cette ville, sans quoi je me serais vu forcé de lui envoyer un tronc d'arbre, ce qui n'aurait pas fait l'affaire. Je me suis demandé ce qu'un homme de lettres entendait par art anarchiste? quoi? ... décidément ils ne comprennent pas! Tous les arts sont anarchistes! Quand c'est beau et bien! Voilà ce que j'en pense.'[26]

This was an evasion, of course, but it was not far from the position taken by Signac in the pages of *La Révolte* in 1891, repudiating social advocacy in art and declaring that innovations in technique and aesthetics challenged bourgeois standards and were more revolutionary than propaganda. Jean Grave and others attacked Signac's view, urging artists to create paintings that would contribute to social change while granting that art should also be inherently beautiful and not always carry a message.[27]

Lucien Pissarro challenged Grave's position in a letter to *La Révolte* that probably reflected his father's views. 'La distinction que vous établissez entre l'art pour l'art et l'art à tendance sociale n'existe pas. Toute production qui est réellement une oeuvre d'art est sociale (que l'auteur le veuille ou non), parce que celui qui l'a produit fait partager à ses semblables les émotions les plus vives et les plus nettes qu'il a ressentis devant les spectacles de la nature … cette oeuvre de pure beauté aura élargi la conception esthétique d'autres individus.'[28]

What did Pissarro himself have in mind when he said that 'Je crois fermement que nos idées imprégnées de philosophie anarchique se déteignent sur nos oeuvres'?[29] Certainly in his paintings he made no overt attack on capitalist society, no blatant advocacy of anarchism. But there are elements in Pissarro's art that reflect his philosophy. His disregard for bourgeois standards of 'beauty,' of official art values in painting, in a sense defied the state. Of course, non-anarchist painters did this, too, but his work had other aspects that set him apart. His peasants represented a way of life exalted by the anarchists. His semi-utopian vision of peaceful villages and fields, in which the only stress is that of healthy work outdoors, is in implied contrast to the horrors of factory labor. There is no hint of the heavy hand of authoritarian government in the life of these peasants, whether working individually or cooperatively, no whiff of the Bourse when they sell their own crops in the marketplace.

This is not 'l'affreuse réalité' that Kropotkin urged artists to portray, it is not the art with a blunt social message that Grave advocated, nor is it simply 'beauty' as an example to enlighten the masses. The paintings do contain 'les émotions les plus vives' before the sights of nature that Lucien called for. Pissarro's vision is of men and women perfectly integrated with their natural environment. At the heart of these paintings is his wish to picture a world that was passing and needed preserving for the ideal society of the future.

As he wrote after reading Kropotkin's *La Conquête du Pain*, 'il faut avouer que si c'est utopique, dans tous les cas, c'est un beau rêve et comme nous avons eu souvent l'exemple d'utopies devenues des réalités, rien ne vous empêche de croire que ce sera possible un jour, à moins que l'homme ne sombre et ne retourne à la barbarie complète.'[30]

Notes

Further abbreviations: R John Rewald, *Pissarro*, New York, 1963; S & H Ralph E. Shikes and Paula Harper, *Pissarro: His Life and Work,* New York, 1980.

1 P.-J. Proudhon, *Du Principe de l'art et de sa destination sociale* (Paris, 1865), p. 310.
2 P.-J. Proudhon, *De la Justice dans la Revolution et dans l'Eglise* (Paris, 1858), vol. 3, pp. 86–93.
3 *Lettres*, p. 258, 8 July 1891.
4 E. Zola, 'Mon Salon,' *L'Evénement*, Paris, 27 April–20 May 1866.
5 Letter to Pissarro from his mother Rachel, 6 November 1870. Musée Pissarro, Pontoise.

6 For extended discussion, see Theodore Reff; 'Pissarro's Portrait of Cézanne,' *Burlington Magazine*, V, 109, November 1967, pp. 627–30.
7 Quoted in J. Lindsay, *Cézanne, His Life and Art* (Greenwich, Conn., 1969), p. 168.
8 L. Venturi, *Les Archives de l'Impressionnisme* (reprinted New York, 1968), vol. 1, p. 122.
9 *Lettres*, p. 233, 13 April 1891.
10 Quoted in Françoise Cachin, 'Looking at Pissarro,' Pissarro exhibition 1980–1, p. 51.
11 21 April 1892, Musée du Louvre, Cabinet des Dessins.
12 *Lettres*, p. 156, 5 June 1887.
13 For the most extensive discussion of Pissarro's factory paintings, see Richard Brettell, 'Pissarro and Pontoise: The Painter in a Landscape' (doctoral dissertation, Yale University 1977), University Microfilms International, Ann Arbor, Mich., pp. 131–64.
14 For Kropotkin's relevant views see his *Paroles d'un Révolté* (Paris, 1885); *Anarchist Communism: Its Basis and Principles* (London, 1887); *La Conquête du Pain* (Paris, 1892); *Fields, Factories and Workshops* (London, 1899).
15 Facsimile ed. pub. by Skira, Geneva, 1972, unpaged.
16 For a discussion of the role of the Eiffel Tower and the Universal Exhibition of 1889 as catalysts for *Turpitudes sociales*, see Richard Thomson, 'Camille Pissarro, "Turpitudes Sociales," and the Universal Exhibition of 1889,' *Arts Magazine*, LVI, no. 8, April 1982, pp. 82–8. Thomson also traces the origins of much of the imagery used in *Turpitudes sociales*.
17 *Lettres*, p. 448, 27 January 1898.
18 Kropotkin, *Paroles d'un Revolté* (1885 ed.), p. 65.
19 Le Club de l'Art Social described in A. Tabarant, *Maximilien Luce* (Paris, 1928), pp. 32–7.
20 For Pissarro's payments of Grave's debts, see letter to Grave, 12 December 1892, Institut Français d'Histoire Sociale, and Jean Grave, *Le Mouvement Libertaire sous la IIIe République*, p. 295.
21 Police dossier of 22 March 1894, Préfecture of Eure, Direction de la Sûreté Générale. Ff 12506, Archives Nationales, Bibliothèque Nationale.
22 *Lettres*, p. 83, 12 March 1884.
23 *Lettres*, p. 351, 5 September 1894.
24 Pissarro's omissions in Pontoise are discussed in Brettell, op. cit., pp. 74–85.
25 *Lettres*, p. 256, 30 June 1891.
26 30 September 1892, Musée du Louvre, Cabinet des Dessins.
27 *La Révolte*, 13–19 June 1891, letter unsigned but attributed to Signac.
28 *Les Temps nouveaux*, I, 32, 1895.
29 *Lettres*, p. 233, 13 April 1891.
30 21 April 1892, Musée du Louvre, Cabinet des Dessins.
Pissarro's political philosophy in relation to his art is discussed in Benedict Nicolson, 'The Anarchism of Camille Pissarro,' *The Arts*, no. 2, pp. 43–51; R. L. and Eugenia W. Herbert, 'Artists and Anarchism, Unpublished Letters of Pissarro, Signac, and Others', *Burlington Magazine*, November and December 1960; Eugenia W. Herbert, *The Artist and Social Reform, France, Belgium, 1885–1898* (New Haven, 1961); Robert L. Herbert, 'Les Artistes et l'Anarchisme,' *Le Mouvement Sociale*, no. 32, July–September 1961.

Chapter 4

The Pissarro family in the Norwood area of London, 1870–1: where did they live?

Martin Reid

In an article in the *Burlington Magazine* some years ago, I set out what I believe to be the correct identification of three paintings by Camille Pissarro of the part of South London where he lived for six or seven months from the end of 1870 to June 1871.[1] If we add to those three the five[2] whose subjects present no problem and two[3] whose subjects have long been clearly established, there remain three paintings of this group whose identification is still unknown.

These are *Etude à Lower Norwood, Londres* (P & V 112), which will keep its secret until the large house which is its main feature can be identified, and two others, *Paysage d'hiver en Angleterre* (P & V 106; plate 32) and *Route de Upper Norwood, avec voiture (temps gris)* (P & V 114; plate 33), both modest suburban scenes. Pissarro would hardly have gone a long way from where he was living to paint either of them. Indeed, P & V 106 is such a very ordinary scene that it is reasonable to ask what led Pissarro to paint it at all. Could it have been a view which came to him ready-made, so to speak, because it was what he saw from the window of his lodgings, or the lodgings of another member of the Pissarro family? Is Pissarro looking down on the scene, e.g. from a first floor window? I cannot say for sure. I know of no evidence that Pissarro, at such an early stage of his life, painted views from windows.[4] He did of course regularly do so in later years when a persistent eye infection prevented him from working out of doors in winter. But, if P & V 106 is not a window view, Pissarro would surely not have ventured far in such cold weather to paint it.

There is no reason to doubt that P & V 114 was painted in the open air, but it shows a scene which could have been paralleled in many of the middle-class streets of the Norwood area. There is nothing in it to have taken Pissarro far afield. The presumption must be that it was a subject near where he was living or on the way to where some of his relatives were living.

In pursuit of my goal, I therefore sought to narrow the field of search by finding out all I could about where Camille Pissarro, his mother, his brother and any other members of his family were living at this time (see map). My efforts have not solved the enigma of any of the three paintings. They have, however, yielded up some information which I find interesting, and believe to be new; the purpose of this chapter is to place this on record.

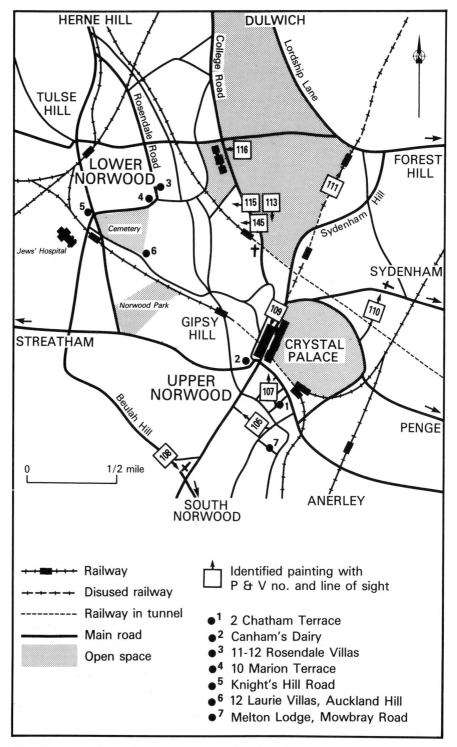

The Pissarro family in the Norwood area of London, 1870–1

The 1871 Census

My search has been greatly assisted by the fact that a national census was taken in Britain on 2 April 1871.[5] Census enumerators visited every dwelling and listed everyone, including visitors and foreigners. The census form required particulars of each individual's name; address; relation to Head of Family; marital status; age; sex; rank, profession or occupation; place of birth; and whether deaf and dumb, blind, imbecile or idiot or lunatic.[6]

Camille Pissarro's correspondence in 1870–1 gives two addresses:

(i) 'Westow Hill, Upper Norwood at Canham's Dairy'[7] The census shows James Canham, a dairyman aged 29, his wife, two daughters, a nephew, a lodger and a servant living at 'Westow Hill Dairy'. Westow Hill is the name of the main shopping street in Upper Norwood. The census does not show the street numbers, but the dairy is listed next to the Swan public house, which is at the end of the street. It must, therefore, have been on the site of what is now the Upper Norwood branch of the National Westminster Bank. On the other side of the Swan towered the Crystal Palace. Canham's Dairy faced a busy shopping street at the front; at the back if Pissarro had a view at all, he would have looked out over the Crystal Palace High Level Railway Station – the terminus; in the near foreground would have been the engine turntable.[8]

(ii) '2 Chatham Terrace, Palace Road, Upper Norwood, Surrey'[9] It is generally assumed that after lodging temporarily[10] at Canham's Dairy Pissarro and his family moved to Chatham Terrace a short way away.

But there is no trace of them there in the census. Everyone was obliged by law to submit to the census and, as we shall see, other members of the Pissarro family co-operated. Nevertheless, I think it probable that Camille Pissarro, Julie Vellay and their two young children, Lucien and Minette, were in fact living at 2 Chatham Terrace, for the following reasons:

(i) The Public Record Office acknowledges that there was some deliberate evasion of the enumerators. Pissarro may have been apprehensive of contact with British officialdom as represented by the enumerators. He and Julie Vellay may also have wished to avoid giving information which would have revealed that they were not married. Indeed, it might not be entirely fanciful to speculate that the census may have been one reason which contributed to their decision a few weeks later, on 14 June 1871, to get married at Croydon Register Office.

(ii) The census does not number the houses in Palace Road. But a comparison with the contemporary local directory, which does number the houses, makes it possible to pinpoint 2 Chatham Terrace in the census: it is a house occupied by a young labourer, his wife and child. These houses had three storeys and the census shows that many of them had far more than three occupants. There would have been plenty of room at 2 Chatham Terrace for the Pissarros as well as the labourer and his small family.

(iii) On the evidence of his paintings alone, Pissarro must have had lodgings somewhere in the area. But I have gone through the census returns over a wide area around and I cannot find them. Palace Road is the sort of place

where one would expect to find them. At the time it had an unusually high proportion of lodging houses and foreigners.

(iv) Camille and Julie's marriage certificate gives their address as 2 Chatham Terrace. There is no reason to doubt that they were living there in June when they were married.

(v) It is possible to calculate from the position and relative heights of the two towers of the Crystal Palace as shown in P & V 107 that Pissarro must have done this painting from 2 Chatham Terrace or somewhere very near. He would hardly have chosen that vantage point if he was not living there.

We cannot exclude the possibility that the Pissarros may have been living somewhere else in South London but further afield than I have searched, or that they had gone away on a visit on the day of the census. But in the absence of any further evidence, the most natural explanation of their not appearing in the census is that they were living at 2 Chatham Terrace but evaded the enumerators.

We have more luck with other members of the family. In Knight's Hill Road (now Knight's Hill, West Norwood) the census shows Alfred Pissarro,[11] married, aged 42, lodger (the word 'lodger' has been partly erased and replaced by 'Merchant in Paris'), born in St Thomas, West India (sic); his wife, Marie Pissarro, 27, born at Besançon, France, and their son Frédéric, 20 months, born in Paris. The house was at the extreme northern end of the road, on the corner of what is now Lansdowne Hill, where a branch of Woolworths stands today. The Pissarros' landlord was William Jackson, a sculptor – no doubt of funerary monuments as the house was nearly opposite the entrance to West Norwood Cemetery.

Then, combing through the census, I came across the following entry for 11/12 Rosendale Villas, Rosendale Road, West Dulwich:

Rosendale Road Park House School

Mme R Pizarro[12]	Mother	Widow	70	Income from property in St Thomas, W. Indies	St Thomas, W Indies
Amelia Isaacson	Dau^r	u/m	21		St Thomas, W Indies
Alice Isaacson	Dau^r	u/m	17		St Thomas, W Indies
Esther Isaacson	Dau^r	u/m	13	Scholar	France, Paris
Alfred Isaacson	Son	u/m	10	Scholar	France, Passy

This is Pissarro's mother Rachel and four of the children of her daughter Emma. Emma, who was a daughter of Mme Pissarro by her first marriage to Isaac Petit, married Phineas Isaacson, a merchant trading with the West Indies. They settled in London in 1865 and she died there in 1868. It is amusing to see the enumerators solemnly recording that Mme Pissarro (aged 70) was the mother of the four children aged between 21 and 10. There is,

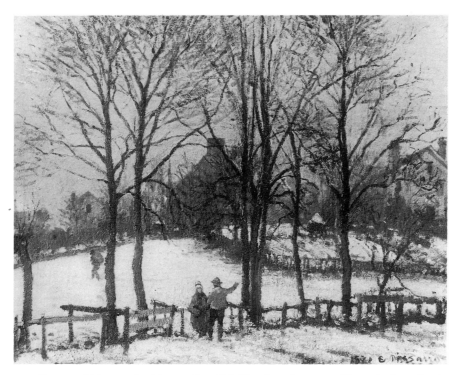

32 *Paysage d'hiver en Angleterre,* 1871, P & V 106, 43 by 54 cm. Present whereabouts unknown

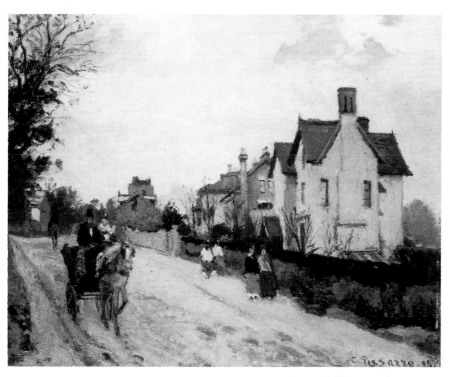

33 *Route de Upper Norwood, avec voiture (temps gris),* 1871, P & V 114, 45 by 55 cm. Munich, Neue Pinakothek

34 The Jews' Hospital, Lower Norwood, from *The Builder*, 19 July 1862. Photo British Library

however, a squiggle above 'son' in the entry for Alfred which could be 'gd' meaning 'grand[son]'.

A comparison of the census return with the Post Office Suburban Directory Southern Division of 1876 shows that Mme Pissarro and the four children were staying at a ladies' school run by a Mrs Lancaster, her four schoolmistress daughters and a schoolmaster. Rosendale Villas consisted of nine pairs of square semi-detached houses. The three pairs at the northern end still stand. Nos 11/12, subsequently renumbered 100–2 Rosendale Road, were the next pair in the row going south. A block of flats now occupies the site. The census entry makes it clear that the school occupied both of the semi-detached houses, and that Mme Pissarro and the grandchildren lived together as a family unit.[13]

It was obviously a convenient arrangement for the motherless Isaacson children to stay, with their grandmother, in a ladies' private school. The eldest, Amélie, had been with Mme Pissarro in France, and they probably travelled together to England. I assume that Esther was a pupil at the school. It was presumably acceptable for Alfred to be there too as he was only 10,[14] but I can find no trace in the census of the Norwood area of his brother Rodolphe, who was evidently the eldest of the family, nor of their father Phineas Isaacson. They are not listed at 23 Norfolk Street, off the Strand, which had been the Isaacsons' family home when Emma died and also the address of the firm of Phineas Isaacson and Co., Merchants. In 1871 23 Norfolk Street was, according to the census, a private hotel. In 1872 Phineas Isaacson is recorded in one local directory and in the Lambeth Rate Book as the occupant of 12 Laurie Villas, Auckland Hill (now 16 Auckland Hill), West Norwood. The house still stands. Later he moved to Holloway in North London.

The search of the census produced a surprise with the following entry, which shows that another family that was later closely linked to the Pissarros was living very near.

Cemetery Road, Thurlow Villas, 10 Marion Terrace[15]

Jacob S L Bensusan	Head	Mar	24	Manager in Counting House	Kent, Greenwich
Miriam L Bensusan	Wife	Mar	23		Gibraltar
Esther L Bensusan	Dau^r		4m		Surrey, Dulwich
Samuel L Bensusan	Father	Mar	73	Retired Merchant	Gibraltar
Esther L Bensusan	Mother	Mar	57		Gibraltar
Orovida L Bensusan	Sister	u/m	28		Middlesex, City of London
Abraham L Bensusan	Brother	u/m	26	Mercantile Clerk	Middlesex Regents Park
Miriam L Bensusan	Sister	u/m	19	none	Surrey Camberwill (sic)

+ 1 servant

Esther Bensusan (the baby of 4 months) was to marry Lucien Pissarro in 1892. No doubt they named their only child after Esther's aunt, Orovida, whom the census shows as living with her younger brother and his family in 1871. The Bensusans were still at the same address in 1872[16] and, in the absence of any evidence, it is a reasonable guess that they remained there until they moved in 1876 to 7 Weighton Road, Anerley; from there they moved in 1888 to Melton Lodge, Mowbray Road, Upper Norwood.

The fact that in 1871 the Bensusans were living a mere 250 metres from where Madame Pissarro and her grandchildren were staying, and along the road to Alfred Pissarro's lodgings, raises the interesting speculation as to whether the Pissarros knew the Bensusans at the time. In his published correspondence Camille Pissarro does not appear to mention the Bensusans before 1884. But we know[17] that Jacob Bensusan was a great friend of Mr Chapman, who is shown in the census as Head of the Jewish School[18] in Norwood, and that Mrs Chapman was a cousin of the Isaacsons. This link and their proximity at the time make it likely in my opinion that the Pissarros were at least aware of the Bensusans in 1871. Lower Norwood tended to attract members of the London Jewish community after the Jewish School, previously in Mile End, East London, moved into imposing new buildings there in 1862 (plate 34). The Jewish School was a substantial establishment having – according to the census – 76 boarders, both boys and girls, between the ages of 7 and 15, and four resident teachers. The establishment has now been replaced by a smaller 'Norwood Home for Jewish Children' opened in 1962 and a synagogue (1963).

Lower Norwood

That seems to be all the census can tell us of the whereabouts of Camille Pissarro and his relations (and future in-laws). But there is one other piece of evidence which I believe has been overlooked. In his much quoted letter to Wynford Dewhurst in 1902 Pissarro said, 'In 1870 I found myself in London with Monet. . . . Monet worked in the parks, whilst I, *living at Lower Norwood* [my emphasis], at that time a charming suburb, studied the effects of mist, snow and springtime. . . .'

Lower Norwood is the name of what is now known as West Norwood. Originally it was just the village of Norwood, but when the higher ground to the south and east was developed and a town centre grew up and took the name Upper Norwood, the old village became Lower Norwood, to make the difference clear. Originally this was just a reference to altitude, but the affluence of Upper Norwood and the relatively modest circumstances of the inhabitants of Lower Norwood caused the word 'Lower' to take on social overtones. As a result there was pressure to change the name, and Lower Norwood became West Norwood in 1885.[19]

In Pissarro's day it was quite clear what was meant by Lower Norwood. It was not so obvious many years later when others, who were unfamiliar

with the neighbourhood, gave titles to his pictures. There are therefore some mistakes. *Lower Norwood, Londres: Effet de neige* (P & V 105) is certainly Upper Norwood. *La station de Penge, Upper Norwood* (P & V 111), which is actually Lordship Lane Station, is not in any part of Norwood. Nor is St Stephen's Church (P & V 113 and P & V 145) in Lower Norwood. Other titles are correct (e.g. those of the Crystal Palace). It is all a bit haphazard.

But on the only occasions known to me when Pissarro himself wrote of 'Upper' or 'Lower' Norwood, he gets his terms right. In the headings of his letters from Canham's Dairy and Chatham Terrace he correctly describes them as in Upper Norwood. Even more significantly, in the title of P & V 115, which he wrote on the back, he refers to the cemetery of Lower Norwood in the distance: he is exactly right.

If, then, Pissarro used the names correctly in these cases (admittedly not a large number[20]) it is a fair inference that when he mentioned Lower Norwood in his letter to Dewhurst he meant just that. It is possible, therefore, that for some part of his stay in the area he had lodgings in or near West Norwood, where his mother and brother were living, but that the evidence is lost. That would certainly suit the evidence given by Shikes and Harper.[21] His mother might have found him lodgings near her, to start with, and he might have moved to cheaper lodgings at Canham's Dairy, in order to keep Madame Pissarro and Julie apart. It is tantalising to speculate where such lodgings might have been – and what would have been the view from the first floor window! Perhaps we shall never know.

Notes

The author wishes to acknowledge valuable help received from Mr E. B. Nurse of Southwark Libraries, Mrs Schmidt and Mrs Hatfield of the Minet Library (Lambeth Archives), Miss Lorna Kingdon, and his wife, Jane.

1 'Camille Pissarro: Three Paintings of London of 1871. What do they represent?', *Burlington Magazine*, vol. CXIX, no. 889, April 1977, pp. 251–61. P & V 108, 111 and 115.

2 Two paintings of the Crystal Palace (P & V 107 and 109), two of St Stephen's Church, College Road, Dulwich (P & V 113 and 145) and one of Dulwich College (P & V 116).

3 P & V 105, *Lower Norwood, London: Effet de Neige*, which is a view of Fox Hill, Upper Norwood; and P & V 110, *La Route de Sydenham*, which shows St Bartholomew's Church, Westwood Hill, seen from Lawrie Park Avenue, Sydenham, London SE26.

4 This may be unduly cautious. No less an authority than Dr Richard Brettell in his catalogue note on *La Garenne de Pontoise, effet de neige*, 1879 (P & V 478) which is no. 34 in the exhibition L'Impressionisme et le paysage français (Los Angeles/Chicago/Paris 1984–5) says that this painting was without doubt executed from the window of a house in what is now the Chemin du Général-Belger.

5 There is similar good fortune in the fact that the first large-scale (25 inches to one mile) Ordnance Survey map of the area dates from the same years.

6 The census records can be seen on microfilm at the Public Record Office, Portugal Street, London WC 2. There is no index of names.

7 See letter 12 in *Correspondance*. I have assumed that Pissarro wrote letter 11 in the same edition, headed 'Westow Hill', from the same address. Ralph E. Shikes and Paula Harper, *Pissarro: His Life and Work*, (London, 1980), give an address on an envelope in a private collection in New York – 'Canham's Diary, Westover Hill, Lower Norwood'. I assume that this is an inaccurate version of the same address.

8 Shikes and Harper (op. cit., p. 89), drawing apparently on unpublished sources, describe Pissarro's favourable impressions of Norwood as he drove with his family from the railway station to their new home at Canham's Dairy. This is odd, because Canham's Dairy was just beside the Crystal Palace High Level Station which would be their natural destination. Perhaps, however, the family took a train to the Crystal Palace Low Level Station or Gipsy Hill or Sydenham Hill. See also note 21.

9 Letters 9 and 10 in *Correspondance*, the latter dated 5 June.

10 Shikes and Harper (op. cit., p. 89) say that Canham's Dairy was a 'temporary haven . . . until they moved a few months later to 2 Chatham Terrace'.

11 Alfred Pissarro (1829–90) was Camille's full brother.

12 In his letter of 10 February to Eugène Petit (97 in *Correspondance*) Pissarro explains why his name should be spelt with 'ss' rather than 'z'. The synagogue registration of his birth has a 'z' and he spelt his name with a 'z' in his early life.

13 Shikes and Harper (op. cit., p. 89), drawing presumably on unpublished material, describe Pissarro's pleasure in visiting the Isaacson daughters.

14 According to Shikes and Harper, Alfred Isaacson started as a pupil at Dulwich College in September 1871.

15 This is a confusing address. Cemetery Road is now Robson Road. Thurlow Villas were the houses on the north side of Park Hall Road between Rosendale Road and Croxted Road. Marion Terrace ran from Chancellor Grove to Rosendale Road.

16 The Borough Engineer's file on the road (Lambeth Archives) records that Jacob Bensusan acknowledged receipt of a letter in 1872 renumbering his house from 10 to 31.

17 Letter to the author from Mr John Bensusan-Butt.

18 There are variations of the name – The Jews' Hospital, Jews' Hospital Orphanage and Asylum, The Jewish Free School.

19 There was a similar background to the change of name of the French departments of Seine Inférieure and Loire Inférieure to Seine Maritime and Loire Atlantique respectively.

20 The incorrect address referred to in note 7, which locates Canham's Dairy in Lower Norwood, is on an envelope addressed *to* Pissarro.

21 See note 8. As Shikes and Harper are using unpublished material, I can only speculate. But if their sources describe the Pissarro family drawing up to their *lodgings* (rather than to Canham's Dairy by name), this would lend some support to the possibility that the Pissarros lodged somewhere in West Norwood before moving to Canham's Dairy. One further pointer in that direction is that if the family went straight to Canham's Dairy, Pissarro's overwhelming first impression would surely have been of the Crystal Palace rather than of the neat stucco villas of Norwood.

Chapter 5

Some Pissarro collectors in 1874

Anne Distel

In a famous letter now in the Fondation Custodia of the Institut Néerlandais in Paris, the critic Théodore Duret wrote to Camille Pissarro on 15 February 1874:

> vous avez maintenant un groupe d'amateurs et de collectionneurs qui vous sont acquis et vous soutiennent. Votre nom est connu des artistes, des critiques, du public spécial. Mais il faut faire un pas de plus et arriver à la grande notoriété. Vous n'y arriverez point par des expositions de sociétés particulières. Le public ne va pas à ces expositions; il n'y va que le même noyau d'artistes et d'amateurs qui vous connait d'avance. La vente Hochedé [sic] vous a fait plus de bien et vous a fait faire plus de chemin que toutes les expositions particulières imaginables[. . . .] Je vous engage beaucoup à compléter cela en exposant cette année au Palais de l'Industrie. Dans les dispositions où l'on semble être cette année, votre nom étant maintenant connu, on ne vous refusera pas. A l'exposition vous serez vu par les 42 mille personnes qui, je suppose, visitent l'exposition, par 50 marchands, amateurs, critiques, qui n'iraient jamais vous chercher et vous trouver ailleurs[. . . .]

In advising Pissarro to face the jury of the official Salon – something the artist had not done since 1870 – Duret made quite clear his scepticism towards 'expositions des sociétés particulières'. This is certainly an allusion to the exhibition projected for the spring of 1874 by the Société anonyme coopérative d'artistes-peintres, sculpteurs, etc., in which Monet, Pissarro and Renoir were active participants and which became known as the first 'Impressionist' exhibition, although the term 'Impressionism' was not yet in existence. It was to be coined by the critic Louis Leroy in *Le Charivari* of 25 April 1874 as a derisive label for a canvas exhibited by Monet entitled *Impression, soleil levant* (Paris, Musée Marmottan). Nevertheless, Duret remained optimistic for Pissarro, reminding him that he could already count on a dependable following of collectors. We should therefore try to establish who, at this date,

Translated by Joachim Pissarro and Roger Mills

constituted the small group of art-lovers who were interested in Pissarro's painting.

We already know the artists among his supporters and need only mention their names. There were members of the Impressionist group, notably Monet, Degas, Henri Rouart, Cézanne and Renoir (Caillebotte probably did not enter the scene either as an Impressionist painter or as a supporter until 1876). To this group must be added Pissarro's 'masters': the Danish painter Anton Melbye (1818–75), the great Corot (1796–1875) and Daubigny (1817–78).[1] We do not know, however, whether or not Pissarro had any contact with Courbet, although Amand Gautier, a friend of both artists, might have brought them together. Among his younger admirers, the most important was his faithful friend Ludovic Piette (1826–78); other admirers were his companion in Venezuela, the Dane Fritz Melbye (1826–96);[2] the Puerto-Rican Francisco Oller (1833–1917), who was also a friend of Cézanne's; and two more exhibitors of 1874: Edouard Béliard (1834–1912) and Auguste de Molins (1821–90).[3] We should also remember that the very young Odilon Redon, who was then making his debut as a critic, had admired Pissarro's work at the Salon of 1868. This leads us to the critics who supported Pissarro. Of these the most notable were Zola, Astruc, Castagnary, Chesneau and, of course, Duret himself.

But who were the art-lovers and collectors who supported Pissarro? Duret's letter mentions one of them by name, Hoschedé, whose first sale, on 13 January 1874, included no fewer than six Pissarros, among which one fetched as much as FF950 – almost the price paid for a work by an artist awarded a medal at the official Salon.[4] The character of the businessman Ernest Hoschedé (1837–91) has recently been studied by both Hélène Adhémar and Daniel Wildenstein in their work on Monet[5] – an artist whose paintings Hoschedé admired greatly. Both authors have emphasized the ostentatious luxury in which Hoschedé lived as master of the Château of Montgeron, as well as his passionate acquisition of works by the Barbizon School, by Courbet, Corot, Manet and by all the Impressionists as well as by Boudin, Lépine and Jongkind. Indeed, Hoschedé can be said to have built up one of the most important collections of avant-garde art in his time until he went bankrupt in 1878. Of the Pissarros that were part of the first Hoschedé sale, four originated without a doubt from the stock of the dealer Durand-Ruel.[6] This reflects the well-known part played by Durand-Ruel in the promotion of Pissarro's work, the importance of which is even more clearly seen in what follows. Despite the fact that the minutes of the sale show that it was Hagerman (a Paris-based dealer, living at 1, Rue Auber, who was also a business associate of Durand-Ruel's) who acquired all the Pissarros of the Hoschedé sale, it appears from the ledger of the Durand-Ruel gallery that Durand-Ruel himself bought back for his stock lots 58, 59, 62 and 63 (see note 4). He thus helped to sustain the prices of Pissarro and the Impressionists, for he also bought back Monet's *Paysage, Ile de la Grande Jatte* and Sisley's *Vue du canal aux environs de Paris*, both of which appeared in the same sale.[7] What is surprising, however, is that Durand-Ruel bought back *Allée plantée d'arbres près Pontoise* (lot 61) for Pissarro himself, at a price of FF735, including expenses – an enormous sum for the impoverished artist,

given that he had originally sold it to Durand-Ruel for only FF200. In the light of these new facts, it is difficult to establish whether or not Hoschedé had been speculating on the work of the young painters. It is true that he kept these works in his collection for only a year; but, on the other hand, he had bought them from Durand-Ruel at high prices ranging from FF300 to 1,000; he lost 5 per cent on these canvases at the auction, proving his investment a rather unsatisfactory one. What is clear, however, is that Durand-Ruel supported the Impressionists very actively (and he was the only dealer to do so at this date), promoting artists who were not only young but also, as Chesneau put it in his preface to the sale catalogue, a 'groupe très discuté dans ses tendances à l'extrême simplicité et pour la sincérité absolue de ses interprétations naturalistes'.

We know that when Camille Pissarro was living in London as a refugee from the Franco-Prussian War, like Monet, he made contact with Durand-Ruel. This was in January 1871. At this point Durand-Ruel bought at least two canvases from Pissarro which were only entered in the firm's records later on.[8] Either at the end of their stay in London or on the return of both men to Paris, Pissarro's contacts with Durand-Ruel were resumed – first in June 1871[9] and then again in March 1872. Evidence of Durand-Ruel's purchases of the time can be found both in the firm's records (stock nos 1176–7) and in a letter from Pissarro to his wife.[10] The year 1872 thus marks the starting-point of regular dealings between the artist and his dealer.[11] Durand-Ruel's purchases between 1871 and March 1873 can be followed in detail. After that date, unfortunately, the firm's records are incomplete and the titles of the works he bought are not known. In just over two years, Durand-Ruel bought thirty canvases from Pissarro for a total of FF11,400. The last three works were bought in March 1873 for substantial sums, two at FF1,000 each and one at FF2,250. In 1874 he bought FF5,035-worth of paintings by Pissarro, but only FF1,190-worth in 1875, the year of the 24 March sale organized by the Impressionists which yielded such poor results (very few works went over FF300). During the period 1871–3 Durand-Ruel also bought works by Pissarro from other people besides the painter himself, acquiring a total of seventeen paintings for the modest sum of FF3,200: he usually paid less than when he bought directly from the artist. This takes the total number of canvases bought by the gallery to forty-seven. As we shall see, very few of these were sold.

A word should first be said about the people from whom Durand-Ruel bought paintings by Pissarro. The most famous and important of these was Pierre-Ferdinand Martin (1817–91), 'le père Martin', who appears to have been Pissarro's first official dealer. The first mention of 'le père Martin' seems to be in a letter from Camille Pissarro to his wife Julie, written in the summer of 1868 or 1869.[12] At any event, he appeared in the 1870 Salon catalogue as Pissarro's Paris agent: the artist is described as living at Martin's address. Tabarant maintains that Martin bought from Pissarro the two landscapes exhibited at the 1870 Salon;[13] however, this cannot be proved. Tabarant also informs us, probably on the basis of an article by Duret, that Martin used to

pay between FF20 and 40 for Pissarro's works. This confirms that the American dealer Georges Lucas could indeed have bought a Pissarro from him for FF20 on 7 January 1870.[14] Clearly, Martin made a considerable profit when he sold the same works to Durand-Ruel for FF150 or FF175! At first Martin had a shop at 20, Rue Mogador, from 1870 he was at 52, Rue Laffitte, and finally in 1877 he settled in a private apartment at 29, Rue Saint-Georges. He was a dealer of considerable perception and from the 1850s onwards he sold works by Jongkind side by side with those by Corot. Duret seems to have kept closely in touch with Martin and as late as 1878 he advised Pissarro to try to renew his relations with his old dealer – probably in order to avoid a total dependence upon Durand-Ruel.[15] Pissarro continued to offer his work to Martin during the period 1873–4.[16]

The second most important dealer for Pissarro was his supplier of materials, Latouche, whose trademark 'Couleurs fines et tableaux modernes' can often be seen on the backs of Pissarro's canvases.[17] At times Latouche also sold paintings by Pissarro just as he did for Monet and Jongkind, probably after accepting the paintings in exchange for materials. He was a friend of the avant-garde painters and known as such, since he exhibited Monet's works (the precise circumstances in which he did this are hard to establish);[18] and it was at his shop that the petition of the artists rejected from the 1867 Salon was first displayed.[19]

Durand-Ruel also bought Pissarros from a man named Hourquebie, of 12, Rue Joubert, who seems likely to have been a runner (he handled works by Boudin and Manet) and he was in close contact with the famous singer Faure, who will be discussed later. Herman, of 69, Rue de Rome, seems to have dealt in Pissarro's paintings, as also did Lebarbier and Lévis. An intriguing figure from whom Durand-Ruel bought no fewer than six Pissarros at this time is Billon. Durand-Ruel's ledger mentions him as living in the Rue de Châteaudun and he is probably the same person who bought a Sisley (lot 56) at the 1875 Impressionist sale, and was then resident at no. 57 in the same street. The 1878 Didot-Bottin directory listed a 'brasserie Billon' at 33, Rue de Châteaudun, a very well-known 'café' at this time. Could this be a neglected Impressionist supporter? He is more likely to have been another runner. Other dealers besides the above are bound to have offered some of Pissarro's works for sale in the years between 1865 and 1875. It is very likely that Carpentier, of 8, Boulevard Montmartre, at whose address Pissarro was registered as resident during the 1869 Salon, would have had some works by the artist. A small dealer, Audry, in the Rue Laffitte, who used to sell Corots (and with whom Durand-Ruel was in contact) sold a small Pissarro to Duret in February 1874.[20] Other names also come up in the artist's correspondence, such as that of Mme Vve Goblet[21] who, according to the Didot-Bottin directory, used to sell 'Curiosités et Tableaux' at 9, Rue de Castiglione. Another famous name which has not yet been mentioned is that of 'le père Tanguy'. Pissarro's correspondence does not provide a full documentation of their relationship but it is likely that the first contact between the two men occurred around 1874.[22]

To return to the activities of Durand-Ruel, it must be stressed that he sold very few of the canvases he purchased. He usually sent them to his agents, either in Brussels or, very frequently, in London (a client named Hamer had an account with Deschamps, Durand-Ruel's London agent) or in the French provinces (in Vienne, for example, a man named Bossi bought one Pissarro; in Marseilles, the client, a stockbroker called Vaïsse, eventually asked to exchange his Pissarro for an *Artilleryman on Sentry-duty* by Dupray, a specialist in military paintings). However Durand-Ruel took the trouble of having the Pissarros in his stock engraved for his illustrated catalogues.[23] Durand-Ruel's only other serious client was the famous singer Jean-Baptiste Faure (1830–1914), who loved the work of Manet, Degas and the Impressionists, and started buying Pissarros regularly as early as 1872.[24] There is no need to dwell on his collection since it has already been studied in detail. More often than not, the visitors at Durand-Ruel's gallery seem to have called there purely for pleasure. The painter Antoine Guillemet describes this in one of his letters.[25]

Apart from using dealers, Pissarro also got in direct touch with art-lovers through his artist friends.[26] It was in this way that he met the famous Dr Gachet of Auvers-sur-Oise – probably through Amand Gautier. Gachet achieved fame through his friendship with Renoir, Cézanne and later Vincent van Gogh; his collection of pictures was subsequently given by his children to the national museums of France.[27]

However, it was mainly through Théodore Duret that Pissarro managed to meet important collectors. An eminent critic whose defence and explanation of Impressionism is extremely well known, Duret greatly admired Pissarro's painting. As early as the 1870s, he owned several canvases by the artist.[28] Even more important he persuaded his friends and contacts to purchase works by Pissarro and the other Impressionists. Many of his friends were from the Cognac region, whence he himself came, and were mostly connected with the wine trade from which he derived his own fortune. The first of these introductions involved Jules Berthet whose London address Duret mentions in a letter in 1871 and with whom Duret went to visit Pissarro in that city during the same year.[29] On that occasion, they were accompanied by 'M. Hecht, un amateur distingué de Paris'.[30] We do not yet know whether this was Henri Hecht or his brother Albert, for both of them were collectors of Courbet, Manet and the Impressionists. However, an unpublished document – Albert Hecht's account book – reveals that on 7 February 1872 Albert Hecht bought a painting by Pissarro from Latouche for '150F + cadre'.[31] Unfortunately this has not yet been identified. Later he acquired three Pissarro paintings at a very low price at the Hoschedé sale in 1878 but it seems that he sold them again very quickly. These paintings, too, remain unidentified.[32] Albert Hecht (Brussels 1842 – Paris 1889) belonged to the same generation as the Impressionist painters. A millionaire businessman with a very un-ostentatious life, he devoted about FF40,000 to purchasing paintings between 1870 and 1888. His acquisitions included a few Flemish and Dutch Old Masters but were chiefly works by 'modern' painters: Delacroix, Corot, Rousseau, Courbet, Manet (whom he had known well since 1871), Monet (whom he knew

as early as 1873), Jongkind, Boudin, Sisley and Degas (with whom he also was acquainted). Unlike his brother Henri, who died in 1891 and who seems to have bought and sold frequently, Albert kept the pictures he had bought, and many have remained in his family's various collections until recently.

Another collector who was introduced to Pissarro by Duret was Etienne Baudry (Saintes 1830–1908). Baudry is chiefly famous today for having received Corot and Courbet in his mansion in Rochemont, near Saintes, and for having been one of the main collectors of Courbet.[33] It was Baudry who, through Juliette Courbet, offered *Les demoiselles de la Seine* to the Musée du Petit-Palais. Yet it is important to remember that Baudry also became interested in the Impressionists. Duret introduced him to Pissarro as 'son cousin ... homme de lettres en même temps qu'un amateur éclairé en peinture ... ancien ami de Courbet et de Castagnary' in 1872 or 1873.[34] Thanks to information kindly supplied by Baudry's grand-daughter, Madame Mélia-Sevrain, who is working on a book about her grand-father, we know that Pissarro was the first Impressionist painter he became interested in (later he also purchased works by Monet). In 1873 he bought two pictures by Pissarro, which it is difficult to identify. In 1874 he bought *La barrière du chemin de fer*,[35] and finally, in 1876, *Usine à Pontoise, allées des vignes* (P & V 162: the only picture that Pissarro and Venturi describe as having belonged to Baudry) and a *Champ de laitues*. Duret described Baudry as a collector prepared to pay 'dans les 500 F environ',[36] and he occasionally settled his accounts in the Cognac which he was producing![37] Baudry in his turn was quick to pass on Pissarro's work to contacts such as Maître Laire, a solicitor in Saint-Jean d'Angely[38] who bought a picture in 1874. As Baudry explained to Pissarro, the painting could be 'celui que vous voudrez, car la personne acquéreur s'en rapporte à vous ou à moi' – an open brief indeed!

Thus, despite Duret's enthusiasm, Camille Pissarro's collectors were still very few in 1874. Even if the baker Murer was already in touch with the artist by that date, it was not until a little later, around 1877, that he added his weight to the ranks of the supporters of Impressionism who eventually included Dr Georges de Bellio, the painter Caillebotte and the composer Emmanuel Chabrier.

We may conclude by quoting Duret once again. He wrote to Pissarro on 2 June 1874, immediately after the first Impressionist exhibition:

> Vous êtes arrivé, après bien du temps à avoir un public d'amateurs choisis et de goût mais qui ne sont pas les amateurs riches payant les grands prix. Dans ce petit monde vous trouverez des acheteurs dans les 2, 4 et 6 cents francs. Je crois qu'avant d'arriver à vendre couramment 1500 et 2 mille il ne vous faille attendre encore bien des années. Tout finit par arriver même la gloire et la fortune et en attendant, le jugement des connaisseurs et des amis vous dédommage de l'oubli des sots.[39]

Notes

This research was initially carried out for the symposium dedicated to Camille Pissarro organized by the Museum of Fine Arts, Boston, on 16 and 17 May 1981, on the occasion of the opening of the Pissarro exhibition at the museum. At the kind suggestion of Mme Edda Maillet I have developed what was only a brief exposé into the chapter which follows.

1 In the Salon catalogues of 1859 and 1866, Pissarro described himself as a pupil of Anton Melbye and in those for 1864 and 1865 he called himself the pupil of both Anton Melbye and Corot. While it is known that Melbye owned paintings by Pissarro (P & V 6, 7, 8) the same cannot be said for Corot. On the other hand, Corot had given Pissarro drawings, one of which is now in the Metropolitan Museum, New York, and another in the Ashmolean Museum, Oxford. On Daubigny's role as an intermediary between artists and Salons when a member of the Salon jury, see the sale catalogue *Archives de Camille Pissarro*, Paris, Hôtel Drouot, 21 November 1975, no. 138 and also a letter to Duret in *Correspondance*, p. 80.

2 Fritz, the younger brother of Anton Melbye, kept amongst other things a group of drawings from Pissarro's youth; see C. Lloyd, in the Pissarro exhibition catalogue 1980–1, nos 94 and 96–9.

3 Béliard acted as a go-between in negotiating the sale of a work by Pissarro to the Museum of Helsinki in 1872 (see the sale catalogue *Archives de Camille Pissarro*, Paris, Hôtel Drouot, 21 November 1975, no. 6). Molins introduced Arosa, father or son, to Pissarro (ibid., no. 137/3).

4 For the Hoschedé sale, see M. Bodelsen, 'Early Impressionist sales 1874–1894 in the light of some unpublished procès-verbaux', *Burlington Magazine*, CX, 783 (June 1968), pp. 332–3, which lists the Pissarro paintings and their buyers:
58 *Bords de l'Oise.* 34 × 45cm; to Hagerman for FF210.
59 *Nature morte, pomme de châtaigners et faïence sur table.* 45 × 55cm; to Hagerman for FF270.
60 *Fabriques et barrage sur l'Oise, environs Pontoise.* 55 × 90cm; to Hagerman for FF950.
61 *Allée plantée d'arbres près de Pontoise.* 49 × 63cm; to Hagerman for FF700.
62 *Chemin près d'un village.* 45 × 54cm; to Hagerman for FF320.
63 *Grand rue de village.* 46 × 54cm; to Hagerman for FF350.
 I shall need to quote prices fairly frequently in this article. Although this can only be a rough estimate, prices quoted can be multiplied by 5 in order to obtain the equivalent in today's money.

5 H. Adhémar, 'Décoration pour le château de Rottembourg à Montgeron', in exhibition catalogue *Hommage à Claude Monet*, Paris, Grand-Palais, 1980, pp. 169–74. D. Wildenstein, *Claude Monet, Biographie et catalogue raisonné, vol. 1, 1840–1881*, Lausanne-Paris, 1974, pp. 80 ff. It should be remembered that Ernest Hoschedé's widow, Alice, became Monet's second wife. After the first Hoschedé sale in 1874 came a second sale on 20 April 1875, which included a few Courbets and Corots. As Adhémar has emphasized, this sale was organized in order to raise money for reinvestment in pictures. The last auction sale, which included works by all the leading Impressionists, was that on 5 and 6 June 1878 (see M. Bodelsen, op. cit. in note 4, pp. 339–40).

6 I am deeply indebted to the late Monsieur Charles Durand-Ruel who kindly opened the archives of his gallery for me, thus enabling me to pursue this research; I also wish to thank France Daguet for helping me to clarify a number of obscure points.
 The works referred to are:
60 *Fabriques et barrage sur l'Oise*, bought from the artist by Durand-Ruel on 12 November 1872 and sold to Hoschedé on 28 April 1873. In Durand-Ruel's stock

book (no. 2123) it is entitled *Promenade au bord de l'eau, vue de Pontoise prise de l'écluse* which confirms the identification of this picture suggested by Bodelsen with P & V 158. Present whereabouts unknown.

59 *Nature morte, pommes de châtaigners* (Durand-Ruel stock no. 2174 which can be identified with P & V 195), bought from the artist by Durand-Ruel on 26 November 1872 and sold to Hoschedé at the same time as the previous picture.

61 *Allée plantée d'arbres*, bought from the artist on 4 September 1872 and sold to Hoschedé on 17 February 1873, the same day as the fourth identifiable picture (Durand-Ruel stock no. 1889 under the title *Route boisée*; it is probably not P & V 37 but rather perhaps P & V 69 or P & V 181).

58 *Bords de l'Oise* (probably Durand-Ruel stock no. 1700, bought from a certain Billou or Billon (see p. 68) on 5 June 1872 under the title *La petite usine au bord de l'eau*, difficult to identify but possibly P & V 174).

The vague titles of the other Pissarros in the sale make it difficult to identify them precisely among the works sold by Durand-Ruel to Hoschedé. They may have been acquired later than March 1873 after which date Durand-Ruel records are lost.

7 In the minutes of the sale, published by Bodelsen, these two works are also listed as sold to Hagerman. The only Impressionist collectors who attended the sale were Dr de Bellio who bought a Monet; Henri Rouart who bought a work by his friend Degas; Etienne Baudry (see below) who acquired a Monet; and Laurent-Richard who bought a Sisley. Laurent-Richard was a famous collector with a more 'classical' taste as can be seen from the sale of his collection (7 April 1873): this was rich in works by Delacroix, Corot and the Barbizon School. He seems to be the same person as the Laurent-Richard known as a tailor and supplier of guards' uniforms for the Paris Salon, and was thus perhaps a business contact of the cloth merchant Hoschedé.

8 Entered, probably at the end of October or beginning of November 1872, as bought from Pissarro 'à Londres en 1870': nos 2031, *Sydenham*, and 2032, *Norwood*, unidentified. See John House, 'New material on Monet and Pissarro in London', *Burlington Magazine*, CXX, no. 907 (October 1978) p. 638 note 17.

9 He purchased two *Effets de neige* at FF200 each.

10 *Correspondance*, p. 71.

11 In April 1872, Durand-Ruel bought from Pissarro a *Route de Versailles à Louveciennes, temps de pluie,* and a *Vue de Marly* (nos 1249–50) and in May 1872 *Le remorqueur* and *Le sentier* (nos 1664–5).

12 *Correspondance*, p. 61.

13 A. Tabarant, *Pissarro*, Paris, 1924, p. 17; T. Duret, 'Quelques lettres de Manet et Sisley', *Revue blanche*, vol. XVIII, 15 March 1899, pp. 433–7; see also the obituary of P. J. Martin, 'décédé à l'âge de 74 ans à son domicile 29 rue Saint-Georges le 30 Septembre 1891', signed by H. Rouart, *Journal des Arts*, 9 October 1891.

14 *The Diary of Georges Lucas, an American Art Agent in Paris 1857–1909*, ed Lilian Randall, Princeton, 1979, vol. I, p. 313.

15 Letter dated 30 October 1878, Fondation Custodia, Institut Néerlandais, Paris.

16 *Correspondance*, p. 89 (letter from Pissarro to Duret).

17 From 1865, the Didot-Bottin directory listed a supplier of fine colours at 25, Rue Neuve Saint-Augustin. From 1867 until 1878 or later he is described as at 34, Rue La Fayette, 'au coin de la rue Laffitte'. Latouche sold three Pissarros in March, April and June 1872: *Route dans un village* (no. 1105), *Omnibus traversent un bois* (no. 1287), *Barrage* (no. 1741).

18 J. Rewald, *History of Impressionism*, 4th rev. English edn, 1973, pp. 150–2.

19 Exhibition catalogue, *Monet*, Paris, Grand-Palais, 1980, p. 55, note 4.

20 Letter from Duret to Pissarro, 15 February 1874, Fondation Custodia, Institut Néerlandais, Paris.

21 Letter from Pissarro to Duret, 5 July 1873, *Correspondance*, p. 80.

22 Tanguy appeared for the first time in the Didot-Bottin directory with the entry 'couleurs fines 14 rue Clauzel' in 1874.

23 Four paintings, nos XXXVI, XLVI, XCVI in 1873 and CXXI in 1874.

24 Record of purchases 1868–73, no. 806, *Effet de neige*, one of the first two paintings bought by Durand-Ruel in June 1871, and bought by Faure on 15 April 1872; no. 1761, *Route d'Osny près Pontoise* was bought through Hourquebie on 17 April 1873; no. 2726, *Palais Royal à l'Ermitage, Pontoise* was bought on 25 March 1873. Quite quickly Faure started to avoid buying through Durand-Ruel and bought directly from the artist. For Faure, see A. Callen, 'Faure and Manet', *Gazette des Beaux-Arts*, vol. LXXXIII, March 1974, pp. 157–78.

25 See the sale catalogue *Archives de Camille Pissarro*, Paris, Hôtel Drouot, 21 November 1975, no. 79, letter from Guillemet to Pissarro, 3 September 1872.

26 Monet persuaded his brother Léon to buy works: ibid., no. 92, letter from Monet to Pissarro, 23 and 25 February 1872.

27 Pissarro was without a doubt in contact with Dr Gachet as early as February 1872 about the illness of one of his children (*Correspondance*, pp. 72 ff). The works by Pissarro that came from Gachet's collection and are now in the Jeu de Paume are: *Bac à la Varenne Saint-Hilaire*, 1864 (P & V 36); *La Route de Louveciennes*, 1872 (P & V 138); *Châtaigners à Louveciennes*, c. 1872 (P & V 146).

28 On 6 December 1873 Duret wrote to Pissarro (Fondation Custodia, Institut Néerlandais, Paris, published by Pissarro and Venturi, p. 26): 'Je me trouve maintenant avec quatre tableaux de vous'; he then requested an exchange. On 15 February 1874 he announced to Pissarro that he had bought 'Un tout petit tableau. C'est un pont avec un bateau sur une rivière. Me voici donc à la tête de cinq tableaux de vous' (ibid.). On his return from Japan, in January 1879, he expressed a desire to buy a large picture. At the sale of the Duret collection (*Vente des tableaux et pastels composant la collection de M. Théodore Duret*, Paris, Galerie Georges Petit, 19 March 1894) there were, however, only four paintings by Pissarro: *Anes au pâturage*, 1862 (P & V 19), bought in December 1873 (see the letter of 6 December quoted above); *Gelée blanche*, 1870 (P & V 83); *Le printemps*, 1873 (P & V 213), acquired at the end of 1873 in exchange for an 1873 *Inondation* bought a short while before from Pissarro (letter from Pissarro to Duret, 2 May 1873, in *Correspondance*, p. 79), now in the Wadsworth Atheneum, Hartford (exhibition catalogue *Pissarro*, Paris, 1981, French edn, repr. no. 23); and lastly a *Rue de village*, 1880 (P & V 521) which may have been the picture he bought on his return from Japan. The fourth picture owned by Duret in 1873 remains unidentified as does the small picture with a bridge and a boat bought in 1874.

29 See the letter from Duret to Pissarro, 9 May 1871 (Fondation Custodia, Institut Néerlandais, Paris) where the address of the friend is given as 'Wine Growers Company'. This suggests that he was in the wine business rather than a journalist and novelist, as J. Bailly-Herzberg seems to think (*Correspondance*, p. 66, note 1). It is possible that this Berthet is the Berthet known to have been the first owner of the *Route de Upper Norwood* (P & V 114), dated 1871.

30 Letter from Duret to Pissarro, 16 June 1871 (Fondation Custodia, Institut Néerlandais, Paris).

31 The account book of Albert Hecht was given by Mme Trenel-Pontremoli to the Musée d'Orsay in 1981; see A. Distel, 'Albert Hecht, collectionneur (1842–1889)', *Bulletin de la Société de l'Histoire de l'Art Français*, 1981 (1983), pp. 269–74.

32 Bodelsen, op. cit., p. 340.

33 R. Bonniot, *Gustave Courbet en Saintonge*, Paris, 1973.

34 Letter dated 'Saturday 19th' (Fondation Custodia, Institut Néerlandais, Paris) which could be October 1872 or April or July 1873. Pissarro also wrote to Dr Gachet on 28 October 1873, 'Duret accompagné de Baudry sont venus m'acheter des tableaux' (*Correspondance*, p. 83).

35 Probably P & V 266, dated twice, 1873 and 1874 (USA, Phillips collection).

Cézanne found the picture very striking (see the letter from Cézanne to Pissarro, 24 June 1874, in *Paul Cézanne, Correspondance*, ed. John Rewald, Paris, 1937, XXXI, pp. 119–22). Pissarro and Venturi quote a letter sent to Baudry by a certain L. Panis whom they believe to have owned the work; however, it seems quite possible from the letter that he only saw the work. Panis may have been the 'homme de lettres administrateur du *Rappel'* who is listed in the Didot-Bottin directory as early as 1870. Panis is also mentioned as a potential collector in a letter from Duret to Pissarro of 2 June 1874 (Fondation Custodia, Institut Néerlandais, Paris).

36 Letter of 2 June 1874 mentioned in note 35.

37 Letter from Baudry to Pissarro, 17 December 1873, sale catalogue, *Archives de Camille Pissarro*, Paris, Hôtel Drouot, 21 November 1975, no. 5, acquired by the Musée Pissarro in Pontoise.

38 Letter from Baudry to Pissarro, 22 August 1874, same lot as the letter mentioned in note 37.

39 Letter mentioned in note 35, published by Pissarro and Venturi, on p. 34.

Chapter 6

Camille Pissarro and Rouen

Christopher Lloyd

Of the many topics broached in the letters of Camille Pissarro to his eldest son, Lucien, few are as sustained as his references to the city of Rouen. The passages occur in letters written in the autumn of 1883, the early winter and late summer of 1896, and the late summer of 1898. One comment in particular is especially striking and of great significance for the arguments advanced here. This is the comparison of Rouen with Venice. On 2 October 1896 Pissarro writes 'C'est beau comme Venise ... c'est d'un caractère extraordinaire et vraiment c'est beau!'[1] This is the key to Pissarro's fascination with the city of Rouen. It helps to explain why he depicted Rouen so frequently not only in his paintings, but also in his drawings and prints. It also helps to explain why so many of his written opinions on art are contained in letters penned while in Rouen under the spell of its motifs. In short, for Pissarro Rouen possessed a potency that Venice had once exerted, and indeed continues to exert, on the European consciousness. In both cities there was a similar contrast between the past and the present, symbolised by the historic architecture and a modern working port: there was a similar magic in the effects derived from the aesthetic relationship between the buildings and the water – in Rouen the Seine and in Venice the lagoon or the canals. It should also be remembered that the two artists most on Pissarro's mind while working in Rouen were, on the basis of his letters, J. M. W. Turner and Claude, both painters of harbours, ships and ports. Above all else, Rouen and Venice had well-established topographical traditions that could be readily exploited. The statement, therefore, that Rouen is as beautiful as Venice is not quite as hyperbolical as it might at first sound. It helps us to understand why Pissarro reacted so earnestly to the city and it also establishes for us the spirit in which he embraced it.

The topographical tradition of Rouen, which Pissarro developed, falls into two broad categories. The first, to which Pissarro, in fact, makes direct references in his letters, may be termed the antiquarian. This is the tradition enshrined in Baron Taylor's *Voyages pittoresques et romantiques dans l'ancienne France*, which had three volumes devoted to *Ancienne Normandie* (1820, 1825, 1878), and was also purveyed by local historians such as A.F. Gilbert or the

prolific Jules Adeline.[2] It is, of course, with Baron Taylor's *Voyages pittoresques* that the much-respected Bonington is associated, executing lithographs of the Rue Grosse-Horloge in Rouen (plate 35) and of the large church of SS. Gervais and Protais in Gisors amongst others.[3] Pissarro, too, responded to the 'motifs pittoresques'[4] that he found in Rouen and Gisors. Interestingly, he also gave expression to them almost solely in the traditional form of prints (plate 36). The artist notes in his letters the changes in the Rue Grosse-Horloge since the publication of Bonington's lithograph,[5] and later, when contemplating making a print of the Rue Saint-Romain, Pissarro states, 'J'ai commencé quelques de vieilles rues que l'on fait disparaître...'[6] This attitude, together with his admiration for the architecture and the famous late Gothic wooden sculptures that adorn the exteriors of so many of the houses, places Pissarro firmly in the antiquarian tradition, as can be seen specifically in one of the studies made in the sketchbook he used while engaged in his first close examination of the city in 1883.[7] Rouen more than any other French city made Pissarro aware of the heritage of French medieval art and prompted him to compare old masters like Rembrandt, as well as contemporaries like Degas, with Gothic artists.[8]

Every visitor to Rouen responded to the old houses and streets that characterised the city. The English were particularly loquacious on the subject. Dawson Turner, the antiquarian and patron of John Sell Cotman, wrote in his *Account of a Tour in Normandy* (London, 1820), 'The streets are gloomy, narrow, and crooked, and the houses at once mean and lofty.... Most of them ... are merely of lath and plaster, the timbers uncovered and painted red or black, the plaster frequently coated with small grey slates laid one over another.... Their general form is very tall and very narrow, which adds to the singularity of their appearance....'[9] The description of the bibliophile the Rev. Thomas Frognall Dibdin in his famous *Bibliographical Antiquarian and Picturesque Tour in France and Germany* (London, 1821) is even more boisterous. He describes what he terms the 'penetralia' of Rouen as follows, 'What narrow streets, what overhanging houses, what bizarre, capricious ornaments – what a mixture of modern with ancient art – what fragments or rather ruins, of old delicately-built Gothic churches'[10] and he continues, 'The narrowness and gloom of these streets, together with the bold and overwhelming projections of the upper stories and roofs, afford a striking contrast with the animated scene upon the quays: – where the sun shines with full freedom, as it were, and where the glittering streamers, at innumerable mast-heads, denote the wealth and prosperity of the town'.[11] This was a contrast that also, quite independently, struck Pissarro so forcibly several decades later.

Stylistically, Pissarro began his depiction of the streets of Rouen with some wariness. After the innovations and subtleties of the prints dating from the late 1870s, the hesitancy with which he approaches these overtly topographical subjects is somewhat surprising at first.[12] It is as though the reputations of Bonington, James Duffield Harding and Samuel Prout – leading topographical artists whose work was widely circulated in *Landscape Annuals* – seems to have given Camille Pissarro pause. Soon, however, there

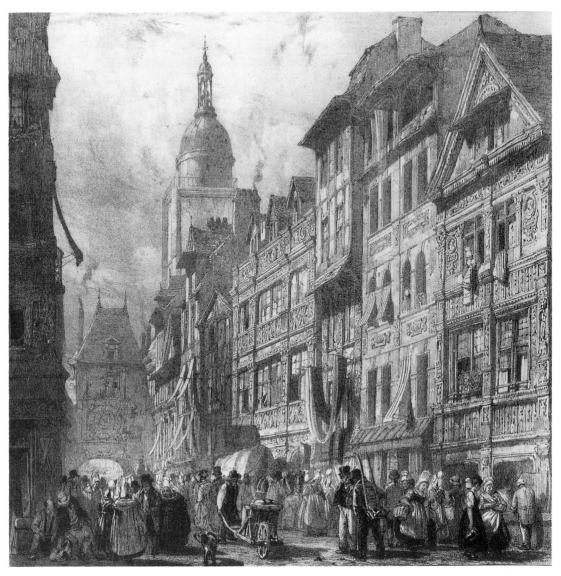

35 Richard Parkes Bonington, *Rue Grosse-Horloge, Rouen,* lithograph, 1824. Oxford, Bodleian Library

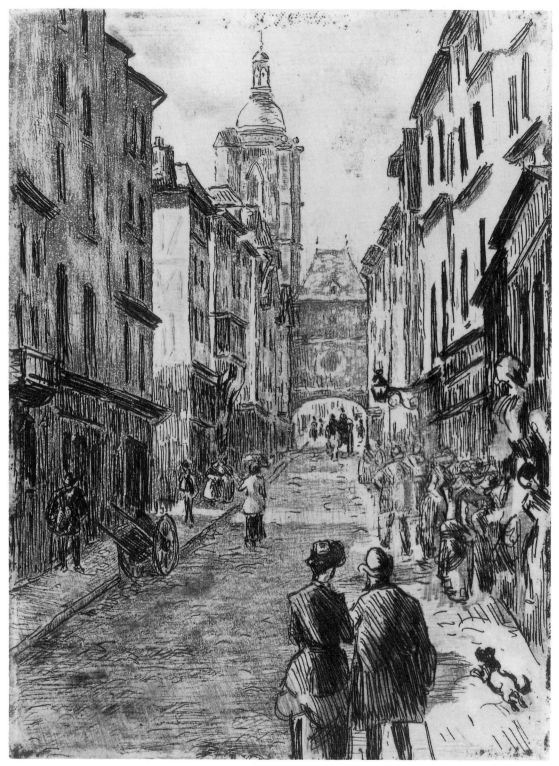

36 *Rue Grosse-Horloge, Rouen,* etching, 1883–4, D 54, 19.2 by 14.7 cm. Oxford, Ashmolean Museum

is a greater confidence in the mingling of line and tone as Pissarro begins to find his own style appropriate for such subject matter.[13] The attractions of the streets of Rouen were not exhausted during the second half of the 1880s when Pissarro made several prints retrospectively, and, indeed, they persisted during the 1890s when he also produced several lithographs, including some of streets not previously represented.[14] The change in medium is significant. It is as though Pissarro had advanced to the stage where he could challenge the topographical tradition of *Voyages pittoresques* on its own ground, and, by choosing several streets that had not been depicted before in that source, extend its boundaries.

The second category of the topographical tradition of Rouen is a broader and more pictorial one. It principally concerns the river Seine, Rouen being placed halfway between Paris and Le Havre. The city, therefore, forms part of a wider panorama. A guidebook of 1830 encouraged its travellers as follows: 'It has been generally remarked by persons coming to Paris by Dieppe or Havre and Rouen, that did travellers know the beauty of this route few indeed would come by way of Calais. . . . It is impossible to form an idea of the beauty of the scene on sailing in the steam packets from Havre to Rouen: from the winding course of the river the views are continually changing. . . .'[15] One artist dominates this particular topographical tradition, namely J. M. W. Turner, whose views of the Seine reverberate through the guidebooks and later accounts of Normandy following the publication of the engravings after his watercolours in *Turner's Annual Tour – The Seine* (London, 1834). Pissarro, in addition, almost certainly knew of Turner's watercolours of Rouen cathedral seen from the Cours-la-Reine, now in the British Museum,[16] which, perhaps also inspired by Monet, was the subject of two of Pissarro's own paintings of 1883 and of two of his prints dating from the mid-1880s.[17] 'C'est curieux que Turner ait choisi juste ce motif, du reste c'est ainsi à Rouen, on touche aux mêmes endroits', he wrote on 20 November 1883.[18]

There were two spectacular views of Rouen that formed part of this particular topographical strand. As Dibdin wrote in his *Bibliographical Antiquarian and Picturesque Tour*, 'The locality of Rouen renders it necessarily picturesque, view it from what station you will.'[19] The first spectacular view was to the north-east of the city from Bon-Secours on the Côte Sainte-Catherine (plate 37). John Sell Cotman,[20] Turner,[21] Théodore Rousseau,[22] Bonington,[23] as well as a host of other artists made admirable records of this view, often in the form of engravings,[24] whilst Pissarro limited himself to a single deftly executed drawing made in 1883.[25] As far as we know, he did not develop this further. The second spectacular view is from the other side of the city from the village of Canteleu to the north-west. This is the village known to Turner,[26] once again, as well as to Corot.[27] It was visited by Pissarro, Monet and Durand-Ruel together in October 1883: 'Nous avons été par une journée superbe, à Canteleu, un village aux environs de Déville, sur une haute colline, nous avons vu le paysage le plus splendide qu'un peintre puisse rêver, la vue de Rouen, dans le lointain, avec la Seine se déroulant calme comme une glace, des côteaux ensoleillés, des premiers plans splendides, c'était féerique.'[28]

Although Monet did paint the view from the Côte Sainte-Catherine in 1892,[29] Pissarro significantly painted neither of these famous panoramic views, regardless of his declared intention to do so. What is more, while using the language of the guidebook Pissarro seems, none the less, to have disregarded this particular strand of the topographical tradition.

It was, however, not a total rejection, because during the middle decades of the nineteenth century modern methods of travel had imposed themselves upon the Seine giving a totally different character to the river that was of special significance for Impressionism – namely trains and steamers. As the anonymous author of a *Voyage de Rouen au Havre sur la Seine en bateau à vapeur par un Rouennais* (Rouen, 1844) put it, 'L'application des machines à vapeur à la navigation est, de toutes les inventions des mécaniciens modernes, celle qui, dans certains contrées, en Amerique par exemple, semble devoir donner les plus importants résultats'.[30] It took a steamer about nine or ten hours to sail from Le Havre to Rouen and a further thirteen hours or longer from Rouen to Paris, the latter being a service only opened in 1836.[31] A service was operated between the months of April and November. By contrast, trains offered a much more varied service. The trip from Paris to Le Havre took between four and five hours by express train, six hours by direct train and seven or eight hours by slow train.[32] These facilities are extolled shortly after their introduction in a fascinating book entitled *La Normandie* (Paris, 1844). The author was the novelist and critic Jules Janin. He provides an illustrated historical account of Normandy written in a purely romantic historical vein. The final chapter is devoted to a journey down the Seine from Paris to Rouen that could now be undertaken at this date either by boat or train (plate 38). In fact, Janin's account was inspired by the opening of the railway line between Paris and Rouen in May 1843. The imagery of many of the vignettes, like Daubigny's *Le Voyage en Bateau* of 1862, has a striking relevance for Impressionist art, so much so that many of the river scenes painted by Monet and Pissarro surely bear a certain relationship to this last glimmering of the romantic topographical tradition, whether it be Monet's trains shooting across the bridge at Argenteuil,[33] or Pissarro's steamers chugging up river.[34] A remarkably impassioned passage in Janin's text runs: 'A deux lieues de Rouen, au petit bourg d'Oissel, se rencontre un des plus beaux travaux du chemin de fer, tant il est vrai qu'à certaine élévation l'industrie devient tant la poésie. Le fleuve est franchi sur un pont d'une rare hardiesse. Là, plus d'une fois, et au même instant, vous sont apparus réunis sur le même point, dans toutes les diverses façons du voyage: la chaise de poste enveloppée dans sa rapide poussière; le cheval du paysan normand, cheval normand comme son maître, et qui ne comprend pas qu'on aille plus vite que le petit trot.... La calèche du château voisin, pleine d'enfants jaseurs; la charette qui ramène la fermière du marché; le cheval de halage qui traine le bateau; la barque à voile poussée par le vent; le canot à la rame; la *galiote*, ce navire fabuleux à l'usage de la norrices de la Normandie; le bateau à vapeur qui mêle sa fumée à la fumée du chemin de fer; enfin l'homme heureux qui obéit à sa fantaisie, qui s'empare à lui seul de tous les rêves, de tous les paysages, de tous les monuments, de toutes les

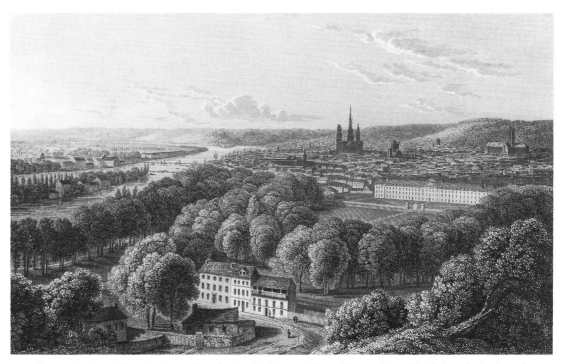

37 Engraving by C. Heath after a drawing by R. Batty, *View of Rouen from Côte Sainte-Catherine*, 1820. Oxford, Ashmolean Museum

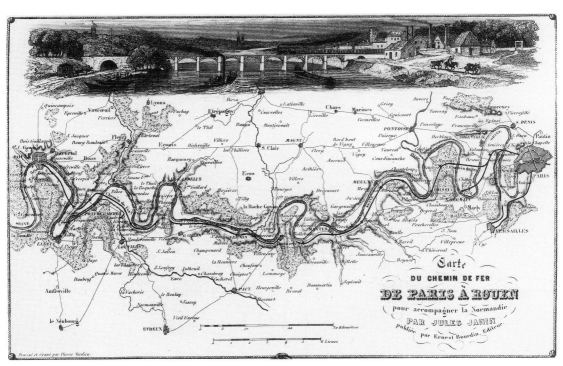

38 Map from J. Janin, *La Normandie* (1844), Oxford, Bodleian Library

39　Vignette from J. Janin, *La Normandie* (1844), p. 504. Oxford, Bodleian Library

40　Vignette from J. Janin, *La Normandie* (1844), p. 554. Oxford, Bodleian Library

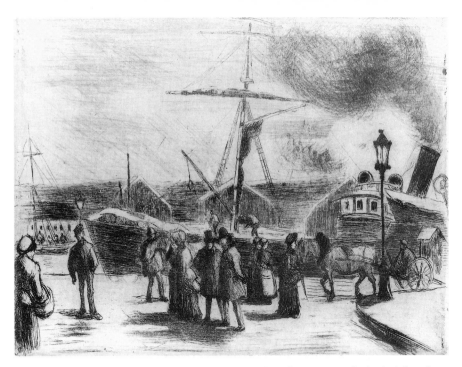

41 *Cours Boieldieu, à Rouen,* etching, 1883, D 46, 15 by 19.5 cm. Oxford, Ashmolean Museum

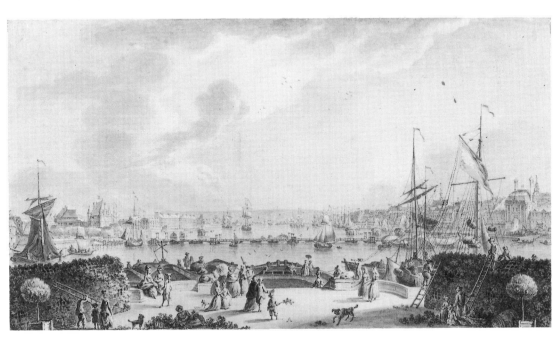

42 Attributed to N.-M. Ozanne, *View of Rouen from L'Ile Lacroix,* watercolour, 1766, Oxford, Ashmolean Museum (Sutherland collection C IV* 474)

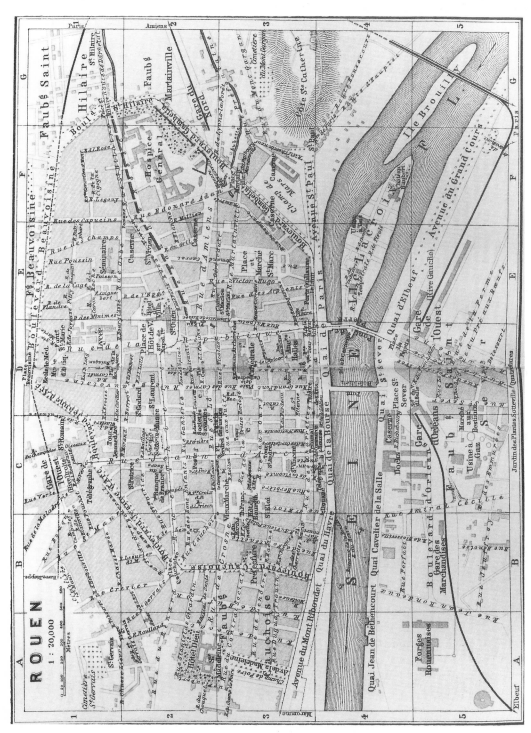

43 Map of Rouen from a Baedeker guide of 1889

joies du chemin, le poète, le rêveur, le seul homme sage, non pas des grandes routes, mais des sentiers détournés, le seul voyageur qui soit véritablement digne d'envie, l'homme qui voyage à pied.'[35] Such passages are not isolated in this type of literature, but this example does reveal, rather vividly, the adjustments that resulted from the introduction of mechanised forms of transport and the attempt to come to terms with the intrusion of modern elements in the landscape, a subject that underpins Pissarro's own work when it is taken as a whole. Of still greater interest are the illustrations to Janin, many of them in the form of vignettes (plates 39–40). One of these (plate 40) shows a steamer alongside a quay at Rouen and it is in several respects comparable with the etchings by Pissarro of the Cours Boieldieu (plate 41).[36] Of this second topographical strand, therefore, it is the genre-like scenes that were explored by Pissarro, as opposed to the set-pieces enshrined in the traditional panoramic views, although both were incorporated in Janin's book. These then are the two traditions to which Camille Pissarro was heir when he began in 1883 to examine Rouen closely for himself and which reach a *summa* in the wood-engravings made by Auguste Lepère for *L'Illustration* published in two parts on 4 and 11 July 1896,[37] that is the very year that Pissarro returned to the city for his second protracted visit.

What kind of a city had Rouen become by the closing decades of the nineteenth century? Certainly it had changed since its prominent role in Anglo-French history during the Middle Ages. Similarly, the semi-rural flavour epitomised by the Cours-la-Reine, which is caught by so many artists,[38] or the elegant appearance of the Ile Lacroix in the eighteenth century,[39] had disappeared (plate 42). Now the city had become extensively industrialised, as the map in the Baedeker of 1889[40] shows very clearly (plate 43). The concentration of medieval streets, churches, buildings, and markets lies around the cathedral on the north side of the Seine. Because of this particular focus, the boulevards, following the old fortified earthworks, circle the outside of the city, like the *viali* of a modern Italian town. As Dawson Turner wrote in his *Account of a Tour in Normandy*, 'The *boulevards* of Rouen are rather deficient in the Parisian accompaniments of dancing dogs and music grinders, but the sober pedestrian will, perhaps, prefer them to their namesakes in the capital. Here they are not, as at Paris, in the centre of the town, but they surround it, except upon the quay with which they unite at each end....'[41] These *quais* formed the main artery of the city leading on the west and east sides to the famous panoramas already referred to overlooking Rouen. It is on the *quais* that the two hotels used by Pissarro for his visits during the 1890s were situated: Hôtel de Paris at 51 Quai de Paris and Hôtel de l'Angleterre on the Cours Boieldieu, in the very places where the city had been most drastically transformed.[42] The *Guide Joanne* of 1893 states that the Cours Boieldieu is 'La promenade la plus fréquentée ... offre un beau point de vue sur les quais, le fleuve et une partie du faubourg Saint-Sever. Il est bordé de plusieurs beaux cafés et restaurants, et la musique militaire s'y fait entendre deux fois par semaine (jeudi et dimanche).'[43] Apart from the rebuilding of the *quais* Rouen was transformed by its increasing importance as a port, which led to the

development of the islands in the Seine at that point (Lacroix and Brouilly) and the faubourg of Saint-Sever. This area to the south of the river was fully industrialised and joined to the older part of the city by the two bridges that appear so often in Pissarro's work – the Pont Corneille made of stone opened in 1829, and the Pont Boieldieu, or Grand Pont, made of iron opened in 1887. The Pont Boieldieu replaced the famous bridge of boats, dating from the seventeenth century, which was so often discussed in the early guidebooks and is frequently shown in views of the city up to and including those of J. M. W. Turner.[44] Throughout history the main industry of Rouen and its surrounding districts had been connected with cloth. There was a preponderance of mills for the treatment of cotton – spinning, tanning, fulling, dyeing.[45] The finished products were sold in the medieval market known as the Anciennes Halles. This industry had begun to be overtaken by the growing importance of the docks, particularly during the second half of the nineteenth century. According to the *Guide Joanne* by the 1890s the docks handled 5,000 ships per annum carrying $1\frac{1}{2}$ million tons of cargo, no doubt as a result of its obvious geographical importance for Paris.[46] This process of industrialisation within the heart of the city, rather than the social conveniences of the Cours-la-Reine or the Cours Boieldieu, is what Pissarro chose to paint so frequently after 1883.[47]

Yet, as so often with Pissarro, he was careful to balance out these factors in both his paintings and his prints, so that the old medieval streets are contrasted with the latest developments in the city. It is again characteristic of the artist that what he omits is as important as what he includes. There is, for instance, one very obvious exclusion and that is the west front of the cathedral, which Cotman,[48] Turner,[49] Lhermitte[50] and Monet,[51] as well as numerous guidebooks, all exploited in widely differing ways. Pissarro avoids this, preferring to show the cathedral from over the rooftops,[52] or allowing it to hover in the background at the end of a street.[53] In the second case, involving the Rue de l'Epicerie, when one would perhaps expect Pissarro to emphasise the medieval elements, he tends to play them down. Where Samuel Prout's or Captain Robert Batty's pencils[54] positively wobble with a feeling of antiquity (plate 44), Pissarro himself, poised under a fifteenth-century structure, the Tour de la Fierté de Saint Romain,[55] does not allow the weight of history to affect his composition (plate 45). Rather, the wooden beams firmly support the houses and they do not give the appearance of collapsing, while at the end the Portail de Calende, the south portal of the cathedral, is hidden from view. Maximilien Luce adopted a similar approach to the streets of Paris, as well as to the church at Gisors.[56] The letters written from Rouen during the 1890s provide further evidence of Pissarro revelling in the modern elements of the city. For example, he wrote in a famous passage in a letter of 26 February 1896, 'J'ai des effets de brouillard et de brume, de pluie, soleil couchant, temps gris, les motifs des ponts coupés de différentes manières, des quais avec bateaux; mais ce qui m'intéresse particulièrement est un motif du pont de fer par un temps mouillé, avec tout un grand trafic de voitures, piétons, travailleurs sur les quais, bateaux, fumée, brume dans les lointains,

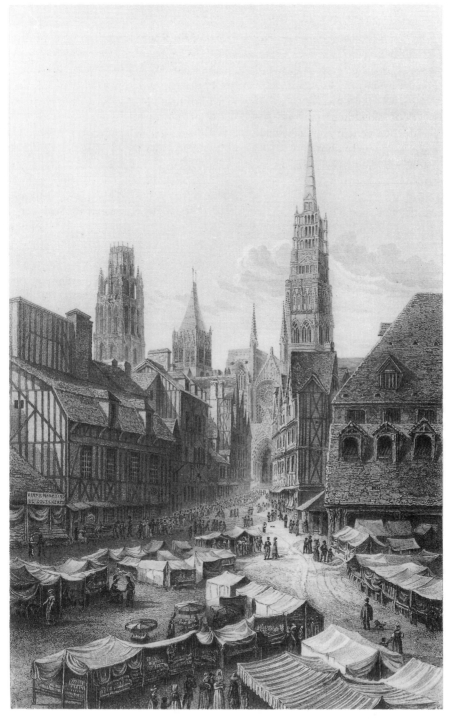

44 Engraving by E. Finden after a drawing by R. Batty, *Rue de l'Epicerie, Rouen,*
1820. Oxford, Ashmolean Museum

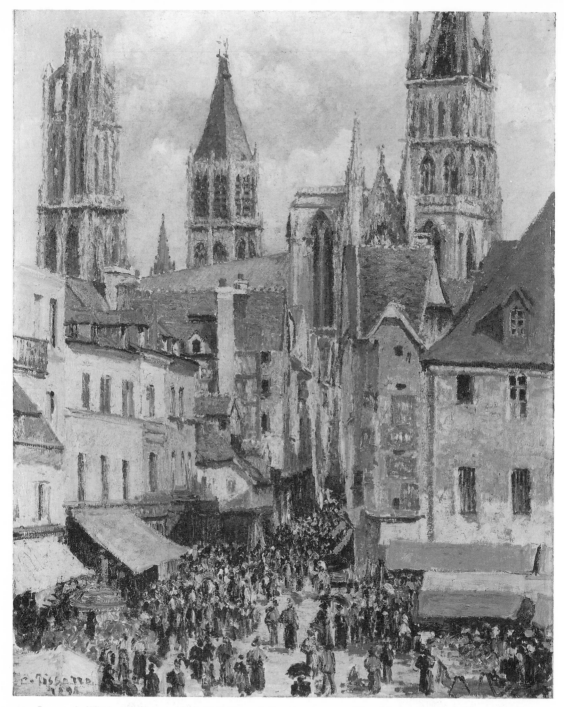

45 *La rue de l'Épicerie, Rouen,* 1898, P & V 1036, 81.3 by 65.1 cm. New York, The Metropolitan Museum of Art, purchase, Mr and Mrs Richard J. Bernhard gift, 1960

46 *Matin brumeux, Rouen,* 1896, P & V 960, 57.1 by 73.5 cm. Glasgow, Hunterian
Museum (University of Glasgow), W. A. Cargill collection

47 Eugène Boudin, *La Seine à Rouen,* 1895. Buffalo, New York, Albright–Knox Art
Gallery, gift of Mr and Mrs Alfred G. Lewis in memory of Mr and Mrs George Howard
Lewis, 1943

très vivant et très mouvementé'[57] and again on 2 October 1896, 'figure-toi, de ma fenêtre, le quartier neuf de Saint Sever, juste en face, avec l'affreuse gare d'Orléans toute neuve et brillante, et un tas de cheminées, d'énormes et de toutes petites avec leur panache. Au premier plan, des bateaux et l'eau, à gauche de la gare le quartier ouvrier qui court tout le long des quais jusqu'au pont de fer, le pont Boieldieu'.[58] It was these scenes which had begun to interest Pissarro in 1883,[59] and that he exploited to the full in 1896[60] and 1898.[61] A comparison of any of Pissarro's depictions of the *quais* (plate 46) with a painting such as that by Boudin entitled *La Seine à Rouen*,[62] of 1895 (plate 47), emphasises the singularity of Pissarro's interest in the city. Where Boudin sets his view of the Seine against the traditional picturesque background of Mont Sainte-Catherine, Pissarro frequently chooses views in the other direction, literally ignoring such well-known motifs. While Boudin does not omit the industrial elements, he does not embrace them as Pissarro does, or make them the principal subject of his painting.

In conclusion one must ask, what role did Rouen play in Pissarro's development? The answer is brief: it served as a catalyst. Having concentrated upon landscape during the 1870s and the human figure during the early 1880s, the visit to Rouen in 1883 came at a critical time. It reawakened Pissarro's interest in topography and in caricature, both features of his art that were omnipresent, but which were not, until this important year, brought to the fore. It has been shown that Pissarro's initial response to Rouen was expressed mainly in prints – the traditional way of depicting the city. It was only in the 1890s that he started to paint the city in earnest. Significantly, this coincided with his selection of more radical subject-matter, centred on the activities of the port, resulting in what can only be described as the most extensive and elaborate representation of an industrialised city in the history of Impressionism and Post-Impressionism, an examination which was to a certain extent continued in Dieppe and Le Havre. An explanation for this fascination with Rouen may lie in the fact that Pissarro saw the city as a larger form of Pontoise, which had a similar combination, although on a much more limited scale, of medieval buildings and an inland port. In any case, where Paris had so far failed to impress Pissarro as a city, Rouen succeeded, so that with the adoption of his late, more impressionistic style during the 1890s it could be said that Rouen re-established Pissarro as a true Impressionist. In addition, the close inspection of Rouen, begun by Pissarro in 1883, probably encouraged him to look for fresh, although dissimilar, motifs in Paris, which were also brought to fruition during the 1890s.

Notes

Since this paper was written in the autumn of 1980, Janine Bailly-Herzberg, the editor of the letters of Camille Pissarro, has also published a study of the artist's visit to Rouen ('Camille Pissarro et Rouen', *L'Oeil*, nos 312–13, July–August 1981, pp. 54–9), which is basically a narrative account incorporating some unpublished documentary material. Inasmuch as the present study concentrates upon the

topography of Rouen and considers Pissarro's selection of motifs, the two articles may be said to complement one another. A visit to Rouen while revising the present article was made possible by an award from the Small Grants Research Fund in the Humanities of the British Academy.

1 *Lettres*, p. 419.
2 A. F. Gilbert, *Description historique des maisons de Rouen,* Paris, 1821. Amongst Adeline's more specialist studies may be mentioned *Description des antiquités ... de Rouen* (1875), *Rouen disparu et Rouen qui s'en va* (1875–6) and *Les Quais de Rouen* (1980).
3 *Ancienne Normandie*, vol. 2 (Paris, 1825), pls 173 and 203 respectively.
4 The phrase is used in a letter of 17 February 1884 (*Correspondance*, p. 285) regarding Gisors.
5 20 November 1883 (*Correspondance*, p. 252).
6 6 February 1896 (*Lettres*, p. 399). Interestingly, in 1900 the Amis des Monuments rouennais enlisted the artist's support to prevent ancient houses being wilfully destroyed (see J. Bailly-Herzberg, 'Camille Pissarro et Rouen', p. 57).
7 Brettell and Lloyd, 158c repr.
8 See letter of 20 October 1896 (*Lettres*, p. 421).
9 Vol. 1, pp. 47–8.
10 Vol. 1, pp. 40–2.
11 Vol. 1, p. 111.
12 D 41–3.
13 D 52–4.
14 D 173–9.
15 *The Traveller's Guide to Rouen* (Paris, 1830), pp. 36–7.
16 A. Wilton, *The Life and Work of J. M. W. Turner* (London, 1979), catalogue of watercolours, 963–5 repr. For reproductions of other watercolours and drawings by Turner of Rouen, see also R. Walter, 'Turner interprète romantique des bords de la Seine', *L'Oeil*, no. 311, June 1981, pp. 32–8 and the exhibition catalogue *Turner en France*, Centre Culturel du Marais, Paris, 7 October 1981–10 January 1982, 18, 32, 106, 131–3.
17 The paintings, both of 1883, are P & V 602–3. The prints are D 49–50. Richard Brettell has pointed out that Monet's general *View of Rouen* (D. Wildenstein, *Claude Monet, biographie et catalogue raisonné*, vol. I, 1840–81, Lausanne-Paris, 1974, 217) was exhibited at Durand-Ruel's in 1883.
18 *Correspondance*, p. 252.
19 Vol. 1, pp. 43–4.
20 M. Rajnai and M. Allthorpe-Guyton, *John Sell Cotman. Drawings of Normandy in Norwich Castle Museum* (Norfolk Museums Service, 1975), 33, pl. 36.
21 Wilton, op. cit., 966; for the engraving, see *Turner's Annual Tour – The Seine* (London, 1834), between pp. 116 and 117.
22 See R. Thomson, *French 19th Century Drawings in the Whitworth Art Gallery* (Manchester, 1981), 73 repr., where reference is made to Corot's painting of the same view (c. 1833–4).
23 M. L. Spencer, *R. P. Bonington 1802–1828* (exhibition catalogue, Nottingham/Norwich/Southampton, 1965) 203, pl. 5.
24 For example R. Batty, *French Scenery from Drawings made in 1819 by Captain Batty of the Grenadier Guards* (London, 1822), 3.
25 Repr. Pissarro exhibition 1980–1, 121.
26 Wilton, op. cit. 1130.
27 A. Robaut, *L'oeuvre de Corot, catalogue raisonné et illustré* vol. III (Paris, 1905), 2032–3 and 3rd supplement, ed. J. Dieterle, Paris, 1974, 45 (exhibited, London, Artemis group, *Corot and Courbet*, 12 June–13 July 1979, 11). A sketchbook used by Corot in Rouen in 1832 is now in the Kunsthalle, Bremen: *Von Delacroix bis*

Maillol, 9 March–13 April 1969, 33-6 repr. The view by Paul Huet in the Musée des Beaux-Arts, Rouen, was rarely depicted. It is from Mont-aux-Malades to the north of the city. For the painting, see M. Nicolle, *Le Musée de Rouen* (Paris, 1920), p. 49 repr. and also P. Rosenberg and F. Bergot, *French Master Drawings from the Rouen Museum. From Caron to Delacroix* (exhibition catalogue, Washington/New York/Minneapolis/Malibu, 1981–2) 52.

28 *Correspondance*, 22 October 1883, p. 243.

29 Wildenstein, op. cit., vol. III (1979), 1314–15.

30 *Voyage de Rouen au Havre*, p. 9.

31 *The Traveller's Guide to Rouen* (see note 15 above), p. 36 and M. Starke, *Travels in Europe*, 9th edn (London, 1839), p. 514,n.l.

32 *Guide Joanne. La Normandie* (Paris, 1893), p. 42.

33 Wildenstein, op. cit., vol. I, 318–19. Still closer to Monet's painting is the vignette of a train crossing a bridge on p. 504 (plate 39).

34 P & V 122.

35 Janin, op. cit., pp. 522–3.

36 The illustration occurs on p. 554.

37 For information and reproductions of these wood-engravings I am indebted to Jacquelynn Baas Slee formerly of The University of Michigan Museum of Art, whose thesis subject is entitled 'Auguste Lepère and the Artistic Revival of the Woodcut in France, 1875–1895'. Slee has established that the preparatory work for Lepère's prints of Rouen was done in 1888 (see A. Lotz-Brissonneau, *L'Oeuvre gravé de Auguste Lepère*, Paris, 1905, 166–77 and C. Saunier, *Auguste Lepère*, Paris, 1931, pp. 59–63).

38 For example, the watercolour by Bonington reproduced, but strangely entitled, in Spencer, op. cit., 259, pl. 27, or the etching by Jules Adeline for his portfolio *Rouen disparu et Rouen qui s'en va* (Rouen, 1875–6), kindly brought to my attention by Rafael Fernandez. For a view in the opposite direction, see the etching in Dawson Turner, op. cit., vol. 1 between pp. 50 and 51.

39 Watercolour drawing probably by Nicolas-Marie Ozanne in The Ashmolean Museum, Oxford (Sutherland collection C IV* 474) presumably drawn in connection with *Les Ports de France*, Paris, 1766. A similar view was engraved, but not from this drawing for *Vues des principaux ports et rades du royaume de France . . .* (Paris, 1819). The most distinguished panoramic view of the city drawn in the eighteenth century is that of 1777 by Charles-Nicolas Cochin (see Rosenberg and Bergot, op. cit., 17 repr.).

40 K. Baedeker, *Paris and its Environs with Routes from London to Paris* (Leipzig and London, 1894), between pp. 366 and 367. The same map also occurs in Baedeker's volumes on Northern France.

41 Vol. 1, p. 50.

42 For views of the *quais* at the beginning of the nineteenth century, see the watercolours by Bonington repr. The Hon. A. Shirley, *Bonington* (London, 1940), pls 13, 58 and 101, or the drawing by Cotman, for which see Rajnai and Allthorpe-Guyton, op. cit., 35, pl. 37.

43 *Guide Joanne*, p. 38.

44 A detailed drawing of the bridge of boats, however, was made by Cotman, repr. Rajnai and Allthorpe-Guyton, op. cit., 34, pl. 38.

45 Details may be found in *The Traveller's Guide to Rouen* (see note 15 above) p. 8. The dyeing industry gave Rouen some peculiar characteristics which were observed by both Dibdin and Dawson Turner. Dibdin (op. cit., vol. 1, p. 114) writes, 'He who wishes to be astonished by the singularity of a scene, connected with *trade*, should walk leisurely down the Rue de Robec. It is surely the oddest, and, as some may think, the most repulsive scene imaginable. . . . Here live the *dyers of clothes* – and in the middle of the street rushes the precipitous stream, called *L'Eau de Robec* – receiving colours of all hues. Today it is nearly jet black:

tomorrow it is bright scarlet: a third day it is blue, and a fourth day it is yellow! . . .'
Dawson Turner (op. cit., vol. I, p. 204) also observed this phenomenon stating
'that it is this circumstance which has given rise to the saying, that Rouen is a
wonderful place, for "that it has a river with three hundred bridges, and whose
waters change their colour ten times a day"'. Interestingly, Monet, of whom one
thinks automatically in this context, did paint this subject (Wildenstein, op. cit.,
vol. I, 206). Also see Lepère's wood-engraving in *L'Illustration*, 4 July 1896, p. 10.

46 *Guide Joanne*, p. 39.
47 Of the forty-five or so paintings of Rouen dating from 1896 and 1898 (see notes
60–1 below) only three (P & V 1044–6) reveal a lingering interest in the Cours-la-
Reine.
48 See Rajnai and Allthorpe-Guyton, op. cit., 33 at p. 80.
49 See Wilton, op. cit., catalogue of watercolours, 965.
50 Reproduced in F. Henriet, *Les Eaux-fortes de Léon Lhermitte* (Paris, 1905), p. 85,
41 between pp. 44 and 45.
51 See, principally, G. H. Hamilton, *Claude Monet's Paintings of Rouen Cathedral*,
41st Charlton Lecture on Art, Newcastle upon Tyne (Oxford University Press,
1960), where some regard is taken of the topographical tradition. Pissarro had
seen the exhibition of Monet's series of the west front of the cathedral at Durand-
Ruel's in May 1895 (*Lettres*, 11 and 26 May, 1 June 1895 and 17 March 1896,
pp. 380–2 and 402 respectively).
52 P & V 947 and 973.
53 P & V 1036–8.
54 The pencil drawing by Prout is in The Ashmolean Museum, Oxford (repr. Brettell
and Lloyd, p. 35) and see Batty, op. cit., pl. 4.
55 Reproduced by Lepère for *L'Illustration*, 4 July 1896, p. 8 and also the subject of
a drawing by John Skinner Prout, nephew of Samuel, in The Ashmolean Museum,
Oxford. Monet had painted the Rue de l'Epicerie from the same viewpoint in 1892
(Wildenstein, op. cit., vol. III, 1316).
56 Compare the paintings *La Rue Mouffetard* (c. 1890) in Indianapolis Museum of Art
(repr. A. F. Janson and A. I. Fraser, *100 Masterpieces of Painting, Indianapolis
Museum of Art*, Indianapolis, 1980, p. 193) and *SS. Gervais and Protais Gisors*, of
1898, in The Dixon Gallery and Gardens, Memphis (repr. M. Milkovich, *Paintings
and Sculpture* vol. I, Memphis, 1977, 24).
57 *Lettres*, p. 400. The passage should be compared with Julie Manet's eye-witness
account of Camille Pissarro painting in Rouen first kindly drawn to my attention
by Anne Distel (*Journal 1893–1899. Sa Jeunesse parmi les peintres impressionnistes
et les hommes de lettres*, Paris, 1980, pp. 104 and 107–8).
58 *Lettres*, p. 419.
59 P & V 601, 604–12, whereas P & V 602–3 and 613 may be described as coming to
terms with the more traditional motifs of Rouen.
60 P & V 946–73.
61 P & V 1036–54.
62 Buffalo, Albright-Knox Art Gallery (see S. A. Nash, *Painting and Sculpture from
Antiquity to 1942*, Buffalo, 1979, p. 268 repr). Boudin was perhaps emulating
Monet's earlier approach to the port of Rouen (see Wildenstein, op. cit., vol. I,
208–12, 217–18).

Chapter 7

Some notes on Pissarro and Symbolism

Françoise Cachin

The following remarks could equally well have been entitled 'The cabbage and the lily'. During the Symbolist period, the 1880s and 1890s, there were plants that were profane and others that were sacred; there were animals that were commonplace and others that were endowed with a musical or literary mystique. From Wagner to Mallarmé, from Maeterlinck to Khnopff or Maurice Denis, plants and animals invariably offered emblematic meanings. Swans, thistles, unicorns, panthers, irises and lilies were everywhere. Now, in French, unfortunately, one says something is pure as a lily, but silly as a cabbage, beautiful as a swan but silly as a goose. And Pissarro, who was pure but certainly not silly, was, for the critics of his time, a painter of cabbages and geese.

In the last twenty years of the century, Pissarro more than anyone personified elementary Impressionism – precisely that which Symbolist critics and artists found unacceptably prosaic. There were two things wrong with Pissarro: first, his naturalistic motifs were put together without any stage effects, since he was more concerned with unity and the reality of everyday life than with emphasis; secondly, like the other Impressionists, he chose to render what appeared to be an immediate visual sensation. A form of pantheistic 'hereafter' could be found in nature as seen by Monet or by Renoir; but in Pissarro's work, despite all the efforts of well-meaning critics such as Huysmans and Albert Aurier, to present his landscapes as the expression of the fecundity of the earth, his paintings and his intentions both failed to accommodate such an interpretation. He repeated and wrote throughout his life that the art he abhorred most of all was 'literary' or 'sentimental' painting.

In 1886 an avant-garde publication called *Le Petit Bottin des lettres et des arts* appeared for the first time. Its authors were Paul Adam, Félix Fénéon, O. Méténier and Jean Moréas, the last of whom had published the *Manifeste du Symbolisme* in the very same year. In this directory Pissarro received the label; 'Impressionist market-gardener, specializing in cabbages'. But before 1886, curiously, there were in fact remarkably few cabbages in Pissarro's

Translated by Joachim Pissarro and Roger Mills

painting! I have been able to count only four pictures where the critics might have discovered any cabbages. First, *L'Hermitage à Pontoise* of the Wallraf-Richartz Museum in Cologne, painted in 1867 (P & V 56); then *Le champ de choux à Pontoise*, 1873 (P & V 230); *Le jardin potager*, 1878, bought by the critic Diego Martelli and today in the Galleria d'Arte Moderna in Florence (P & V 451); and lastly *Les paysannes bêchant* (probably cabbages!), dated 1881 (P & V 534): these girls might actually be digging up lettuces. In any case, only four pictures out of over 500 contain cabbages.

Nevertheless, a whole series of works executed in Pontoise between 1876 and 1882 were painted along a slope covered with grass near the river Oise, in a hamlet called 'Le Chou' (The Cabbage) owing to the fact that at this time a particular species of cabbage was grown in the surroundings of Pontoise. But in the pictures painted by Pissarro at this place I feel I must point out that there is not one single cabbage to be found, either in *La sente de Chou*, 1876, now at the Staechlin Foundation in the Kunstmuseum, Basle, or in the picture with the same title in the Musée de la Chartreuse, Douai, painted in 1878, that was included in the 1981 London exhibition. Nor are any to be seen in P & V 446, 497, 595 and 562 entitled respectively *Le Chou à Pontoise*, *Les carrières du Chou* or *Le Chou* (1882, from Georges Lecomte's collection). Le Chou is merely the name of a hamlet, just like L'Hermitage, Les Grouettes or Les Pouilleux. Are we to understand that critics attend more to titles than to the contents of the pictures themselves? Or that they consider a brief glance at an exhibition and a reading of the catalogue entries a sufficient basis for the writing of articles?

The question is: given the extremely limited number of paintings of cabbages in comparison to Pissarro's constant repetition of his favourite themes (orchards, roads, farmyards, apple-picking, harvests, hillsides, fields), why should the critics have paid such extraordinary attention to that particular vegetable? The cabbage obviously acquired the status of a symbol; cabbages were found by the critic where hitherto there were none. The cabbage had previously been a still-life object with a more or less metaphysical meaning, e.g. in Chardin's fasting meals or as a vegetable hanging in the seventeenth-century Spanish *bodegones*: symbols of very coarse food, the counterpart to images of *vanitas*. But a cabbage in a landscape is nothing but a cabbage. It is the epitome of what was condemned in Pissarro: his decision to depict a landscape that would be neither heroic, nor romantic, nor bucolic, nor even rustic, but a landscape worked by peasants. This is the world of market-gardening, simple and charming, devoid of Courbet's heroism or of Millet's grandeur. 'C'est moi qui suis juif', Pissarro used to say, 'et Millet, Biblique.' However, it is hard to understand why the first critic to stigmatize Pissarro as a painter of cabbages (so rare in his work, except perhaps in his etchings) was Castagnary, the champion of realism. As early as 1878, he criticized Pissarro's 'penchant déplorable pour les cultures maraîchères' and the fact that he did not 'reculer devant aucune représentation de choux, ni de légumes domestiques'. This in 1878, when only one picture of Pissarro's entire oeuvre was guilty of such a charge!

The very same year the same wretched cabbage was waved about like a banner in Duret's defence of Pissarro in his *Les Peintres impressionnistes*, a leaflet that was republished in 1885, precisely in the middle of the upsurge of Symbolism. I shall quote this text at some length, as it juxtaposes two fundamental aspects of Pissarro's art that are sometimes praised, sometimes criticized: his melancholy and his modesty.

> les toiles de Pissarro communiquent au plus haut degré la sensation de l'espace et de la solitude, il s'en dégage une impression de mélancolie.
> Il est vrai qu'on vous dira que Pissarro a commis contre le goût d'impardonnables attentats. Imaginez vous qu'il s'est abaissé à peindre des choux et des salades, je crois même aussi des artichauts. . . . Or, pour les partisans du 'grand art', il y a dans un pareil fait, quelque chose de dégradant, d'attentatoire à la dignité de la peinture, quelque chose qui montre dans l'artiste des goûts vulgaires, un oubli complet de l'idéal, un manque absolu d'aspirations élévées, et patati, et patata.

Not much later, perhaps out of a sense of pique at the totally unfounded suggestion of cabbages in his work, Pissarro became genuinely interested in the subject and in 1883 he started painting in gouache and in oils a series of peasants sorting cabbages. One of these (P & V 617) was started in 1883 and then resumed in 1895 at the height of the Paris vogue for Symbolism and Pre-Raphaelitism.

In this particular instance the cabbage is clearly connected with rural work, with the simplest form of peasant life, as it is traditionally regarded as the food of poor land-workers. Yet, on the other hand, it is also very appropriate to the countryside which Pissarro chose to paint, since the area around Pontoise was one which specialized in growing cabbages and leeks.

Had cabbages been a recurrent theme in Pissarro's pictures rather than being found principally in the writings of his critics, a social interpretation of his systematic cabbage-painting would be possible: Pissarro, the reader of Kropotkin, the privileged recorder of peasant activities. Likewise, a sociological interpretation of race could be attempted: Pissarro, the wandering Jew, who chose to find his roots in the traditional vegetable of the French peasantry. Another interpretation would be a Symbolist one: by choosing a symbol of peasant life, real and down-to-earth as it is, Pissarro found a reply, in the middle of the Symbolist era, to the idealistic allegories of lilies, arums and so on. There would probably be an element of truth in all these interpretations, were it not for the fact that Pissarro's cabbages were merely an oft-repeated journalistic tag. Yet one thing remains certain: what Pissarro intended as an antidote to noble and literary subject-matter – his modest kitchen-garden – was seen as a strong, provocative iconographic object, an expression of the naturalism which, in the 1880s, had to be rejected. Hence, probably, this myth of the cabbage. It is amusing to notice that J. K. Huysmans himself refers to the inevitable cabbage in his review of the Indépendants' exhibition of 1881, praising it and depicting its poetry in a contorted sentence typical of his decadent style: 'il y a là une terre grasse que le printemps

travaille, c'est un alleluia de nature, une exubérance de campagne, éparpillant ses tons violents, sonnant en d'éclatantes fanfares de verts clairs soutenues par le vert bleu des choix.'

In the 1890s, when all the avant-garde (the Symbolists themselves, Seurat, even Gauguin the exotic Symbolist deserter from Pissarro's kitchen-garden) were finding Impressionism prosaic and lacking in ideas, Octave Mirbeau published a series of strong if slightly heavy articles entitled 'Des lys! Des lys!', 'Encore des lys!' and 'Botticelli proteste' in which he defended the Impressionists, and Pissarro in particular, and derided the Pre-Raphaelites and their French followers, the 'Rose-Croix' group. Pissarro must have been delighted with these articles by his principal defender at the end of the century, the man who helped him to achieve fame at the end of his life. It was to Mirbeau that Pissarro wrote about the Symbolists in December 1891: 'au fond ils n'aiment peut-être pas les choux par ce qu'il est peu aisé d'en faire un plat succulent.... nos admirables ancêtres les gothiques n'ont pas dédaigné ce légume aussi bien du point de vue de l'art ornemental que de l'art culinier!'

Having thrown back at the Symbolists the Gothic sources with which they themselves claimed affinities, Pissarro wrote to Mirbeau in January 1892 with the ultimate reproach, the reproach of the true poet, for the supporters of idealism in painting, those who favoured the swan against the goose, the lily against the cabbage: 'tous ces gens là sont d'affreux matérialistes qui ne voient que le sujet et n'ont aucune des sensations qui se dégagent d'une oeuvre d'art.'

Chapter 8

Camille Pissarro: city and country in the 1890s

Kathleen Adler

During the 1890s Camille Pissarro painted many views of Paris: views of the Place du Havre and Rue Saint-Lazare seen from the windows of the Hôtel Garnier in 1893 and 1897; a series of paintings of the Boulevard Montmartre and Boulevard des Italiens from the Grand Hôtel de Russie in 1897; and a series of the Avenue de l'Opéra and Place du Théâtre Français seen from the Grand Hôtel du Louvre in 1898.[1]

At a time when his Impressionist colleagues had largely abandoned the subject of urban Paris, Pissarro's reasons for the choice of these motifs must be examined. His recurring eye infection forced him to limit himself to views seen through windows for much of the decade, and he was becoming dissatisfied with the range of subjects provided by Eragny, travelling increasingly and restlessly in search of new motifs.[2] These factors, however, explain neither the number of paintings of Paris nor the choice of the particular areas of the city on which he focused his attention.

The paintings of these series represent the culmination of Pissarro's interest not only in urban scenes as such, but in the distinctive nature of the urban experience and in the fundamental differences between city and country. Pissarro's Paris paintings prior to the 1890s do not draw a sharp distinction between urban and rural life,[3] and neither do the many paintings of the Jardin des Tuileries and the Louvre of 1899 and later. They are cityscapes, while the paintings under discussion are commentaries on urbanism.

In his move away from Montmartre,[4] Pissarro came to focus on the heart of Second Empire Paris, the area of Paris in which the changes wrought during Baron Georges Haussmann's period of office as Préfet of the Seine (1853–69) and the subsequent completion of many of his endeavours were most clearly to be seen. The editor of Haussmann's *Mémoires* commented in 1890: 'For everyone, the Paris of our times is his [Haussmann's] Paris, perhaps even more so than at the time of Empire.'[5] With the completion of the designs, the whole scheme was revealed, in contrast to the excavations and upheavals of Haussmann's own day. As Roger Shattuck observed in *The Banquet Years*, Haussmann's changes to the city 'were more than architectural renovations. Paris now had the space to look at herself and see that she was no longer a

village clustered about a few grandiose palaces, nor merely a city of bustling commerce and exchange. She had become a stage, a vast theatre for herself and all the world.'[6] From the upper storey windows of various hotels, carefully selected for their vantage points, Pissarro observed and painted the play of human life on the roads and pavements below. He used the rather bland and undifferentiated façades of the *maisons particulières* to create the effect of a theatrical backdrop to a constantly changing pageant.

The Hôtel Garnier overlooked the continual bustle of the Place du Havre, in front of the recently rebuilt[7] Gare Saint-Lazare, the terminus of the railway line from Dieppe which Pissarro used to come to Paris. Of the areas of Paris that Pissarro explored in the 1890s, this one had the closest associations with the work of his colleagues: Manet's *The Railroad* of 1873, showing a portion of the Pont de l'Europe behind the Gare Saint-Lazare, Caillebotte's *Pont de l'Europe* of 1876, and Monet's series of the Gare Saint-Lazare of 1876–7.

In *Lordship Lane Station, Upper Norwood, London* (plate 48),[8] painted in 1871, the locomotive chugging directly towards the viewer suggests the railway's function in linking distant suburbia with the city. By contrast, the diagonal railway line and distant train in *Le chemin de fer de Dieppe, Eragny*[9] of 1886 implies the feelings of isolation and insignificance created by the coming of express trains to small towns or villages like Eragny, which seemed almost to cease being entities in their own right, and became merely part of the view seen from the windows of a passing train.[10] In the four views of the Place du Havre of 1893 and the five paintings of 1897, Pissarro concentrated on the station as a point of arrival in or departure from the city, the nineteenth-century equivalent of the medieval gate.

The Grand Hôtel de Russie overlooked the Boulevard Montmartre, which adjoins the Boulevard des Italiens in the west and the Boulevard Poissonnière in the east. The Boulevard Montmartre was first built in the eighteenth century, and was one of the wide straight roads which Haussmann used to form a coherent system of communication between the main centres of the city, in this case between the Place de la République and the Place de la Madeleine. Pissarro painted the boulevard at various different times of day and in different weather conditions, stacking several canvases around the walls of his room, ready for use at the appropriate moment. He also painted the boulevard once at night, his only night-time picture (London, National Gallery, P & V 994), and three times *en fête*, during the Mardi-Gras celebrations of mid-February 1897 (plate 49). The Mardi-Gras canvases were prepared in advance of the movement and activity of the processions. Pissarro told Lucien:

> Me voilà installé et en train de couvrir de grandes toiles. Je vais tâcher d'en préparer une ou deux pour faire la foule le jour du Mardi-Gras. Je ne sais encore ce que cela fera; je crains fort que les serpentins ne me gênent.[11]

Examination of *Boulevard Montmartre, mardi-gras*[12] suggests that the architectural constants of the scene were established on the canvas before the

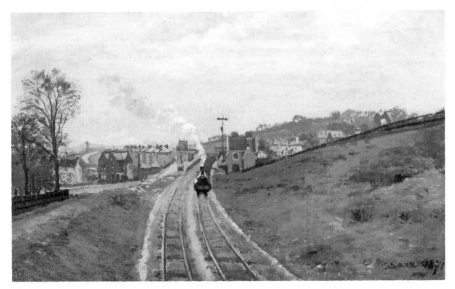

48 *Lordship Lane Station, Upper Norwood, London*, 1871, P & V 111, 45 by 74 cm. London, Courtauld Institute Galleries (Courtauld collection)

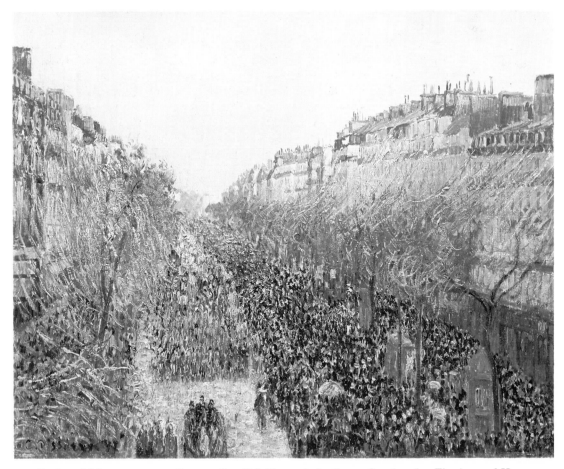

49 *Boulevard Montmartre, mardi-gras*, 1897, P & V 995, 65 by 81 cm. Los Angeles, The Armand Hammer Foundation

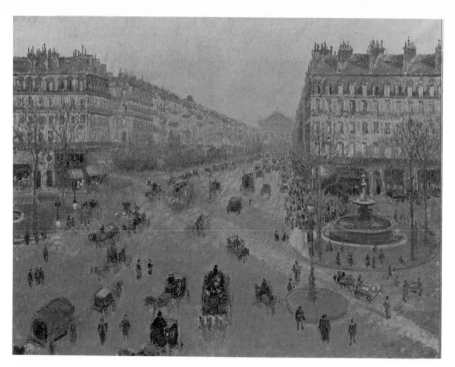

50 *Avenue de l'Opéra, soleil, matinée d'hiver,* 1898, P & V 1024, 73 by 91.8 cm. Reims, Musée de Saint Denis

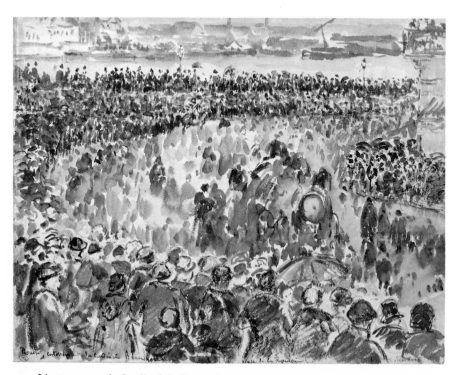

51 *L'enterrement de Cardinal de Bonnechose à Rouen,* watercolour, 1883, 22.8 by 29.5 cm. Paris, Musée du Louvre

throng of people was added. The effect achieved resembles that described by Louis Veuillot in *Les Odeurs de Paris* thirty years before:

> Les rues de Paris sont longues et larges, bordées de maisons immenses. Ces longues rues croissent tous les jours en longueur. Plus elles sont larges, moins on y peut passer. Les voitures encombrent la vaste chaussée, les piétons encombrent les vastes trottoirs. A voir une de ces rues du haut d'une de ces maisons, c'est comme un fleuve débordé qui charrierait les débris d'un monde.[13]

The Avenue de l'Opéra had always been regarded by Haussmann as a key element in his grand design, but as one of the links at an angle to the main routes, and because the hillock Saint-Roch raised the elevation of the Rue Thérèse and the Rue des Pyramides, posing constructional problems, it had not been completed during Haussmann's prefecture. It was completed as a show piece for the 1878 *Exposition Universelle,* and its elegant shops made it popular with wealthy Parisians and foreign visitors alike.

In 1889 Théo Van Gogh wrote to his brother Vincent of 'those qualities of rusticity [in Pissarro's paintings] which show immediately that the man is more at ease in wooden shoes than in patent-leather boots.'[14] For his series of the Avenue de l'Opéra, Pissarro installed himself in the very heart of patent-leather boot territory. The Grand Hôtel du Louvre, where he took rooms, was a relic of the Second Empire, described by George Augusta Sala in 1879:

> The vast dimensions of its principal apartments, the splendour of the decorations and furniture of the entire establishment, made the Hôtel du Louvre in its youth a rarity and a phenomenon. The erection of the hotel marked the dawn of the Imperial epoch.[15]

Pissarro was delighted with the scene that unfolded in front of him from the windows of the hotel. On 15 December 1897 he wrote to Lucien:

> J'oublie de t'annoncer que j'ai trouvé une chambre au Grand Hôtel du Louvre avec une vue superbe de l'Avenue de l'Opéra et du coin de la Place du Palais-Royal! C'est très beau à faire! Ce n'est peut-être pas très esthétique, mais je suis enchanté de pouvoir essayer de faire ces rues de Paris que l'on a l'habitude de dire laides, mais qui sont si argentées, si lumineuses et si vivantes. C'est tout différent des boulevards. C'est moderne en plein![16]

In Pissarro's Paris paintings the view is consistently constrained by the window frame, an automatic perspective frame and guide to the regulation of horizontals and verticals. Pissarro restricted himself severely in the many paintings viewed from a window, but at the same time examination of the paintings reveals how he adapted and varied the perspective of the paintings to achieve particular effects. Some but not all of the Boulevard Montmartre paintings appear to be conventionally set up one-point perspectives, while others, the night scene for example, employ intuitive perspective. In both types of painting, Pissarro then exaggerated the not entirely parallel sides of

the boulevard to heighten the sense of the architecture as a frame to the activity on the boulevard. Architecture is often employed in a comparable manner in topographical prints, but Pissarro's angle of vision makes the roads appear to run up the picture plane, while the carriages and pedestrians are composed on the picture surface very deliberately to increase a feeling of movement; in topographical prints they serve to reinforce the stability of the architecture and are frequently arranged in horizontal planes. *Avenue de l'Opéra, soleil, matinée d'hiver* (plate 50) has a distinct pinprick hole on its surface at the vanishing point, suggesting that Pissarro had set up the perspective by stretching threads across the canvas, a procedure which appears curiously timid for a painter of his experience. The dense crowds on the pavement in this canvas make a wedge shape which brings Charles Garnier's Opera House at the end of the avenue into great prominence.

Pissarro's boulevards and avenues are in Henri Bergson's terms 'living, moving, growing – a ceaseless flux'.[18] In these paintings Pissarro captures many of the peculiar qualities of urban life and of the city that Paris had become in the 1890s. His grasp of the nature of cities must be seen together with his understanding of rural life, his recognition of the inextricable relationship between city and country, and his wish to create a unified whole.[19]

Gustave Geffroy recognized the qualities of Pissarro's paintings when he wrote in his review of their exhibition at Durand-Ruel's in 1898:

> Les villes ont une physionomie particulière, passante, anonyme, affairée, mystérieuse qui doit tenter le peintre ... L'air que nous respirons est enfermé par ces cadres, à nous donner l'émotion de nos rues boueuses, de nos pluies, de nos avenues qui vont se perdant en une perspective de brume. Dans cette atmosphère véridique, la mêlée des voitures et des passants tournoie, se croise, se mêle, avec un prodigieux sens du mouvement rythmé des foules. A plusieurs reprises, ce combat social visible dans les allées et venues inquiètes de la rue, est aperçu et résumé par Pissarro, et c'est une des beautés de cette série de toiles que la représentation de l'agitation fatale des vivants parmi ces décors d'un jour.[20]

There are isolated precedents in Pissarro's work for crowded urban scenes viewed with some detachment from an upper storey window. In 1883 he painted a watercolour, *L'enterrement de Cardinal de Bonnechose à Rouen* (plate 51),[21] which is not only a prelude to the paintings of the late 1890s but also forms the basis of one of the drawings in the *Turpitudes sociales* of 1890. In the watercolour he shows a mass of people who have lost their individual identities in becoming part of a group, perhaps by implication showing the institution of the church as emphatically at variance with his concept of individual liberty. As Drawing 6 of the *Turpitudes sociales,* the scene is captioned: *L'enterrement d'un cardinal, qui avait la prétention de représenter Jésus-Christ sur la terre, hypocrisie, mensonge et luxe!*[22]

Bank Holiday, Kew[23] of 1892 (plate 52) is one of a number of paintings in which Pissarro stressed the importance of fairs and festivals in the lives of people living outside major cities. In showing a group of people compressed

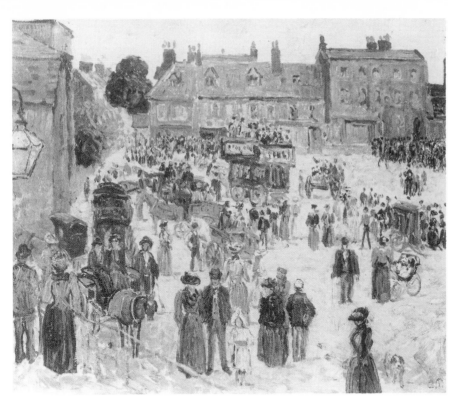

Bank Holiday, Kew, 1892, P & V 793, 46 by 55 cm. Formerly collection of Sir Charles Clore

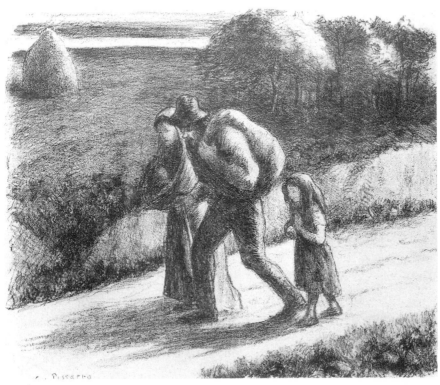

53 *Les trimardeurs,* lithograph, 1896, D 154, 25 by 30.2 cm. Ashmolean Museum

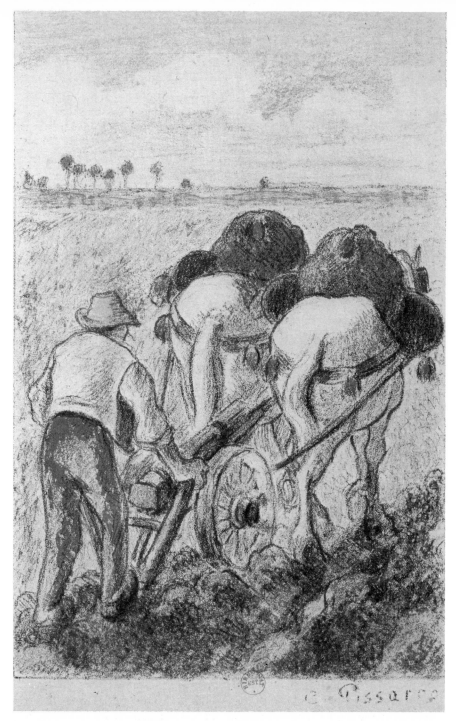

54 *La charrue,* coloured lithograph, 1897, D 194, 22.2 by 15 cm. Paris, Bibliothèque Nationale

into a tightly contained space, this painting anticipates two of the themes of the later Paris paintings, the importance of architecture in defining spatial relationships and the detachment with which the motifs are viewed. Unlike Claude Monet, who in his pair of *Boulevard des Capucines* paintings of 1873[24] included two spectators leaning over a balcony to look at the scene below, most prominently in the horizontal version which Pissarro would have seen again at Monet's and Rodin's show at Georges Petit's in 1889, or Gustave Caillebotte, who frequently made the psychological link between the observer and the scene observed the key to his paintings and a source of deliberate tension,[25] Pissarro completely effaced himself and the rooms from which he painted. In only one painting does Pissarro use the window to make a link between the interior and exterior worlds, a painting of 1884, *Jeune fille à la fenêtre, Eragny,*[26] showing his wife's niece Nini looking out at the garden at Eragny shortly after the Pissarros' move there. Her fashionable city clothes heighten the contrast between the city and the rural seclusion of Eragny.

During the 1890s the conception of the gulf between city and country was one that was widely discussed in France, prominently by Kropotkin and by Pissarro's friends Elisée Reclus and Jean Grave. Although France became industrialized more slowly than any other Western European country, by the 1890s the growing tide of movement to the cities and the changes in society, especially rural society, created by mechanization were clearly apparent. It was part of the creed of anarcho-communism to contrast the manual labourer with workers used to operate machinery and to stress the loss of dignity and security experienced by machine operators, whether in agricultural or factory labour. Jean Grave wrote in *Les Temps Nouveaux* in 1898:

> Autrefois, un ouvrier qui avait conscience de sa valeur pouvait se permettre d'envoyer promener Monsieur son patron ... Aujourd'hui il ne suffit plus être un abatteur de besogne, de bien connaître son affaire, il faut être humble et soumis envers son Excellence le capitaliste.[27]

Pissarro's work of the 1890s reveals an awareness of the divide between city and country. If one extends his concept of unity, of a sense of balance and harmony[28] from individual works to his *oeuvre* as a whole, the city paintings may be seen as complementary to his many renderings of rural life. Octave Mirbeau observed in *Le Figaro* in 1892: 'The eye of the artist, like the mind of the thinker, discovers the larger aspects of things, their wholeness and unity. Even when he [Pissarro] paints figures in scenes of rustic life, man is always seen in perspective in the vast, terrestrial harmony, like a human plant.'[29]

The lithographs Pissarro executed for *Les Temps Nouveaux* indicate his recognition of change in the hitherto comparatively stable pattern of French rural life. *Les sans-gîte* (plate 53)[30] shows a phenomenon of the age, a displaced labourer, carrying his few possessions in a sack slung over his shoulder, trudging wearily down a country road, accompanied by his wife and child. The setting is entirely rural, without a feeling that the city exercises an almost hypnotic pull, as in the work of the Belgian writer Emile Verhaeren, who

wrote of the division between town and country in three volumes of poetry and a play published between 1893 and 1898, the years of Pissarro's Paris series.[31] Nor is there, as in Raffaëlli's work of the 1880s, a sense of an urban wasteland. Pissarro's figures are bowed in dejection, the long shadows in front of them perhaps a reference to their future, and they are at variance with the tranquillity of their surroundings, the haystack an indication of a completed seasonal cycle.

During the 1890s the plight Pissarro portrayed was common and many families were the victims of an agricultural crisis caused largely not by mechanization but by a failure to mechanize or to consolidate the smallholdings and little farms that were the basis of French agriculture, and consequently, a failure to match the prices of their competitors in other countries.[32] The family Pissarro depicted had become outsiders, a recurring theme in his graphic work at this time, for example, *Mendiant à la béquille*[33] and *Mendiant et paysanne*.[34] These outsider figures, by representing the changing social and economic climate of their times, urge others, apparently stable, to question their own state.

The cover Pissarro designed for a lecture by Kropotkin republished in *Les Temps nouveaux* in 1897 is most closely related to the idea of a 'vast, terrestrial harmony'. Both in this coloured lithograph, *La charrue* (plate 54),[35] showing the single figure of a ploughman with his pair of horses and *charrue* (wheeled plough), and in an earlier print, *Le labour* (1888) for *Travaux des champs*,[36] Camille's and Lucien's joint project, Pissarro's rendering of the scene, with the ploughman viewed from the back and anonymous, the horses and plough at a diagonal, is related to traditional ploughing scenes in Books of Hours, and also to contemporary depictions of ploughing such as Léon Lhermitte's *Le labourage,* published in André Theuriet's *La Vie rustique* in 1888. Pissarro's view of the ploughman in *La charrue* would seem to accord with that expressed since Hesiod's *Works and Days* in the ninth century BC, in which the farmer is seen as the stabilizing element of a society, engaged in constant toil against the forces of nature, but resisting cultural cross-currents. Since Hesiod, too, this image has appeared to retreat from the present into an ever-receding Golden Past.[37] Robert Herbert has described Pissarro's lithograph as anachronistic,[38] and certainly Pissarro's vision of the ploughman was becoming increasingly difficult to sustain as the farmer's life was changed by mechanization. However, agricultural development in France was so slow[39] that ploughing with a *charrue* was not uncommon in the late nineteenth century; the still cruder *araire*, which was simply the bough of a tree shod with metal, was in use in areas of France until the First World War.[40]

Pissarro's choice of this image to illustrate a lecture entitled 'Les Temps Nouveaux' was made for two reasons. First, Kropotkin saw the peasant farmer as a 'decentralized unit'[41] who would represent the starting point for revolution, for he had not been stripped of dignity and a sense of worth by the pressures of either urbanization or mechanization. Second, the use of the *charrue* necessitated a collective approach to farming, since due to the ploughing teams requiring a wide space for turning, the long thin strips

ploughed in any area were divided among several owners.[42] Ownership of the land did not imply complete freedom to work it as one pleased, and access to an individual's plot often meant going through several neighbouring plots.[43] Collectivism on this scale was entirely in keeping with the beliefs of anarcho-communism. Kropotkin's vision of the future was one of free groups, federated to satisfy 'all the infinitely varied needs of the human being'. He called for a 'return to a state of affairs where corn is grown, and manufactured goods produced, *for the use of those very people who grow and produce them.*'[44] Pissarro's *La charrue* suggests an endorsement of these views, and he would have agreed with his friend Charles Malato that 'the age of gold is not in the past, it is in the future!'[45]

Pissarro's peasant figures in painting and in graphics have a dignity and monumentality which is frequently stressed by their large scale in relation to the picture format, as in *La charrue*. In the many paintings of the market at Gisors, *Le marché à la volaille, Gisors*[46] for example (plate 55), the figures are closely observed, although generalized, and are defined by their relationship with each other rather than with an architectural setting, as in the Paris series. Maurice Denis wrote of his generation's regard for the 'rudes simplifications des paysanneries de Pissarro'.[47]

As Richard Brettell suggests,[48] it was the economic interrelationships between the fields and the town which fascinated Pissarro, and for him the life of the peasants was not the traditional cycle of sowing and harvesting, but rather one of events that ended with the market. From the 1870s Pissarro had painted fairs, markets and holidays. In 1872, in *Fête de Septembre*,[49] he showed market stalls set up in Pontoise, on one of the rare occasions that he depicted the centre of the town. Fairs and markets were important social events in rural life. In 1896 Abbé M. M. Gorse wrote that fairs were a new factor in the peasants' life. They provided a social and sociable life of great importance, and were the equivalent in rural terms of visits to the theatre, the cabaret, or the races in urban society.[50] In comparing a painting of a rural market scene, such as the market at Gisors, to the Paris Mardi-Gras paintings, it is apparent that the participants in the urban festival are an anonymous mass, while the crowded rural market scenes are ones of lively social inter-course between individuals. The social role of the market continued to increase in importance during the last thirty years of the nineteenth century,[51] and neither self-sufficiency nor other shopping facilities deterred people from attending neighbourhood markets, to exchange news even more than goods. Fairs and markets multiplied in rural areas concurrently with their dis-appearance in Paris.[52]

In his landscape paintings, Pissarro used figures in the sense that Frédéric Henriet suggested in *Le Paysagiste aux champs* in 1876: 'La figure humaine est comme un centre d'attraction, qui absorbe à son profit les détails environnants'.[53] Figures constitute small but important elements in almost all the landscape paintings. The figures in the Paris series are in marked contrast not only to the large-scale peasant paintings but also to the small-scale figures in landscapes. They are small, individually insignificant, often little more than

the 'tongue-lickings' Louis Leroy saw in Monet's *Boulevard des Capucines* in 1874. No single figure or group of figures is a centre of attraction, instead individuals blur into an apparently random pattern of jostling crowds and traffic.

Five years after Pissarro's Boulevard Montmartre and Avenue de l'Opéra paintings, the German sociologist Georg Simmel was to identify the intensification of nervous stimulation as one of the factors that most distinguishes life in the city from rural life. 'With each crossing of the street, with the tempo and multiplicity of economic, occupational and social life, the city sets up a deep contrast with small towns and rural life.'[54] Simmel argued that the deepest problems of modern life arise out of the attempt by the individual to preserve his autonomy and individuality in the face of overwhelming social forces. Pissarro, pre-Simmel, understood this conflict and explored the differences between urban life, all change and movement, and the slower pace and greater continuity of rural life.

In 1893 Emile Durkheim had formulated the concept of *anomie*, a state of social disequilibrium in which the hierarchy of values disintegrates and 'all regulation is lacking'.[55] Durkheim's first book, *De la Division du travail social* of 1893 was followed by *Les Règles de la méthode sociologique* in 1895 and *Le Suicide* in 1897. It is tempting to speculate that Pissarro had read Durkheim, although there is no clear evidence to support this. Georges Lecomte recalled that Pissarro was particularly fond of reading sociology and often bought volumes on sociology during his afternoon walks along the *quais*.[56] The concept of *anomie* is now a cliché of urban life and one that Pissarro seems to have understood whether or not he had read Durkheim. A painting like *La Place du Théâtre Français* (plate 56) is almost a visual rendering of a lack of social order: carriages and pedestrians are intermingled, going pell-mell about their business with complete disregard for anyone or anything else, in an indeterminate space created by eliminating the horizon line.

Pissarro regarded contemporary Paris without nostalgia at a time when an increasingly romanticized view of 'old Paris' was becoming fashionable. During the 1890s the government began to take an interest in aesthetics for the first time, and public interest in history and antiquarian studies grew.[58] Haussmann commented despairingly on this vogue in his *Mémoires* in 1890: 'That the narrow and tortuous streets, especially those of the centre, were almost impenetrable to traffic, filthy, stinking, unhealthy – they do not worry about this!'[59] Pissarro and his anarchist friends looked determinedly forward to a future which they perceived as possible and practical. Elisée Reclus wrote in 1896 that the world he and his friends envisaged, in which individual liberty was cherished, was not a utopian dream. He said: 's'il est une société chimérique, impossible, c'est bien le pandemonium dans lequel nous vivons.'[60]

Pissarro painted his most important Paris paintings during the Dreyfus Affair, described later by Léon Blum as 'years of tumult, of veritable civil war [during which] everything converged upon a single question and in the most intimate .feelings and personal relationships everything was interrupted, turned upside down, reclassified. . . . The Dreyfus Affair was a human crisis,

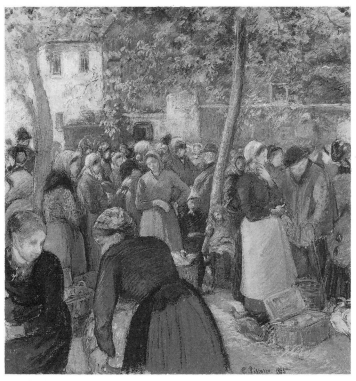

55 *Le marché à la volaille, Gisors,* tempera, 1885, P & V 1400, 81 by
81 cm. Courtesy, Museum of Fine Arts, Boston, bequest of John T.
Spaulding

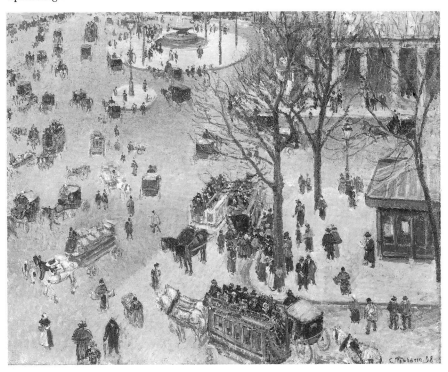

56 *La Place du Théâtre Français, Paris,* 1898, P & V 1031, 73 by 92 cm. Los Angeles
County Museum of Art, Mr and Mrs George Gard de Sylva collection

less extended and less prolonged in time but no less violent than the French Revolution.'[61] We know that Pissarro followed every twist of the affair with keen interest. His wife Julie complained: 'Doubtless the Zola affair takes all your time, so you can't write to me. That interests you much more than your family'.[62] He was a supporter rather than a participant. Although he made frequent financial contributions, often at considerable sacrifice, for such causes as a subscription to aid the children of an accomplice tried with the anarchist Ravachol, or to assist Pouget, publisher of *Le Père Peinard*, when he was arrested in 1896, he felt that he was not even in a position to sign the petition supporting Zola, since he was still a Danish citizen and feared possible deportation.

On the one occasion when the disturbances precipitated by the Dreyfus affair impinged on him directly, he described the occurrence in a letter to Lucien which I believe he misdated. This is the letter dated 19 November 1898, but written, it would appear, in January 1898.[63] The letter tells how he had to pass through a gang shouting 'Mort aux Juifs! A bas Zola!' It ends: 'En dépit des événements graves qui se déroulent à Paris, je suis obligé, malgré mes préoccupations, de travailler à ma fenêtre comme si rien n'était. Enfin, espérons que tout cela finira par des chansons.'[64] This is a clear expression of Pissarro's conception of his role as a painter, always detached, an observer who used the windows from which he worked to interpose a distance between himself and the scenes he painted.

Pissarro commented directly on what he perceived as the iniquities of capitalism and urbanization only in a private work, the collection of pen-and-ink drawings for his nieces in London, Alice and Esther Isaacson, completed in 1890 and called *Turpitudes sociales*. The drawings were never intended for publication.[65] They illustrate Pissarro's political views, which were in close alignment with those of Jean Grave, and many of the drawings were captioned with quotes from *La Révolte*, Grave's newspaper.

The title drawing shows a philosopher seated on a hill, looking, Pissarro said, ironically at Paris. The Eiffel Tower rises above the surrounding buildings, its pinnacle attempting to hide a rising sun with ANARCHIE written in the curve of its rays. The philosopher holds a scythe and an hour-glass, almost empty, stands next to him. Pissarro explained to Alice and Esther: 'Ce philosophe représente le temps . . . tu vois que c'est du symbolisme!'[66]

The philosopher of *Turpitudes sociales* bears a marked resemblance to Pissarro himself, both in physical appearance and in his detachment. Pissarro looked at both the city and the country, but he belonged to neither world. During the 1890s in particular, he was constantly pulled between Paris and Eragny, content in neither place. 'Je suis assez content d'aller voir ce qui se passe à Paris. Malgré un grand abattage de travail, je me suis fort ennuyé à Eragny. . . . Est-ce l'inquiétude après l'argent? L'hiver qui se fait déjà sentir? La lassitude des mêmes motifs et le manque de renseignements pour mes figures d'atelier?', he wrote on 20 October 1895.[67]

Pissarro's only statement about peasants was in a letter to Octave Mirbeau dated 21 April 1892, in which he commented on a passage by Kropotkin:

[Kropotkin] croit qu'il faudrait vivre comme les paysans pour bien les comprendre. Il me semble qu'il faut être emballe pour son sujet pour le bien rendre, mais est-il nécessaire d'être paysan? ... Soyons d'abord artiste et nous aurons la faculté de tout sentir, même un paysage, sans être paysan.[68]

At Eragny, the Pissarro family did not live like peasants, but like bourgeois, and although Pissarro described his temperament as *rustique*[69] neither by birth nor by experience was he in any way a peasant. Although Julie Pissarro's origins were closer to the peasantry, her family were wine-growers, albeit on a small scale. Zeldin points out that the winegrowers were not genuine peasants, and they lived in an almost urban culture, in villages of a thousand or more.[70]

Pissarro, in his psychological detachment from the peasants and the land, and his physical detachment from the city, isolated behind upper storey windows, personifies Frédéric Henriet's definition of a landscape painter as 'un être essentiellement intermittent'.[71] At no time in his career is this 'other-ness' more apparent than during the decade in which he alternated between city and country.

Despite their detachment, the Paris paintings must be seen as expressions of Pissarro's political and social views. Kropotkin believed that to show the existing social order was by definition to criticize it.[72] Paul Signac wrote in 1891: 'The anarchist painter is not the one who will create anarchist pictures but he who, without concern for wealth, without desire for recompense, will fight with all his individuality against official bourgeois conventions by means of a personal contribution!'[73] In the same year, Pissarro wrote to Lucien:

Peut-être suis-je en retard ou bien mon art ne concorde pas, ne cadre pas avec les idées qui semblent devenir mystiques. Ce serait alors une autre génération qui, débarrassée des idées religieuses, mystiques, mystérieuses, reviendra à des idées plus modernes, qui pourra avoir les qualités nécessaires pour aimer cette voie. Je crois fermement que nos idées imprégnées de philosophie anarchique se déteignent sur nos oeuvres et dès lors [celles-ci sont] antipathiques aux idées courantes.[74]

Notes

This article is a revised version of a paper originally read at the Camille Pissarro symposium organized under the auspices of the Arts Council of Great Britain and held at the Courtauld Institute of Art on 31 October 1980. In the intervening years my own views on the subject have altered, and a considerable body of material on the rural/urban divide has appeared, which is obviously not reflected here. I am grateful to John House for his comments on an earlier version of this paper, and to Tamar Garb for a more recent reading of it.

1 P & V 836–9, 981–1000, 1018–32.
2 The inflammation of the tear duct from which Pissarro suffered from 1888 was often precipitated by exposure to wind or cold, making outdoor painting difficult.

Between 1896 and 1898 he visited Rouen on four occasions, Troyes, Châtillon-sur-Seine, Grancey-sur-Ource, Dijon, Mâcon, Lyons, Cluny, London for almost three months, and Amsterdam.

3 For example, *Les boulevards extérieurs, effet de neige,* 1879 (Paris, Musée Marmottan, P & V 475) is related to paintings of rural scenes, such as *La sente du Chou, Pontoise,* 1878 (Douai, Musée de la Chartreuse, P & V 452) in its angle of vision, the importance of the trees, and the placing of the figures.

4 Pissarro stayed at 18, Rue des Trois Frères, Montmartre, from 1878 to 1883 whenever he visited Paris. On later visits to Paris he frequently stayed at the Hôtel Garnier near the Gare Saint-Lazare.

5 Quoted in L. Benevolo, *History of Modern Architecture* (London, 1971), vol. 1, p. 79.

6 R. Shattuck, *The Banquet Years* (London, 1969), pp. 5–6.

7 The station building was rebuilt between 1886 and 1889, according to K. Baedeker, *Paris et ses environs,* 1903, p. 217.

8 London, Courtauld Institute Galleries, P & V 111.

9 Private collection, P & V 694.

10 Raymond Williams discusses this loss of identity relating to the development of improved transportation systems in his novel *Border Country,* 1964.

11 *Lettres,* 13 February 1897, p. 431.

12 Los Angeles, The Armand Hammer Foundation, P & V 995.

13 L. Veuillot, *Les Odeurs de Paris* (Paris, 1867), p. 134.

14 *The Complete Letters of Vincent Van Gogh* (London, 1958), vol. 3, pp. 550–1, T 16.

15 G. A. Sala, *Paris Herself Again* (London, 1879), p. 127.

16 *Lettres,* pp. 441–2.

17 1898, Reims, Musée de Saint Denis, P & V 1024.

18 H. Bergson, 'The Perception of Change', quoted in I. J. Gallagher, *Morality in Evolution: The Moral Philosophy of Henri Bergson* (The Hague, 1970), p. 17.

19 Pissarro wrote to Esther Isaacson on 5 May 1890: 'j'ai commencé à comprendre mes sensations à savoir ce que je voulais vers les 40 ans – mais vaguement – à 50 ans c'est en 1880, je formule l'idée d'unité sans pouvoir la rendre à 60 ans je commence à voir la possibilité de rendre –'. Vente Drouot, *Archives de Camille Pissarro,* 1975, lot 146.

20 G. Geffroy, *La Vie artistique* (Paris, 1900), vol. 6, pp. 183–5. quoted in Pissarro exhibition 1980–1, p. 37.

21 Reproduced in colour in R. Cogniat, *Pissarro* (New York, 1975), p. 42.

22 Reproduced in a facsimile edition, published in Geneva in 1972, with an introduction by A. Fermigier.

23 Formerly collection of Sir Charles Clore, P & V 793.

24 D. Wildenstein, *Claude Monet. Biographie et catalogue raisonné, I. 1840–1881* (Paris, Lausanne 1974), 292 and 293.

25 For example, in *Jeune homme à sa fenêtre,* 1875 (Berhaut 26), or *Homme au balcon, Boulevard Haussmann,* 1880 (Berhaut 139).

26 Algiers, Musée National des Beaux-Arts, P & V 652.

27 J. Grave, 'Le Machinisme', *Les Temps Nouveaux,* 1898.

28 Letter to Esther Isaacson, 5 May 1890.

29 Quoted in R. E. Shikes and Paula Harper, *Pissarro: His Life and Work* (New York, 1980), p. 261.

30 D 154 (*Les trimardeurs,* 1896).

31 *Les Campagnes hallucinées, Les Villages illusoires, Les Villes tentaculaires* (poetry); *Les Aubes* (play). In Verhaeren's work, 'Tous les chemins vont vers la ville' ('La Ville' in *Les Campagnes hallucinées*).

32 J. H. Clapham, *The Economic Development of France and Germany 1815–1914* (Cambridge, 1921), p. 172.

33 D 182 (1897).

34 D 183 (1897).

35 D 194 as 1901.

36 London, British Museum. Drawings by Camille, woodcut by Lucien Pissarro. Reproduced in Shikes and Harper, op. cit., p. 286.

37 See R. Williams, *The Country and the City* (London, 1973), especially Chapter 2, 'A Problem of Perspective'.

38 R. Herbert, 'City vs. Country: the Rural Image in French Painting from Millet to Gauguin', *Artforum,* VIII (February 1970), pp. 51–2.

39 See T. Zeldin, *France 1848–1945. Ambition and Love* (Oxford, 1979), pp. 131–97.

40 Clapham, op. cit., p. 171.

41 Quoted in R. L. and E. W. Herbert, 'Artists and Anarchism: Unpublished Letters of Pissarro, Signac and Others – II', *Burlington Magazine,* CII (1960), p. 478.

42 See J. Horne, 'The Peasant in 19th Century France', catalogue of *The Peasant in 19th Century Art,* Dublin, The Douglas Hyde Gallery, Trinity College, 1980, p. 20.

43 Zeldin, op. cit., p. 139.

44 Kropotkin, from *Fields, Factories and Workshops,* quoted in H. Read (ed.), *Kropotkin: Selections from his Writings* (London, 1942), p. 97.

45 C. Malato, *Revue Anarchiste,* quoted by Signac in a letter to Cross, 1893, in E. W. Herbert, *The Artist and Social Reform* (New Haven, 1961), p. 191.

46 1885, Boston, Museum of Fine Arts, P & V 1400.

47 M. Denis, 'L'Epoque du Symbolisme', *Gazette des Beaux-Arts,* LXXVI (1934), p. 166.

48 R. Brettell, 'Camille Pissarro: A Revision', in Pissarro exhibition 1980–1. p. 29.

49 1872, Paris, Collection Durand-Ruel, P & V 188.

50 Abbé M. M. Gorse, *Au bas pays de Limosin* (Paris, 1896), pp. 282–3, quoted in E. Weber, *Peasants into Frenchmen. The Modernization of Rural France 1870–1914* (London, 1977), p. 411.

51 Ibid., p. 409.

52 V. Fournal, *Les Spectacles populaires et des artistes des rues* (Paris, 1863), p. 193.

53 F. Henriet, *Le Paysagiste aux champs* (Paris, 1876), p. 117.

54 G. Simmel, 'The Metropolis and Mental Life', in K. H. Wolff (ed.), *The Sociology of Georg Simmel* (Glencoe, Ill., 1950), p. 420.

55 E. Durkheim, *Le Suicide* (Paris, 1897), quoted in H. S. Hughes, *Consciousness and Society* (London, 1961), p. 35.

56 G. Lecomte, 'Un Centenaire: un fondateur de l'Impressionnisme, Camille Pissarro', *La Revue de l'art ancien et moderne,* LVII (March 1930), pp. 162–4. Lecomte said that Pissarro particularly liked a series with red covers; this was the *Bibliothèque Sociologique* which was published by P.-V. Stock and included works by Kropotkin and Grave. Durkheim's books were published by Félix Alcan as part of the *Bibliothèque de Philosophie Contemporaine.*

57 1898, Los Angeles, County Museum of Art, Mr and Mrs George Gard de Sylva collection, P & V 1031.

58 A. Sutcliffe, *The Autumn of Central Paris* (London, 1970), p. 189.

59 Quoted in Sutcliffe, loc. cit.

60 E. Reclus, *L'Anarchie* (Paris, 1896), p. 21.

61 Quoted from B. Tuchman, *The Proud Tower* (London, 1966), p. 171.

62 Quoted in Shikes and Harper, op. cit., p. 306.

63 The letter is written on the paper with a black mourning border which Pissarro used shortly after the death of Félix in November 1897. It is addressed 'Hôtel du Louvre' although he was at Eragny three days earlier than the date on the letter, and again in early December, and did not stay at the Hôtel du Louvre on short visits to Paris, preferring the Hôtel Garnier. The events described in the letter are those of January 1898, not November. There were riots in the provinces and in Algiers on 17 and 18 January, while in Paris trouble was confined, as Pissarro writes, to the activities of a few ruffians. Zola was charged on 18 January. Pissarro wrote to Zola only twice in 1898, after a long coolness between the two men, once

on 14 January, the day after *J'Accuse* was published, and once on 26 February, and mentions in his letter to Lucien having written to Zola and having been asked by Clemenceau to sign the Zola petition.

64 *Lettres,* p. 463.
65 The private nature of the project enabled Pissarro to be more open and direct than was his custom. But, as he told Alice and Esther, 'J'ai dû choisir, vu votre éducation et votre sexe, les turpitudes les plus honnêtes de la bourgeoisie' (undated letter, reproduced in facsimile, *Turpitudes sociales*, Geneva, 1972).
66 Undated letter to Alice and Esther Isaacson (1890), reproduced in ibid.
67 *Lettres,* p. 385.
68 C. Kunstler, 'Des Lettres inédites de Camille Pissarro à Octave Mirbeau (1891–1892) et à Lucien Pissarro (1898–1899)', *La Revue de l'art ancien et moderne,* LVII (April 1930), p. 228.
69 *Lettres,* p. 68 (20 November 1883).
70 Zeldin, op. cit., p. 169.
71 Henriet, op. cit., p. 101.
72 Kropotkin, *Paroles d'un révolté* (Paris, 1885), quoted in R. L. and E. W. Herbert, loc. cit.
73 Quoted from L. Nochlin, *Realism* (Harmondsworth, 1971), p. 236, from a manuscript in the Signac Collection.
74 *Lettres,* p. 233 (13 April 1891).

Chapter 9

A rebel's role: concerning the prints of Camille Pissarro

Michel Melot

One striking feature of the French reviews of the Camille Pissarro retrospective held in London, Paris and Boston in 1980–1 was that the critics seemed uniformly uncomfortable when confronted with the artist. His independent character and his passion for novelty, combined with an inflexible dogmatism in his choices, defies classification. His obstinate refusal to conform frequently raised the prospect of failure. His is a continuity of breaking-points, and a chronological reconstruction of his prints cannot rely on a harmonious and continuous development. A superficial study of his work, based on the tenacious methodology of the *catalogue raisonné,* suggests a body of work which evolved in a regular fashion, but this is not a true reflection of the situation. However, numerous recent studies on Pissarro provide a basis for the study of his work using more dialectical methods.[1]

Pissarro always rejected both institutions and systems. He never allowed himself to be judged by a selection committee. In this context, dealers provide an advantage over the Salon system, as the jury is both diffused and anonymous. None the less, he used dealers unwillingly. If he was the most faithful adherent to the principle of the co-operative among the Impressionists, it is probably because this system remained loyal to him during times of failure. Even within the confines of this organization, his choices show that he distrusted even the most liberal system available to the artist, that of spontaneous social demand. As soon as his art began to appeal to a larger public audience, his personal scruples, conscious or not, forced him back to the sidelines.

When Pissarro began printmaking in 1862, the low and underrated status of printmaking was a powerful lure. Yet, slowly, prints acquired more standing in the art world and certain members of the public lobbied to elevate the print to the level of an independent work of art with an intrinsic value of its own. On the one hand, Pissarro was extremely uncomfortable about this infatuation with the print and refused to respond to a growing demand for his works; to him the print was neither a reproduction, nor a multiplication, nor even a decorative or an applied art, and certainly never a commercial object. On the other hand, having himself imposed many conditions on his production of prints, he contributed to the classification of the print as a 'pure' object of art.

How did this elevation of the print to the rank of art object between 1850 and 1890 actually occur? If, as has been argued by a sociologist, an art object is defined by its 'relative autonomy' in relation to the rest of the world of commerce, this autonomy must first be found in the artist's ambition to be free from all commitments which might entail specific practices or specific prices; a work of innovation and creativity must appear to spring entirely from the artistic urge. In practice, however, individual creativity and innovation can also be the product of social pressures, or rather the artistic urge reacting to social pressures; this is precisely the role played by a rebel. When drawing up a balance sheet, it is apparent that Pissarro was involved in all the enterprises which between 1862 and 1896 raised the print into the world of art for art's sake. As Janine Bailly-Herzberg points out, his first plate must be considered a result of his experiences with the Société des Aquafortistes.[2] Both its style and its format support this hypothesis. Yet it was never published, either because the jury rejected it for inexplicable reasons or because Camille Pissarro never completed the terms of application for membership. The latter possibility would be in line with his psychological make-up, since, as we shall see, this is a pattern which will be repeated throughout his career as a printmaker.

His first lithographs on transfer paper date from 1874. If one exempts the work of Cadart in 1862, this is a relatively early date for the artistic use of the lithograph and is comparable with the artistic debuts of the great painter-lithographers Fantin-Latour (1873) and Whistler (1878). However, none of these lithographs was published and very few are extant. In 1881 Pissarro worked on the project of *Le jour et la nuit* with Degas, Mary Cassatt and Bracquemond. This project stimulated the Impressionist printers to print up to fifty editions of each design using Salmon's studio. For unknown reasons this was never issued.

It was also in 1880 that Pissarro accepted Théodore Duret's idea for an exhibition of his etchings in London. The first allusion to this project is found in Pissarro's letter to Duret dated 16 December 1880, but on 23 December he wrote, 'Quant à l'eau-forte, je n'ai pas eu le temps et les moyens de poursuivre les essais.... Nous nous sommes arrêtés brusquement! Le besoin de vendre me pousse à l'aquarelle, l'eau-forte est délaissée pour le moment.' On 4 January 1881, he wrote to his niece Esther, 'Je suis à peu près décidé d'envoyer avant peu une collection d'eaux-fortes à Deschamps marchand à Londres'; however, two weeks later, on the 17th, he wrote to Duret, 'Après avoir mûrement réfléchi je suis décidé à m'abstenir de tout envoi d'eaux-fortes et même d'aquarelles à Londres'.

Another important fact concerning Pissarro's printmaking which is revealed by the new edition of the artist's correspondence is Durand-Ruel's invitation dating from 16 September 1885 to undertake the etchings which would illustrate the catalogue for an exhibition the dealer was planning to hold in the United States. Following the usual custom of Durand-Ruel, these were to be etchings of Pissarro's own paintings, as was then very fashionable and had already been done by Manet, Millet, and Dupré. Durand-Ruel may

have been thinking of reviving the idea of his extensively illustrated catalogue of 1873. Pissarro was probably not interested and did not pursue the offer, while both Manet and Millet used the ambiguity inherent in the relationship between a reproduction and an original print to add value simultaneously to their etchings and to their paintings. It was also in 1885 that Lepère provided Pissarro for the first time with recipes for the preparation of wood-blocks. This, too, is an early date if one remembers that artists' wood-block prints were not widely disseminated until the last decade of the century. Moreover, it is possible that since 1884 Pissarro had known of Millet's wood-blocks, which were the first attempt by an artist to use the wood-block in a deliberately archaic fashion. Here again, the pattern of Pissarro's personality is repeated; he is at once an innovator, and the first to reject his own innovations; he invariably makes a false start and does not complete what he begins.

In 1889 Pissarro and the other *peintres-graveurs* were asked to participate in the exhibitions of the Société des Peintres-graveurs. He exhibited with them for two years but in 1891, when the Société became an institution, he was excluded from its membership and asked to exhibit as a guest. At the same time the original print achieved popularity, but one could say that even this held a threat for Pissarro. In 1888 Fénéon discussed Pissarro's prints at length in an article in the *Revue Indépendante*.[3] From 1889 onwards, many factors indicate a growing interest in his prints. The Beraldi family preserved all the letters they received from him (they are now in the Bibliothèque Nationale in Paris), which allowed Henri Beraldi to include an entry for Pissarro in his well-known dictionary of nineteenth-century printmakers, *Les Graveurs du XIXe siècle* (12 vols). Pissarro's letter to Beraldi of 27 July 1889 states simply: 'Je vous remets, ainsi qu'il a été convenu, le catalogue complet de mes eaux-fortes. Quelques unes ne sont pas terminées, au fur et à mesure, je vous ferai part quand elles seront finies.' This remark is clarified by Pissarro's comments in a letter dated four days later (31 July) which has been preserved in the Avery archives in the New York Public Library: 'Devant bientôt mettre sous presse le catalogue général de mes oeuvres gravées, je désirerai autant que possible assigner un numéro d'ordre à ces epreuves.' Another letter in the Avery archives shows Pissarro's embarrassment when faced with his first major commission for prints from a private collector: 'Je n'ai jamais vendu des eaux-fortes depuis que j'en fait. Je me trouve donc fort embarrassé de vous indiquer un prix.' Millet had had the same reaction when Sensier forced him to exhibit his etchings with Cadart.

Pissarro tried very hard to sell his prints. At times he placed them hopefully with dealers: 'Je comptais avec Thibaudeau grand marchand d'estampes', he wrote to Esther in 1889, and on 15 January 1891 he wrote to Lucien: 'Je voudrais que Bénézit devienne pour la gravure notre Théo van Gogh!' However, he did this without enthusiasm and without making any concessions. Thus, when Mary Cassatt 'insiste beaucoup pour que je fasse une exposition d'eaux-fortes en couleurs avec elle à New York', he refused because 'je suis à la peinture pour l'instant, je ne voudrais pas perdre mon filon' (9 May 1894). A critical examination of his reasons for ignoring both the 1880 exhibition in

London and the 1891 exhibition of the *peintres-graveurs* clearly shows that in the last analysis he held tightly to his rejection of anything which appeared to be institutional. In 1880, for instance, he was especially concerned not to compromise his values with regard to the founders of the Etching Club of London, whom he considered too academic. The founders were Legros, Seymour Hayden, Herkomer and Tissot. On 17 January 1881 Pissarro wrote to Duret: 'Je n'ai du reste aucune confiance dans les membres d'académies qui feront partie de ce jury.... du reste je n'y tiens pas, je hais l'officiel, même chez les Anglais!' He felt the same disgust for the *peintres-graveurs* whom he derisively labelled the 'patriots'. Finally he declared: 'Je n'accepterai pas leur invitation. Ils ont soif de l'officiel!' 'J'ai vu des tentatives de gravures en couleurs qui doivent figurer à l'exposition des patriotes, mais que c'est laid, lourd, terne et commercial.' (10 January 1891, 1 April 1891).

This series of events illustrates how the creation of works of art can be freed from society's demand for them. The paradox inherent in the situation is that only when demand has been resisted can it be met. In this case, demand is based on the assumption that a print is an autonomous work of art which must be produced independently and which cannot therefore expect to receive immediate recognition; the artist must be aware that the impatience of an amateur collector is a snare and a trap.

However, in order to acquire the autonomy needed for the status of a major art form, the print must carry a heavier philosophical burden than this. To comply with the demands of popular taste can certainly discredit an art form, but it cannot disqualify it. Rather, it was the relationship between the print and 'Industry' which some regarded as doing this. Where does Pissarro fit into this issue? Philosophically, he opposed 'Industry' and could easily ally himself with 'art for art's sake', but he certainly had to modify his position on this issue in order to take account of his socialist, near-revolutionary, ideas, and he did not undervalue those artists who relied on the mechanical presses to spread their work. His most frequent praise was for Daumier and Keene. He spoke often of Daumier: 'Je t'envoie ... dix dessins lithographiques de Daumier', he wrote to Lucien (22 January 1884). 'Je les regarde souvent. ... Comme lithographie on n'a pas fait mieux.' 'C'est cependant des "merveilles" à tous les points de vue' (17 February 1884). As can be seen from the new edition of Pissarro's letters, he also admired Charles Keene. Yet, while acknowledging the work of these artists, Pissarro disapproved of their methods and frequently raged against the process of mechanical reproduction, calling it 'l'expéditif gillotage qui rend de si grands services au commerce' (15 January 1891); 'le gillotage est à la gravure ce que les faux tapis turcs sont aux vrais. ... J'ai enfin vu les gravures du *Figaro* imprimées à Londres; ils n'avaient pas besoin d'aller si loin pour faire si mauvais, c'est horrible, horrible!!!' (early March 1884). He also refused all commissions from illustrated journals. Gustave Kahn's *La Vogue* did not last long enough to encourage him to participate in it and when Edmond Renoir approached him for *La Vie moderne* he explained: 'j'ai décliné la chose, par horreur du gillotage' (10 February 1884). In order to reconcile his views, he was forced to make distinctions of

quality, since while he personally refused to participate in these endeavours, he did at the same time encourage Lucien to try his hand at the rapidly developing field of illustrated journalism, even though he felt it was nothing more than a means of keeping bread on the table. 'Cependant tout en travaillant pour gagner sa vie il faut que ce soit bien; cela peut se faire, les Daumier, les Gavarni, les Henri Monnier, les Keene le font bien' (19 February 1884). However, these exceptions in no way nullify his rejection of the mechanical reproduction processes, which he saw as having led to the abandonment of the traditional print-making processes. His view that these traditional processes alone were legitimate for the production of true works of art was undoubtedly the catalyst for his attempts to promote original prints; this is evident in two major passages from his letters to Lucien which were inexplicably suppressed in John Rewald's edition of Pissarro's correspondence. In a passage written early in March 1884, he both attacks the *Figaro* and discovers Millet's wood-blocks. Comparing them he states, 'Voilà ce qu'il faudrait faire reprendre: la lithographie, eaux-fortes, bois, tout ce qui est direct'; and on 29 January 1884, he makes the following comparison: 'Je n'ai pas vu le *Figaro illustré*, mais on m'a dit que c'était horriblement laid, ce qui ne m'étonne pas. C'est en effet le procédé qu'emploie *Vierge*, très largement traité. ... Du reste c'est tout ce qu'il y a de moins artistique, il y a loin de cette espèce de typographie au dessin sur bois, ou lithographique. ... Cela ne veut pas dire que ce procédé, entre les mains d'un Degas ou d'un Keene serait mauvais, quoique le procédé soit mécanique et par conséquent anti-artistique.'

Two dangers threaten a rebel: failure and success. Failure nurtures his rebellion without quelling it. Success does not offer support to the artist since it damages his rebellion. For a nineteenth-century printmaker, after 1890 success was more to be feared than failure. In 1898, an irate Pissarro wrote: 'On ne s'occupe ici que d'estampe, c'est une rage, les jeunes ne font plus que cela.' Pissarro was, involuntarily, one of those responsible for this situation: not because of the success of his own work, but because of his refusal to accept commissions (to which prints are particularly amenable); because of his use of limited editions (in 1889, he said to Avery: 'Je pense qu'il faut tirer un nombre limité d'epreuves'); and because of the relatively high prices he asked for his work in order to distinguish the original print from a reproduction. At a time when he could have benefited from his success, he remained faithful to dissension. Vollard exemplifies the audacious and facile dealer who was able and willing to take advantage of the growing value of prints. 'Vollard, ce dont tu peux être sûr, ne s'occupera que de ce qui se vend: des noms; des autres, il s'en fiche!' (26 April 1896) Pissarro absolutely refused to join in any of the many dealers' groups which Vollard suggested and which were in fact perfectly reputable. When he was faced with the imminent possibility of success, Pissarro said: 'je fais des gravures parceque cela m'amuse et je ne tiens pas à les vendre.' In fact, his coloured prints, even at the height of their popularity, never attained any greater degree of public recognition than had his lithographs, etchings or dry-point engravings. It is precisely for this reason that Pissarro later held such a central position in the rise of the status of the

original print: the manner in which works are viewed is a necessary element of his definition of the print as art, and this, in whatever context, explains the shyness of critics when commenting on Pissarro. How can a critic, limited to formal analysis, explain the importance of a work of art in terms of how it was made rather than in terms of its subject matter? Even if they are honest, critics are limited by classifications as contradictory as those used by Arthur Hind at the conclusion of a long and brilliant essay: 'mediocre prints, marvellously used'.[4]

The critical reception of the 1980–1 exhibition lies outside the scope of this paper, but a reading of French periodicals quickly reveals comments which confirm the critics' discomfort. Prints were prominently displayed in the exhibition, but their prominence was merely noted; those responsible were congratulated. It is, of course, true that Pissarro's prints were a little-known part of his oeuvre which has finally been recognized in the wake of the recent vogue for contemporary prints. Indeed, Pissarro's prints were one of the principal sources for this vogue. They in fact underwrite the significance of contemporary print-making. Actually, contemporary attitudes are similar to those of Pissarro himself, who because he believed that art was beyond social judgment, provided a basis for the rise of prints into the category of pure art.

The social demand for prints, which was still underground when Pissarro began printmaking, increased with such potency that it could no longer be ignored. However, the artist's illusion that he was exempt from this demand came from deep within himself and it is only today that Pissarro's rebellion can be understood as one part of the organic process of the recognition of an art form. Camille Pissarro is dead; he cannot break the chains with which posterity binds him. But rest assured that were he alive today, things would be different.

Notes

1 This chapter is the continuation of my work on Pissarro's prints which has been published in the catalogue *L'Estampe impressionniste,* Paris, Bibliothèque Nationale, 1974; 'L'Estampe impressionniste et la réduction au dessin' in *Nouvelles de l'estampe,* no. 19, January–February 1975, pp. 11–15; and 'La Pratique d'un artiste: Pissarro graveur en 1880' in *Histoire et Critique des Arts* no. 2, 2ème trimestre, 1977, pp. 14–38. This new study has been made possible by the publication by Janine Bailly-Herzberg in 1980 of vol. 1 of the *Correspondance* which contains material that did not appear in the 1950 *Lettres.*

2 Janine Bailly-Herzberg, *L'Eau-forte de peintre au XIX siècle,* Paris, 1972, vol. 2, p. 159.

3 Félix Fénéon's article in the *Revue Indépendant* of January 1888 is reprinted in Joan U. Halperin, *Félix Fénéon, oeuvres plus que complètes,* Geneva/Paris, 1970, vol. 1, p. 92.

4 Arthur Hind, 'Camille Pissarro graphische Arbeiten' in *Die Graphischen Kunst,* vol. XXXI, 1908, pp. 34–48.

Chapter 10

Camille Pissarro, Rembrandt and the use of tone

Barbara Stern Shapiro

For the past year my colleague in the Boston Museum print department has been working on a catalogue for an exhibition entitled *Printmaking in the Age of Rembrandt*. While preparing material for the Rembrandt etchings to be included and proofreading for the Pissarro exhibition catalogue, I detected a relationship between the two *peintres-graveurs*, more than I thought possible and, perhaps, even more than Pissarro himself was consciously aware of. To be sure, Pissarro's printed work did not derive from Rembrandt but the two artists appear to have shared certain problems and often found their own but similar solutions. Both responded sympathetically to a vignette of realism and used a more immediate means to explicate their images. They gave light an authentic effect and freely modelled with shade instead of defining by contour lines. Many of their artistic problems were resolved in their prints as each artist made a personal investigation into the use of etched tone.

Of all his contemporaries, Rembrandt was the only painter-printmaker who most assiduously explored the progression of states on a single plate and who manipulated a film of ink on selected areas of a copper plate to obtain continuous tone. Further, he sought tonal effects through the use of drypoint burr, by abrading the plate, and by utilizing the accidental or intentional granular biting that occurred when the ground on the plate broke down within an acid bath.

The Entombment (plate 57), executed about 1654, dramatically demonstrates these principles. The first state or stage of the copper plate was realized through systematic hatched lines evenly bitten throughout. The plate was cleanly wiped and depended upon Rembrandt's highly sympathetic imagination and his gifted use of the open etched line. One is hardly prepared for the striking changes that take place in the second state. Rembrandt literally worked over the plate with additional lines, drypoint, and bits of engraving to take the composition from one that was cast in a full glow of light to one veiled in murky shadow. What is far more pertinent is the amount of ink that he overlaid on the surface of the plate to create an extraordinary range of tones in the second and third states. By varying the inking and wiping on the plate, Rembrandt could alter the emotional intensity of the highly charged

scene. Curiously, in the fourth state (plate 58) he made an experimental about-face, and again cleanly wiped the plate now more fully incised with lines – in this way he was able to probe the inner recesses of the dark grotto and judiciously introduce a sombre light. Rembrandt printed a number of impressions in each state and although fine impressions may be rare or uncommon, they are not unique. Obviously, he perceived the states as another manifestation of a creative process rather than in terms of a curiosity or an artificial progression to his final version. In many of Rembrandt's prints that encompass a range of states, he was not preoccupied with a sequential development from first to last but considered the single printing plate as a vehicle to express a variety of artistic ideas. He may have drastically changed his concept of a subject but by recording each state through the printing of impressions, Rembrandt proved his regard for the cumulative changes of the plate.

I am convinced that Pissarro was not unmindful of Rembrandt's efforts, especially given the intense espousal of Rembrandt as an etcher in mid-nineteenth century France. Concurrently, the first illustrated catalogue of Rembrandt's prints containing forty etchings and wood engravings appeared in Paris in two volumes in 1859 and 1861; whether Pissarro had access to these volumes is yet to be determined. The single most important event that symbolized the renewed interest in etching as a fine art, and thereby in Rembrandt, was the formation in May 1862 of the Société des Aquafortistes. Alfred Cadart, the publisher and ardent champion of original etchings, organized the society along with the master printer, Auguste Delâtre and Félix Bracquemond, a prolific etcher and proficient technician. Today, we familiarly call this period the Etching Revival. Whether there was an actual revival of an art that had disappeared or whether there was merely a shift in emphasis which led to an increased production of etchings, as William Ivins and, more recently, Alan Shestack believe,[1] must be discussed at another time. All agree, however, that these artists – printers, amateurs, and painters alike – were inspired by Rembrandt and his skilful use of the etched line along with the drypoint line and its velvety ridges of burr. That Rembrandt's virtuoso achievements with the distribution of ink on a plate to create shade was given unreasonable importance in the nineteenth century is also generally accepted. In the hands of Delâtre, Rembrandt's rich drypoint was reduced to a process known as *retroussage* in which ink was drawn out or wiped from the etched lines and spread over the plate into a dark tint to resemble drypoint. From a positive point of view, these variable inkings led to the creation of monotypes, but from the negative aspect, the exaggeration of Rembrandt's controlled methods of inking became a facile manner to disguise poor draughtsmanship. Contemporary critics called it *sauce abondante* and recently it has been appropriately dubbed by Eugenia Janis as *sauce hollandaise*.[2] Significantly, Pissarro, who was briefly a member of the Société, never produced a print for the folios. In fact, he later explained that his prints were much clearer than the ones pulled by 'cet affreux Delâtre; il sauce trop.'[3]

The question stands: what did Pissarro extrapolate from Rembrandt's

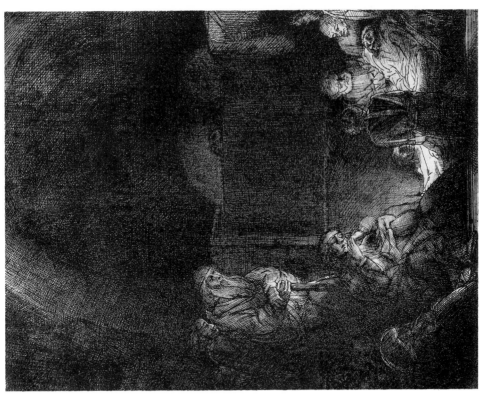

58 Rembrandt, *The Entombment*, fourth state, etching, Museum of Fine Arts, Boston, gift of Miss Ellen Bullard

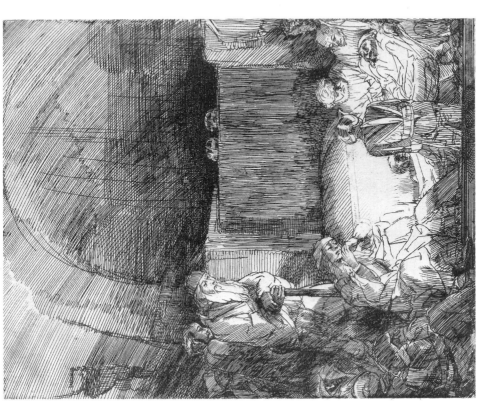

57 Rembrandt, *The Entombment*, first state, etching, Metropolitan Museum of Art, The Sylmaris Collection, gift of George Coe Graves, 1920

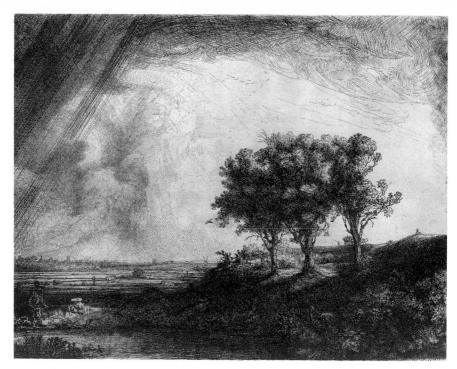

59 Rembrandt, *The Three Trees,* etching, Museum of Fine Arts, Boston, William
Norton Bullard collection

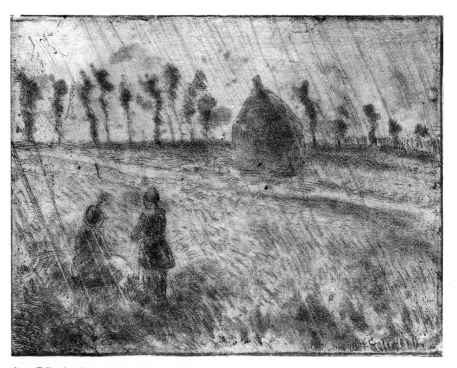

60 *Effet de pluie,* sixth state, etching, 1879, D 24, 15.9 by 21.3 cm.
Paris, Bibliothèque Nationale

highly original etched work and inventive procedures and how did Pissarro achieve his own tonal effects without being dragged into the inky 'pot de mélasse' of the 1860s? His prints of these comparable years are made up of straightforward fine and cross-hatched lines and appear as clear-cut reactions to the inky prints of many of his contemporaries. It is true that by the late 1870s when Pissarro was making prints with Degas, the 'Rembrandt' phenomenon had subsided, but Degas' admiration for Rembrandt's techniques is well known and the etchings produced by Degas and Pissarro during their collaborative years are reminiscent of Rembrandt's complex etchings. It is worth noting that during this mutual work period, the two avant-garde artists experienced a crisis in painting direction. Although Pissarro had already produced pictures of great spatial harmony, he felt that they lacked compositional unity. He painted fewer works in 1879–80 and turned to making some of his most inventive prints attempting in this manner to solve his stylistic difficulties. In *Femme vidant une brouette*, dated 1880,[4] we note the dramatic changes on the plate through the development of twelve states of which Degas owned eight. Just as with *The Entombment*, Pissarro began with a similar spare effect; this second state is sketched with drypoint. By the fifth state the plate is completely reworked, the motifs are enlarged and the overall light is drastically reduced by a gray tone. This was effected in part by inking but also by a special technique called *manière grise*, a term coined by Pissarro and recorded in an article by Félix Fénéon in 1888. In this method the plate was scraped with a roughened emery point or stump, with sandpaper, or metal brushes creating a tone that resembles a fine aquatint grain. Maxime Lalanne in his *Treatise on Etching* (written originally in French in 1866) mentions that sandpaper could only be used in the hands of an expert. It acted as a form of drypoint or could be bitten with acid in conjunction with other processes. In this fifth state the entire configuration of the image and development of space was abruptly changed and the build-up of tone became the key factor. Pissarro often spoke of the method and even subtitled some of his prints with the term. Like Rembrandt's drypoint burr, the *manière grise* technique was fragile and could not endure a large printing of the plate. In the eighth state, most of the original drypoint work has disappeared and Pissarro applied a coarse grain aquatint to strengthen the dark gray background and to heighten the sense of surface patterns relating it more distinctly to the facture of painting. In the last state, Pissarro covered the scraped areas with a new aquatint and added drypoint strokes to give greater clarity to the foliage and to bind the various aquatint layers. The seasonal change from a restrained wintry landscape to a glorious sunny day of this small printed painting was achieved by means of fixed tone. There was no variation of ink on the surface of the plate nor did Pissarro selectively wipe the plate to alter the light. In his own fashion, he achieved a similar result to Rembrandt, that is producing a series of impressions of a changing motif or equivalent versions of the same vision. Pissarro recognized the art of special inking when he complimented Whistler on his prints but as for himself, he wrote to his son, Lucien, that he wished to achieve suppleness before the printing of the plate. No matter what he did to

the plate, Pissarro depended only on what it would yield to him without an inky concealment.

Rembrandt's large etching of *The Three Trees* of 1643 (plate 59), a wide vista of the Dutch countryside and Pissarro's *Effet de pluie* of 1879 (plate 60) are both remarkable and comparable depictions of weather elements at work. Over existing linework in the sky, Rembrandt has lightly etched the billowy storm clouds and drawn with strong drypoint lines the diagonal rays of rain to indicate an unexpected rain shower. This is one of two landscape etchings of the period in which there is a positive rendering of the sky. A scene with various weather effects was uncommon in Rembrandt's day just as Pissarro's print was unusual among contemporary printmakers. By scoring the surface of the plate with oblique drypoint lines and sharply burnishing through the figures, Pissarro has altered the quality of light and uniquely created the suggestion of slashing rain. Although one knows that a corresponding interest in images of weather can be found among the Japanese woodcuts of Hokusai and Hiroshige, it is certainly possible to see the inspiration of Rembrandt. The *St Catherine* riverside in Rouen (D 48) made by Pissarro in 1883 also reveals the same overall effects of light and mood as *The Three Trees*. The fleeting clouds, the strong overplay of light and shadow that places the scene in a soft focus, and the implications of transparent vaporous effects demonstrate both artists' tonal mastery of the etching medium. For both, the rain-laden atmosphere has successfully served as the principal motif.

For the most part, Rembrandt did not make use of the manipulation of ink in his etched portraits. Rather he depended on closely laid meshes of etched lines, supplemented by drypoint with and without burr; in this portrait of the preacher Jan Sylvius of 1646 (plate 61) he employed the controlled use of a granular bitten tone. Minute cross-hatched strokes define the shadow of Sylvius's right hand while a textured grain is clearly noticeable on the preacher's face and on his fur lapels. The continuous tone reads as a fine transparent wash. It has been suggested that Rembrandt used a sulphur tint, a process similar to the aquatint method invented in the eighteenth century, or he may have reworked the grainy tone with a scraper and burnisher after the plate was bitten; more likely, Rembrandt masked certain areas with an acid-resistant substance such as wax or varnish, leaving an abraded surface on the plate after it was bitten.

Pissarro in his own manner employed these very same methods and also exploited new and unconventional techniques. In the detail of the Rouen riverside (D 48), he has delicately used the *manière grise* method, stopping out or painting out those areas which he wished to protect from the acid. Small touches of aquatint give the same transparent effect as Rembrandt's granular bitten tone. Both artists concentrated on mood rather than on linear effects and in these two images, the tonal work executed on the plate has furthered their painterly aims.

Another striking comparison in the use of tone can be seen in Rembrandt's *St Francis Praying* of 1657 (plate 62) and Pissarro's *Place de la République, Rouen* of 1883–4 (plate 63). Most early impressions of Rembrandt's second

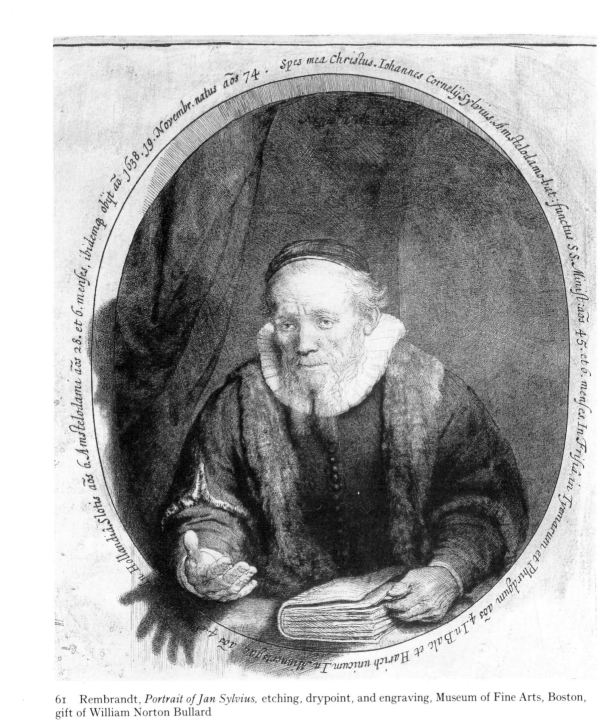

61 Rembrandt, *Portrait of Jan Sylvius,* etching, drypoint, and engraving, Museum of Fine Arts, Boston, gift of William Norton Bullard

62 Rembrandt, *St Francis Praying,* drypoint, Museum of Fine Arts, Boston, 1951 purchase fund

63 *Place de la République, Rouen,* second state, etching, 1883–4, D 65, 14.2 by 16.5 cm. Paris, Bibliothèque Nationale

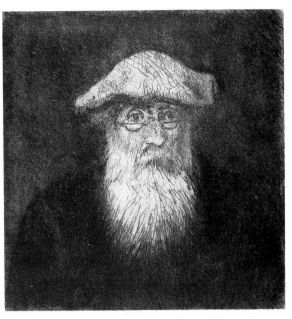

64 Rembrandt, *Self-portrait,* fourth state,
etching and drypoint, Museum of Fine Arts,
Boston, Harvey D. Parker collection

65 *Self-portrait,* second state, etching, 1890–1, D 90,
18.5 by 17.7 cm. Museum of Fine Arts, Boston, Lee M.
Friedman fund

66 *Grand'mère (effet de lumière),* seventh state, etching and aquatint, 1889–91, D 80, 17.1 by 25.3 cm.
Museum of Fine Arts, Boston, Horatio Greenough Curtis Fund

67 Rembrandt, *Adoration of the Shepherds*, fourth state, etching and drypoint, Museum of Fine Arts, Boston, Harvey D. Parker collection

state are characterized by the generous use of surface tone to establish varying relationships between the saint, the crucifix, and the landscape. In this impression, the sense of spirituality is heightened by the selective filming and wiping of the ink which envelops the saint and crucifix in shadow. Philip Hamerton's words were most appropriate when he wrote in *The Etcher's Handbook* (1871), 'But after all, there is nothing like printing as Rembrandt did with your own blackened right hand.' Hamerton, however, became disenchanted with artificial printing and by the 1878 edition of his book *Etching and Etchers* he did not even mention Delâtre's name. Pissarro, on the other hand, literally painted his plate with a resist to protect selective portions of the shaded work and to introduce whitened areas. The bitten tones have provided a sculpturesque modelling effect as well as the remarkable suggestion of rain-washed streets. In contradistinction, Pissarro often painted directly on to the plate with acid in a positive manner to create tone instead of drawing with resist to withstand the acid. All of these tonal and painterly means were firmly established on the plate and were recorded with the printing of each impression. Lucien Pissarro refers to this print when he wrote to his father in 1891:

> et voici textuellement ce que Ricketts m'a dit devant *La Place de la République*: 'Vous savez, je préfère certainement certaines eaux-fortes de votre père à celles de Whistler, et pour trouver un autre aquafortiste il faut remonter jusqu'à Rembrandt...' N'est-ce pas un exquis compliment? Il le pensait sincèrement et je crois qu'il a raison.... c'est lui [Rembrandt] qui a inventé cette gravure libre et si spéciale au métal mordu.... Je crois qu'en ne te préoccupant pas trop du métier, tu as trouvé quelque chose d'analogue à ce que Rembrandt a fait, tu as trouvé une façon de te servir du métal qui est liée très intimement à la matière; c'est précieux![5]

Finally, an examination of the two self-portraits (plates 64 and 65) proves that Pissarro noted the etched work of Rembrandt and assimilated his ideas and techniques. Both etchings show the artists in self-absorbed introspection – the mood is serious and even melancholy and any interest in fashionable dress is disregarded. One is struck by the frankness and intimacy of the self-portraits, and the piercing look of the two artists is most arresting. Pissarro's single etched self-portrait is similar in characterization to Rembrandt's and emerges from its Rembrandtesque background as an equal *tour de force*. However, Pissarro's plate was of poor quality zinc and did not permit any additional reworking whereas Rembrandt was able to execute a more finished and polished etching on his copper plate. Rembrandt combined etching, drypoint, and touches of engraving to obtain a subtle play of light and shadow. In his Sylvius portrait he had employed a bitten tone to better model the surface of the skin; in a similar fashion, Pissarro made convincing use of the clearly unintentional breaking down of the etching ground to further shade and model the facial features. It was typical of both artists' pragmatic approach to take creative advantage of accidents that occurred on the plates. The network of etched lines in Pissarro's self-portrait and the abraded surface of

the plate that holds a film of ink recalls the special wiping effects found in many of Rembrandt's prints of the 1640s to mid-1650s.

There are other striking and surprising comparisons that can be made in format, technique, and subject matter. It has already been suggested that the prints and drawings of Camille's mother in her last years are mindful of Rembrandt's sketches of Saskia ill in bed and more particularly Pissarro's etching of *Grand'mère* (*effet de lumière*) (D 80) compared to Rembrandt's *Adoration of the Shepherds* (plates 66 and 67).[5] I do not wish to force the issue but merely to try to indicate that Pissarro demonstrated in his prints a remarkable affinity to the etchings by Rembrandt. Although Pissarro's graphic work (as well as Degas's) is related to other artistic phenomena that took place in nineteenth-century France such as the flourishing of lithography, the advent of photography, Japanese colour woodcuts, and above all, the Impressionist aesthetic as it was revealed in paintings, it is just as persuasive to accept that Pissarro looked upon Rembrandt (as far as the execution of his prints was concerned) as one of his major influences. In a letter written to Lucien in 1898, his words seem paradoxically to confirm his respect for Rembrandt while firmly expressing his own individuality:

> Je suis allé à l'exposition de Legros chez Bing. Très importante. Selon moi, ses eaux-fortes sont de beaucoup supérieures à sa peinture, quoique par-ci, par-là, Rembrandt soit mis à contribution! Quand on aime les Rembrandt comme je les aime, je trouve les imitateurs trop au-dessous. Vraiment non! c'est par trop pénible, sourd, plutôt noir de ton et même les motifs de chaumières côniques sont par trop chipées. A quoi bon regarder en arrière et jamais la nature si belle, si lumineuse et si diverse de caractère? Toujours dans la poussière des vieux maîtres, que l'on ne devrait pas démarquer, sous prétexte de les vénérer! Il me semble qu'il vaut mieux suivre leur exemple, en cherchant des éléments dans ce qui nous entoure, avec nos propres sens. Je dis peut-être une grosse bêtise, cela ne fait rien, j'y tiens ferme.[7]

In the final analysis, Rembrandt and Pissarro as painter-printmakers both succeeded in promoting the imaginative potential of printed tone to achieve painterly effects in their etchings. Rembrandt used the distribution of ink as a tool to amplify the spiritual dimensions of mortal events and to express the chiaroscuro of nature in seventeenth-century Holland. More than two centuries later, Pissarro, responsive to the personal development of the intaglio medium in the hands of Rembrandt, recognized and integrated into his printmaking techniques the expressive possibilities of his contemporary Impressionism. From his painted work he expertly transferred the vibrant strokes of colour on to his plates in the form of bitten tones, creating in a small print format his own form of black and white Impressionism.

Whether Pissarro visited the Cabinet des estampes at the Bibliothèque Nationale, or studied Charles Blanc's compendium of Rembrandt's etchings (or other photographic reproductions alluded to by Hamerton in 1868), or whether he had access to the original prints must still be investigated.

Only then could we document with certainty the positive relationship between Rembrandt and Pissarro as printmakers.[8]

Notes

In the light of the tendency to consider Pissarro's prints purely as iconographic sources for his paintings, it is hoped that this discussion of only one facet of his innovative techniques will enable the student of Pissarro to view his etchings and lithographs as works of art unto themselves, surely as the artist intended. It should also be kept in mind that just as one can only appreciate Rembrandt's prints by examining a range of fine early impressions taken by the master, so it is necessary, when evaluating Pissarro's printmaking skills, to consider seriously those impressions printed by the artist (or under his supervision) when the work on the plate was fresh.

1 James Burke, *Charles Meryon Prints and Drawings* (Yale University Art Gallery, 1974), 'Some Thoughts on Meryon and French Printmaking in the Nineteenth Century' by Alan Shestack, pp. 15–21.
2 *The Painterly Print: Monotypes from the 17th to the 20th Century* (New York, Metropolitan Museum of Art, 1980); see the informative essay 'Setting the Tone – The Revival of Etching, The Importance of Ink', by Eugenia Parry Janis, pp. 9–28.
3 *Lettres*, p. 332.
4 See illustrations of five states in B. Shapiro, *Camille Pissarro: The Impressionist Printmaker* (Boston: Museum of Fine Arts, 1973), nos 20–4.
5 *Lettres*, p. 223.
6 Richard Thomson, University of Manchester, kindly informed me of these relationships at the Pissarro symposium in London.
7 *Lettres*, pp. 450–1.
8 It is known that Degas owned Rembrandt reproductions (see *Degas Atelier Vente*, November 1918, 'no. 4. L'Oeuvre de Rembrandt, 353 Reproductions') which may have been available to Pissarro. Considering the size of Rembrandt's print *oeuvre*, it is most likely that these folios were reproductions of his etchings.

Index

Note: numbers in bold type refer to the illustrations